LIVING MEMORIES

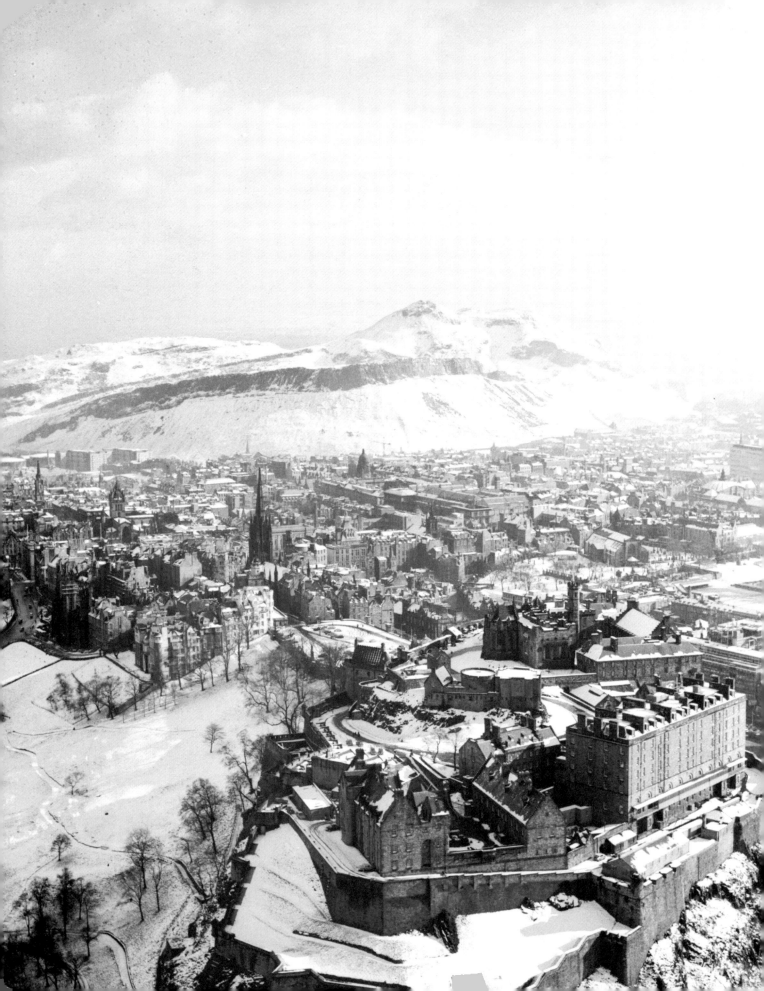

LIVING
MEMORIES

A PORTRAIT OF EDINBURGH IN THE LAST CENTURY

JENNIFER VEITCH

based on the *Evening News* series by Sandra Dick

BIRLINN

in association with

EDINBURGH
Evening
News

First published in Great Britain in 2005 by
Birlinn Ltd

West Newington House
10 Newington Road
Edinburgh
EH9 1QS

www.birlinn.co.uk

ISBN 10: 1 84158 452 5
ISBN 13: to follow

Design by Creative Link, North Berwick
Printed and bound by Scotprint, Haddington

Frontispiece White City: A frozen blanket covers Edinburgh's Old Town, turning familiar sights into a greetings card image

Contents

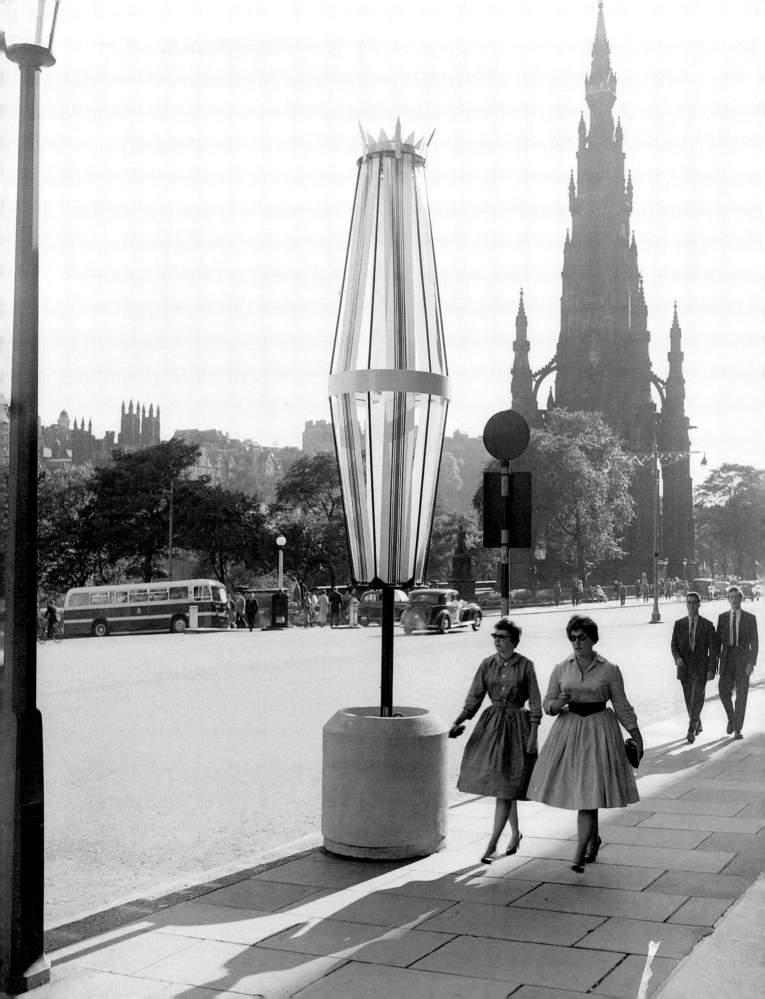

Foreword

For 132 years, the *Evening News* has been documenting daily life in Edinburgh, and our archives are a unique record of the city's development in that time. Those of us privileged enough to work on the paper can sometimes be guilty of failing to appreciate the fantastic array of pictures our library contains. Indeed, back in 1963, when the *News* amalgamated with the *Evening Dispatch*, much of the picture library was undervalued, and, sadly, many old glass plates were destroyed because of lack of space in the North Bridge offices. But when an old bundle of pictures comes down to the editorial floor, there is guaranteed to be a scrum of journalists examining the fascinating images.

It is a pity that the most of our archive photographs never see the light of day, with only one or two appearing when news stories or features demand. It seemed only right, therefore, that we should find a way to let people share what we might otherwise take for granted. The result was the publication of our Living Memories supplement and now this beautifully produced book.

At a time when transport is at the top of the city's agenda, I find the images of trams and now defunct train stations particulary interesting, and it should be no surprise that it will cost hundreds of millions to recreate what was foolishly ripped up in the Fifties and Sixties. And so, too, the images of St James' Square, Leith Street and Bristo Square stand as testimony to well-meaning but essentially befuddled civic leadership which was fortunately halted before any more damage was done.

Our team of photographers will continue to capture images of Edinburgh, and while we have long accepted that today's news might be tomorrow's fish-and-chip wrappers, we know that it is also history for future generations.

John C. McLellan

John McLellan, Editor, *Edinburgh Evening News*

Light fantastic: Giant lanterns were put in place to brighten up the east end of Princes Street during the 1959 Festival

Introduction

There is no habitation of human beings in this world so fine in its way . . . as this, the capital of Scotland.

Andrew Carnegie

For centuries Edinburgh has captured the imaginations of visitors and citizens alike with a unique brand of enchantment, and it's not difficult to see why. An iconic castle keeps guard over the city from a volcanic crag, while medieval skyscrapers still tower over labyrinthine cobbled closes in the Old Town. The 17th-century splendour of the Palace of Holyroodhouse still charms, while the restrained grandeur of the New Town never fails to impress. And the neoclassical gems designed by Playfair remain as inspirational today as when the city was first crowned 'The Athens of the North'.

All of these buildings are steeped in history and character, and thanks to a very happy mixture of geography, accident and design, tourists can marvel at these treasures today in much the same way as visitors like the poet Robert Burns did more than two centuries ago.

But only in the last century did this rather small city on the wind-battered western fringes of Europe take its place on the world map. Thanks to the success of the Festival and its upstart sibling, the Fringe, the people of Edinburgh have seen their city transformed from little more than a pretty, parochial backwater to a cosmopolitan world centre for the arts. The pace of change has accelerated still further over the last decade, with the city's confidence boosted by devolution and the reopening of the Scottish Parliament after almost 300 years.

While Edinburgh's architectural heritage might be remarkably well preserved, it belies the tumultuous changes of the 20th century: and only those who have lived through those changes can really appreciate how much.

Edinburgh was spared the worst of enemy bombardment in the Second World War, and the city's custodians resisted the temptation to rip out the heart of the town to make way for motorways and car parks. Nevertheless, entire streets have disappeared in slum clearances, landmark buildings have gone, workplaces which once employed thousands of people have shut down, entire industries have all but vanished, the much-loved trams have been scrapped and many of the cinemas, theatres and dance halls where Edinburgh people laughed and fell in love have long since closed their doors.

Nevertheless, there have been some real highs along the way: imagine celebrating the end of the Second World War with dancing in Princes Street, the excitement of watching the Famous Five at Easter Road or the Terrible Trio at Tynecastle, being part of the hysterical crowds which greeted The Beatles in 1964, spotting the countless stars who have shone at the Festival, watching Scotland win medal after medal at the Commonwealth Games – at least in 1970, if not 1986 – and joining the elated crowds celebrating the 'yes, yes' result of the 1997 devolution referendum.

Throughout this roller-coaster ride, the *Evening*

Nice try: A little boy tries to get some water out of a frozen drinking fountain in Frederick Street in January 1980

In the shade: Models from the Christine Reid agency are the height of Sixties sophistication at the Evening News–sponsored Ideal Home Exhibition, held at the Waverley Market in April 1966

News has been recording not only the major events in the city, but the everyday lives of the citizens of Edinburgh. From the women making sweets at Duncan's chocolate factory or churning out hot-water bottles at the North British Rubber Company, to the men toiling in breweries and dockyards and down the mines, to the children playing 'peevers' and 'bools' in the streets, to the crowds of fans cheering on Hearts or Hibs, to the courting couples who glided around the dance-floor to the big band sounds of the 1950s, the *Evening News* photographic archive has preserved it all.

As readers of long standing will recall, the newspaper itself has undergone some significant changes. The *News* merged with the *Evening Dispatch* in 1963, and some months later the landmark decision was made that the amalgamated paper should have front-page news. This was established from 1 April 1964, under a newly designed masthead. In May 1995, the *Evening News* made the switch from broadsheet to tabloid, and in April 2005 the paper was again redesigned. Like the

city it reports on and reflects, the *News* has not stood still. But the founding principle – to be a newspaper worthy of Edinburgh – has remained at the heart of the whole undertaking.

At the dawn of the 21st century, anyone reading the *Evening News* knows that Edinburgh, although not without its flaws and its problems, has emerged as a confident, aspirational capital city. The archives of the newspaper remain, not only as an important historical record of how the city used to be, but as a crucial reminder that its success is only due to the strength of character of its people.

While Edinburgh has produced some rather famous sons in the 20th century – Sir Sean Connery and Tony Blair are recognised the world over – it is the city's greatest-ever writer, Robert Louis Stevenson, who has best summed up Auld Reekie's allure.

'The place establishes an interest in people's hearts,' he wrote. 'Go where they will, they find no city of the same distinction; go where they will, they take a pride in their old home.'

ACKNOWLEDGEMENTS: This book was inspired by the Living Memories series of features by Sandra Dick, published in the Edinburgh Evening News in February and March 2005. Very special thanks are due to Sandra, not only for laying so much of the groundwork, but also for offering so much encouragement. And thanks too to the Library, Photosales and Enterprise departments at The Scotsman Publications Ltd for help in bringing this book together.

Many others have also provided their invaluable support. In particular, kind thanks go to David McDonald, director of the Cockburn Association, and transport historian Gavin Booth. Last, but not least, I want to thank Neville Moir at Birlinn for his unflappable patience and understanding.

Jennifer Veitch
September 2005

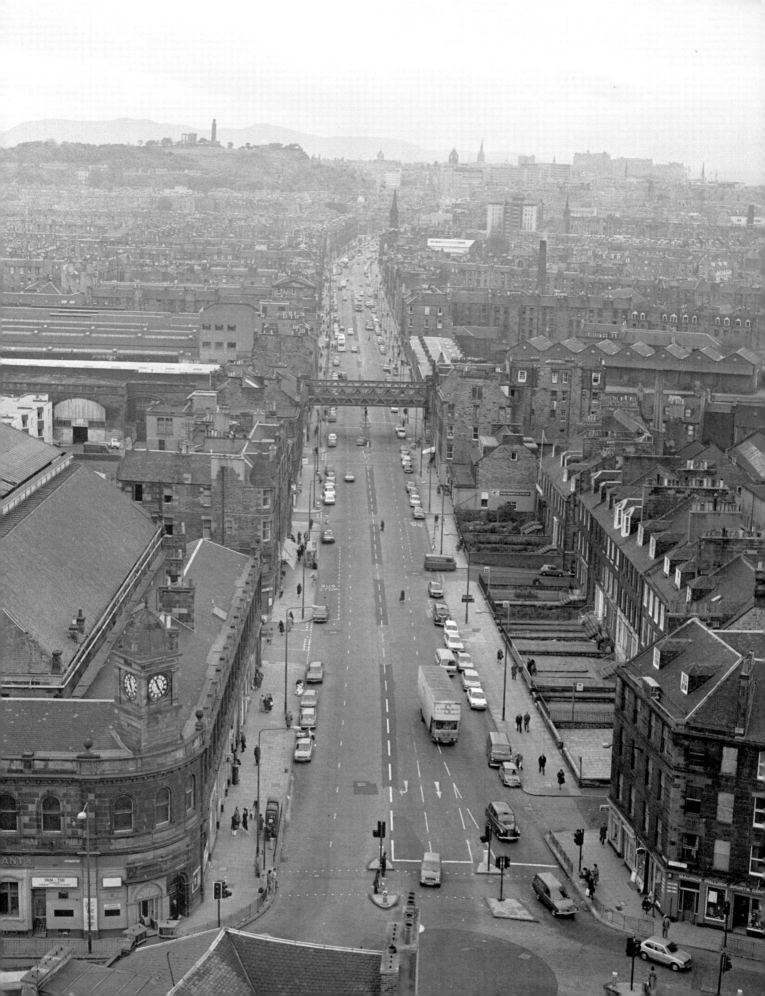

CHAPTER 1

Changing Spaces

The view of Edinburgh from the road before you enter Leith is quite enchanting: it is, as Albert said, fairy-like

Queen Victoria

There are few urban skylines in the world that can rival the enduring beauty of Edinburgh's delicate spires, turrets and domes. Built on seven hills, the city boasts a medieval Old Town and a Georgian New Town, both studded with rare architectural gems. Both were deemed to be of such crucial historical importance that they were designated a World Heritage Site by UNESCO in 1995, a status designed to guard against the twin threats of decay and encroaching development.

But the lasting value of Edinburgh's centuries-old buildings has not always been fully appreciated. It is ironic that while the Second World War had left Scotland's Capital city remarkably unscathed, the integrity of its built heritage would come under increasing threat in the post-war 20th century: the enemy would not be Nazi bombardment, but the wrecking ball, swinging in the name of progress.

No city ever stands still, and by the turn of the 20th century, the well-heeled professional classes had long since deserted the Old Town in favour of James Craig's exquisitely planned New Town, north of Castle Rock. During the Victorian era, many of the high-rise tenements on the Royal Mile, the Canongate, the Cowgate and the area around the Pleasance had almost sunk to the level of disease-ridden slums. Starting in the 1920s, and continuing into the 1960s, vast new housing estates mushroomed on the periphery of the city, offering poor people a higher standard of accommodation.

But it came at a price for Edinburgh: entire streets disappeared, including tenements at Greenside, Arthur Street and Carnegie Place off the Pleasance, India Place and Mackenzie Place in Stockbridge, and the Kirkgate and the Citadel in Leith.

The crumbling, soot-blackened walls, the leaking roofs, shared toilets and damp, dank rooms were all demolished, but much of the community spirit of those who had lived there vanished with them. As a result, brand new housing estates such as Craigmillar, Pilton and Wester Hailes would become bywords for poverty, deprivation and countless complex social problems. The ultimate failure of these housing estates as social experiments would, ironically, come to reinforce the 'Jekyll and Hyde' contrast between the Old and the New Towns in Robert Louis Stevenson's day, widening the gap between the affluent and the deprived.

Not all the modern structures that replaced the old city-centre slums would be welcomed either. The 1960s saw large swathes of central Edinburgh bulldozed to make way for monolithic concrete buildings. Edinburgh University's redevelopment of George Square, just south of the city centre, came in for particular criticism, with tower blocks replacing large sections of the much-admired Georgian domestic architecture. The David Hume Tower was completed in 1963, followed by the Appleton Tower in 1966 and the University Library in 1967. But redevelopment was not meant to end here; there

Queen's view: This picture, taken in October 1977, from the foot of Leith Walk, shows a skyline that had changed relatively little since Queen Victoria described the view as 'fairy-like'

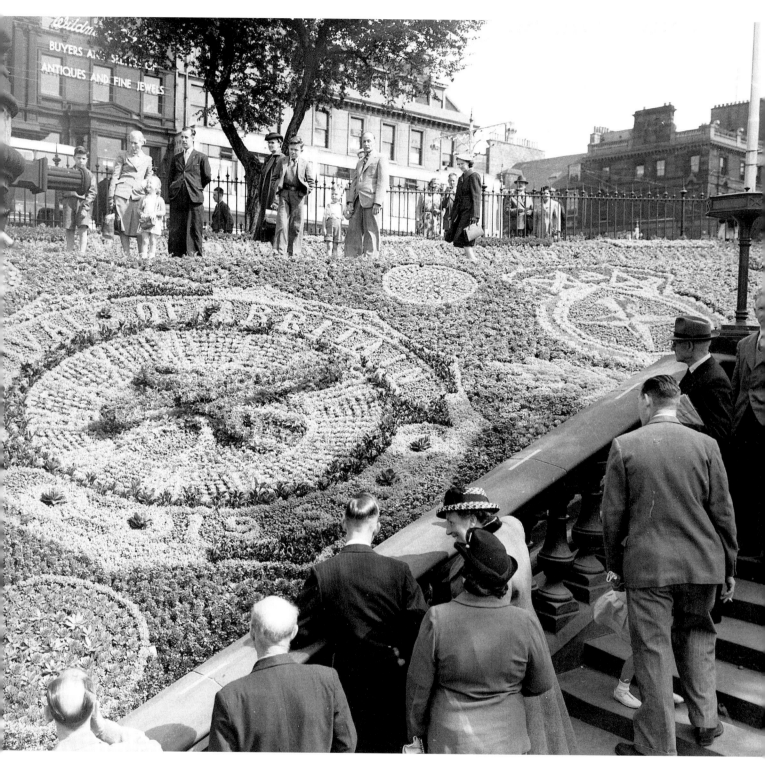

Hands on: The Floral Clock, with its mechanical cuckoo,
became a welcome addition to the city centre in 1903. Its
enduring popularity is underlined by this picture of the clock
being admired by Edinburgh citizens in 1951

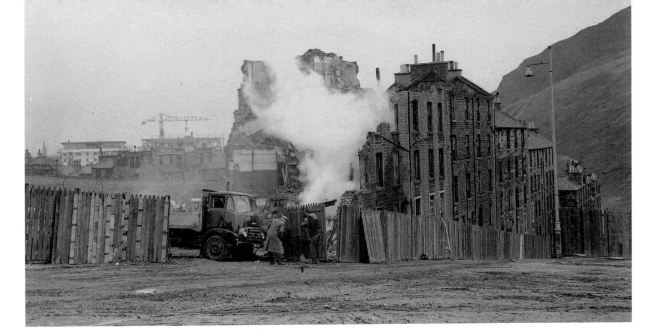

All fall down: Slum tenements in Arthur Street, St Leonards, are demolished in April 1956 – while new housing, visible in the top left of the picture, is built at nearby Dumbiedykes

were plans to create a new campus extending as far east as the Pleasance! Fortunately for those who were struggling to conserve Edinburgh's heritage, however, the project was never completed, although as a preparatory measure several tenements in Bristo Street were swept away. In the process, the city lost one of its landmark shops, the distinctive half-timbered building which was home to Parker's Stores.

Perhaps the most drastic of all the 1960s' changes was the St James Square Development, a vast shopping mall and office complex, complete with multi-storey car parking and an ugly bridge across the top of Leith Street to Calton Hill. Conservationists tried to prevent the development from going ahead, or at least to have it scaled down, but to no avail. In 1965, St James Square and the neighbouring tenements on Leith Street, with their quaint split-level rows of shops, were completely eradicated to make way for what would become the most universally loathed building in the city. In 1975 Her Majesty the Queen officially opened the St James Centre and the adjacent New St Andrew's House, which had been built as a new home for Scottish Office civil servants.

That same year, George Bruce, writing in *Some*

Practical Good, a history of the Cockburn Association's first 100 years, spoke for many horrified Edinburgh residents when he described the shopping mall as an 'Alcatraz'. He added: 'We continue to pay for the errors of the worst days of the Corporation, approximately the decade between 1955 and 1966. We suffer now, and must do so for at least 125 years, from Edinburgh's latest and worst eyesore, the St James Centre. The gross bulk is certainly the greatest disservice so far to the conservation of civilised living.'

Thirty years on, and despite recent attempts to renovate the St James Centre, the citizens of Edinburgh have still not taken the development to their hearts; it is regularly voted Edinburgh's worst building. David McDonald, current director of the Cockburn Association, has described the mall as 'one of the monstrosities of modern Europe, bang in the centre of town', and 'the greatest architectural blunder of 20th-century Edinburgh'. Some less forgiving critics might go still further and argue that it qualifies as the worst building ever constructed in the city. The St James development's reputation was not enhanced by the fate of New St Andrew's House, which had to be abandoned after twenty years following the discovery of asbestos.

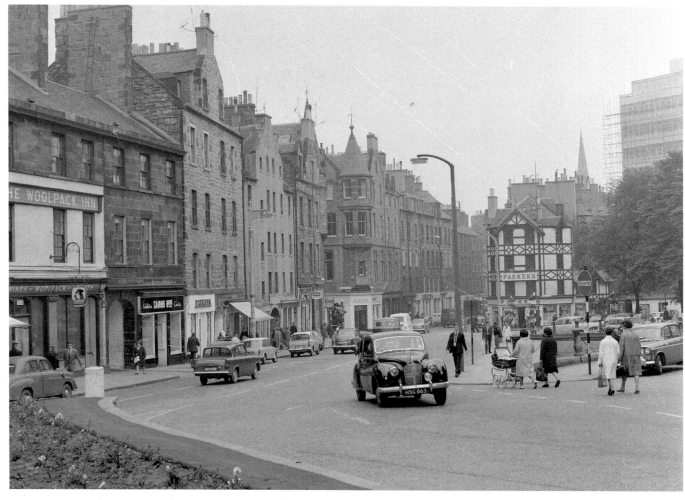

Timber: Parkers store, with its distinctive half-timbered design, pictured here in June 1965, would be demolished to make way for Edinburgh University's redevelopment in the Bristo Square area. The construction of the Appleton Tower is visible in the background

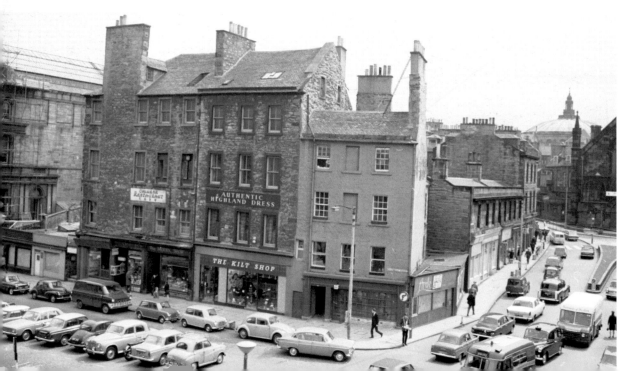

Museum piece: The western corner of Chambers Street and site of the city's first Chinese restaurant – pictured here in 1968 – has long gone to make way for the modern Museum of Scotland

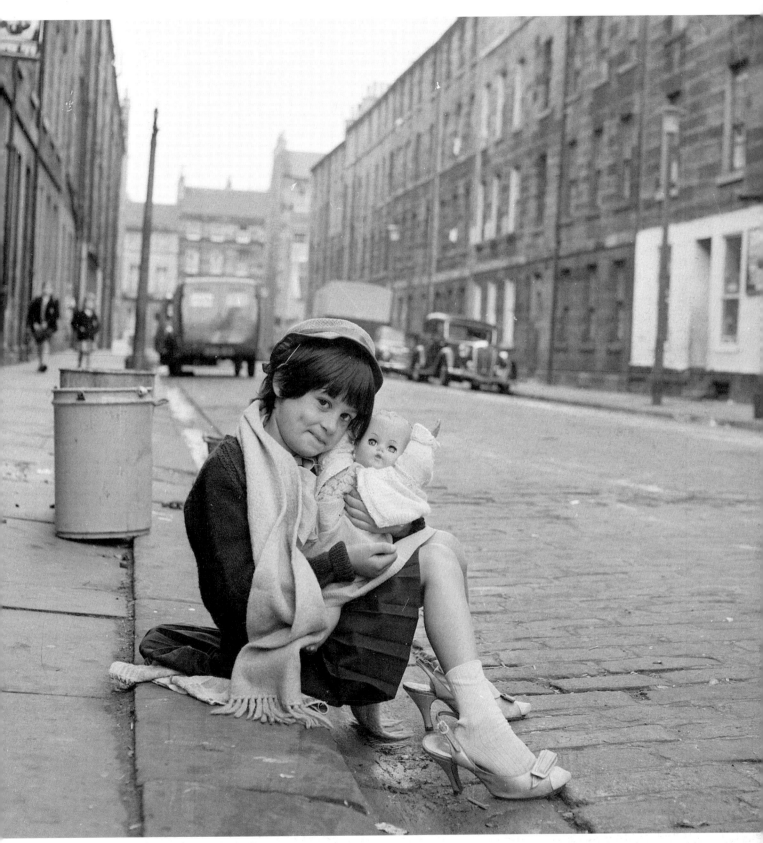

Dolled up: Wearing her mother's high-heeled shoes, seven-year-old Diana Molloy plays outside her home at Jamaica Street in 1964, shortly before the family were moved out of their 'slum' tenement to a new house with the luxuries of a bath and an inside toilet

Square deal: The area around St James Square has now changed beyond recognition. It was demolished in 1965 to make way for the construction of the little-loved St James Centre

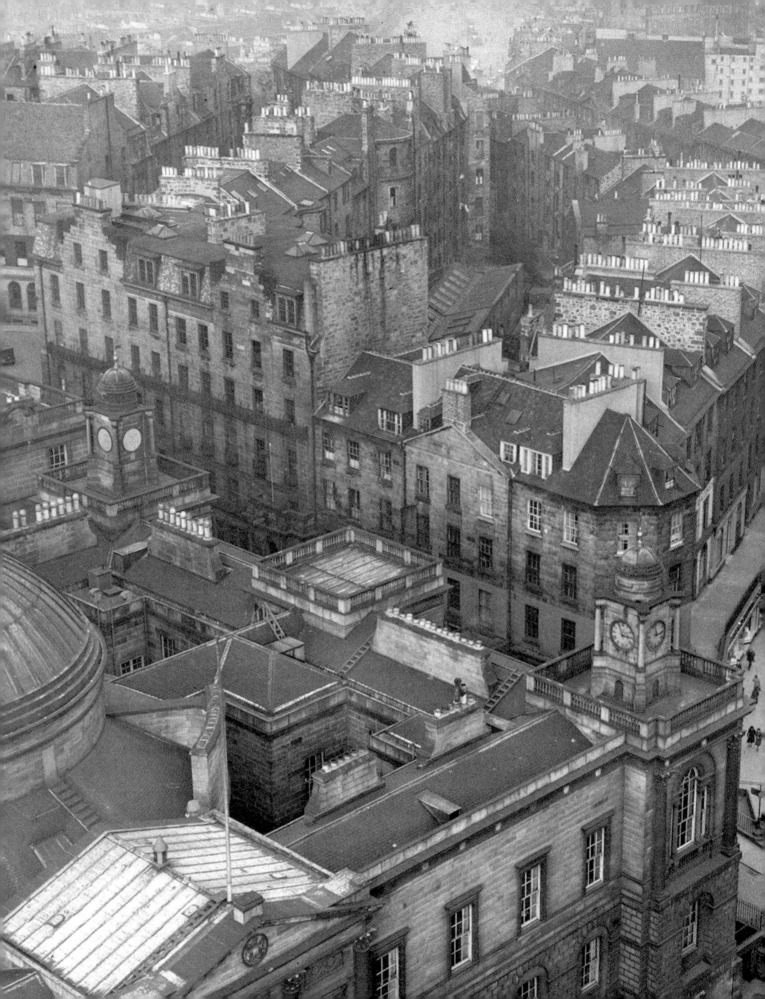

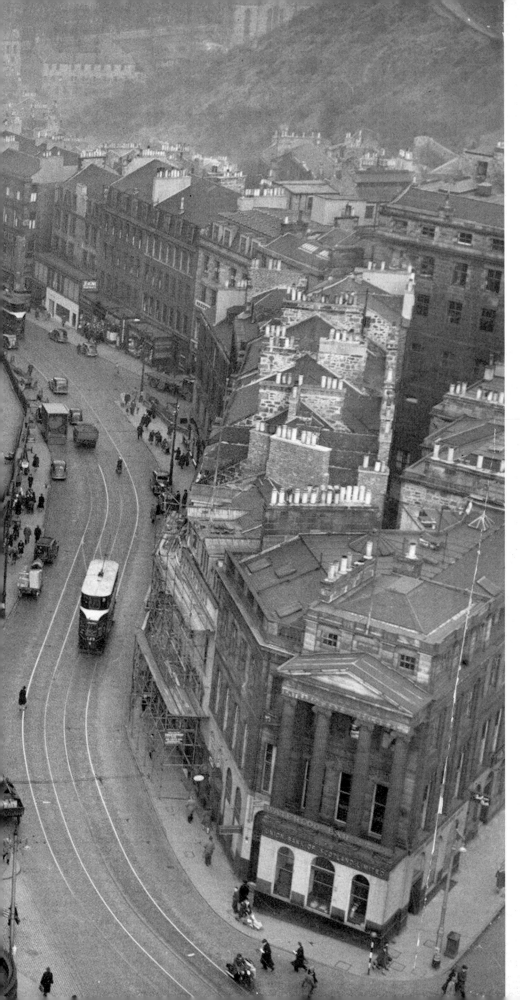

Top of the Walk: This view of Leith Street, taken from the Clock Tower of the North British Hotel in the 1960s, shows how much the East End has changed since the demolition of St James Square and the construction of the St James Centre

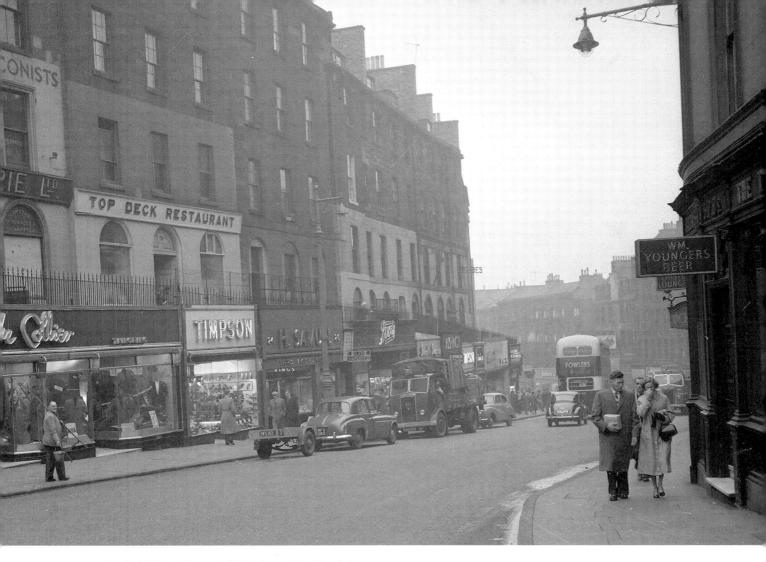

Top deck: This quaint row of split-level shops, pictured here in the 1950s, would also be knocked down to make way for the 1970s shopping mall

Another nearby failure in capturing the public's imagination was the kinetic sculpture, erected at Picardy Place in 1973. An early experiment in community art, this metal structure, complete with fluorescent-tube lights, was supposed to change colour in accordance with the elements of the weather, but it did not work for long. The sculpture was eventually removed – but not before it had become a city-wide laughing stock.

The east end of the city saw further major changes with the demise of the Waverley Market, a much-loved landmark and a public meeting space beside the city's main railway station. This market was more than a place devoted to buying and selling all manner of wares; it was also a city-centre arena, playing host to bands, exhibitions, carnivals and the circus when it was in town. In 1985, the Waverley Market was replaced by a shopping centre of the same name, although it was subsequently designated Princes Mall. For some, the Americanised shopping mall will never replace the vibrant, ever-changing marketplace. Gus Guthrie, a member of the Cockburn Association, recalls: 'You knew the following day there would be a circus, exhibition or show on. As a child it was very exciting. Edinburgh misses a marketplace like that.'

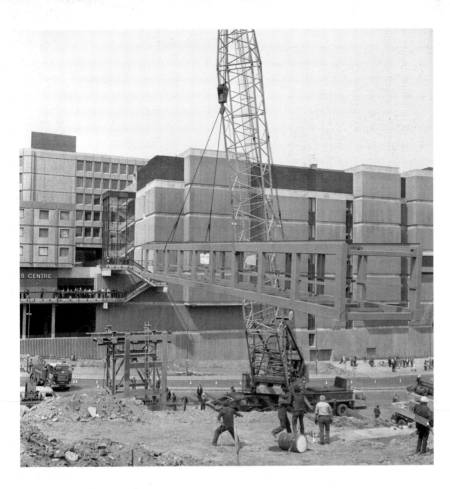

Site for eyesores: Pictured in June 1975, the bridge connecting the St James Centre with Calton Hill is lowered into position

Switched on: The lights are on at the kinetic sculpture – one of Edinburgh's first examples of community art – at Picardy Place in April 1974. But the weather-dependent sculpture usually failed to work, and would become a city laughing stock

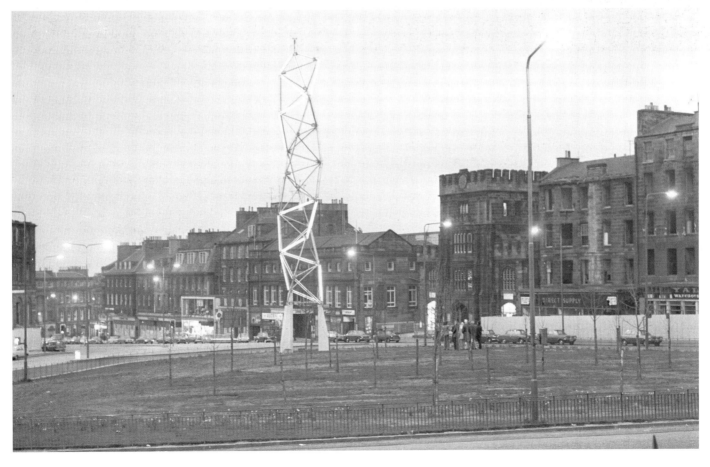

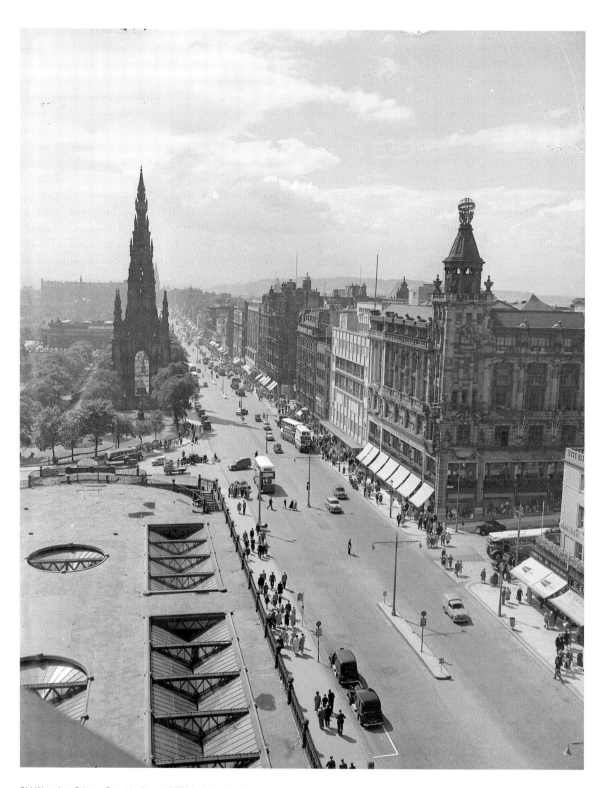

Old Waverley: Princes Street in August 1951 looks much the
same as it does today – except for the roof of the old
Waverley Market, to the bottom left of the picture, which
was the central meeting place for the Capital's citizens

Even Princes Street itself, the city's showcase shopping thoroughfare, was not protected from the wrecking ball: the old New Club building was demolished, along with the Life Association and the North British and Mercantile Office. Today the street is a higgledy-piggledy mix of architectural styles, and not a few so-called 'rotten teeth'. Conservationists were particularly opposed to the Royal Bank of Scotland's application in 1973 to demolish the Victorian façade of their branch next to Binns at the West End and replace it with a brown glass frontage. When the bank's proposal was rejected, the glass walling was wrapped around the existing structure, and campaigners denounced the result as 'an architectural joke in bad taste'.

Next door at Binns, the 1970s also heralded significant change. That famous seven-storey Edinburgh department store was acquired by House of Fraser and its name changed accordingly in 1976. Another Princes Street stalwart, R.&W. Forsyth, would vanish in the early 1980s when the shop was sold to the Burton Group. After the closure of Arnotts' branches at North Bridge and South Bridge in 1976 – formerly the sites of Patrick Thomson's and J.&R. Allan's – only the iconic Jenners remained, but in 2005 it was also bought by House of Fraser. Six decades of cinema history on Princes Street came to an end in 1973, when the Jacey, formerly the Monseigneur News Cinema, ran its last reel.

But perhaps the people of Edinburgh who mourn the passing of the way Princes Street used to be can at least be thankful that it has been protected from the worst ravages of concrete development which afflicted other major cities - Edinburgh could easily have succumbed to the demand for motorways and city centre car parking.

Indeed in 1955, the city council applied for a provisional order to use East Princes Street Gardens as a car park, and in *Some Practical Good*, George Bruce recorded that a letter of protest was sent to the Town Council by the Cockburn Association, a public appeal was launched . . . and a meeting of public protest was held on November 30 . . . On 16th December, the Town Council withdrew the scheme.

The protesters won the day, and the countless residents and visitors who have relaxed in the Gardens should thank them for their efforts. After East Princes Street Gardens were spared, the city's first multi-storey car park opened in Castle Terrace in 1962. But it would not take long before the council would unveil an even more audacious traffic-related scheme.

In 1965, the council proposed the creation of an Inner Ring Road around the centre of the city. Linking with approach roads to the east and west, this six-lane highway would have ripped through the middle of the Meadows, demolished Warriston Crescent and blocked off much of the access to Arthur's Seat. Viaducts and flyovers would have been prominent at Calton and at Greenside.

It is difficult to gauge whether the proposals or the perception that the council was trying to force them through without public consultation caused more outrage, but in 1965, the Cockburn Association reported: 'The continued efforts of the Corporation to keep the proposed line of the Inner Ring Road secret became increasingly farcical as individual owners of property threatened by it prised out the location of successive segments. What has yet to be demonstrated is that a Ring Road is necessarily the best approach to Central Edinburgh's traffic problems.'

Incredibly, despite the public outcry, the council pressed ahead with the plans, and was only halted when the Secretary of State instructed the council to drop the proposed route for the northern section and to reconsider the plans for the entire scheme. It was a major victory for those who passionately cared about preserving Edinburgh's historic buildings for future generations. But it did have long-term consequences which are being felt today: while other cities, including Glasgow, built their way out of congestion difficulties, Edinburgh was storing up traffic problems for decades to come.

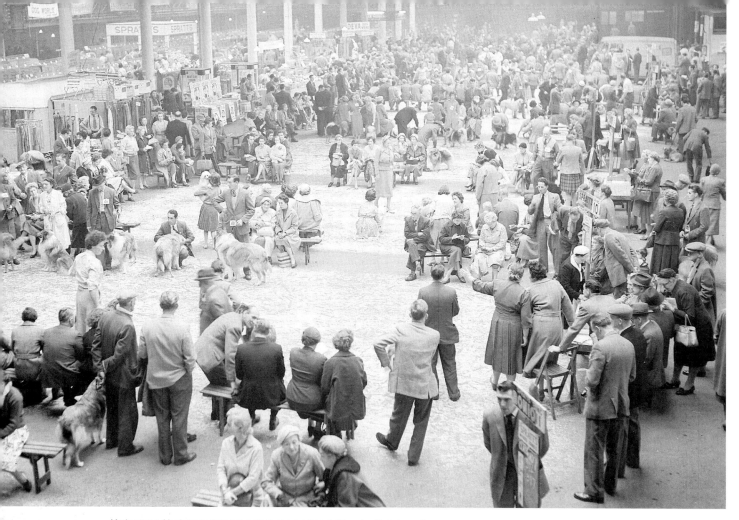

Market town: Much more than just a place to buy and sell, Waverley Market was the hub for events in the city centre, and as this picture from October 1959 reveals, it was the venue for the Scottish Kennel Club's all-breed dog show

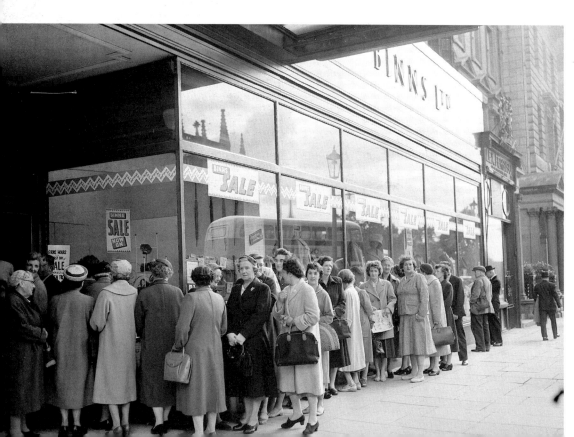

Bargain Binns: The queue for the summer sale at Binns department store at the West End of Princes Street snaked out of the door in July 1959. Now a branch of House of Fraser, the store remains a popular meeting place

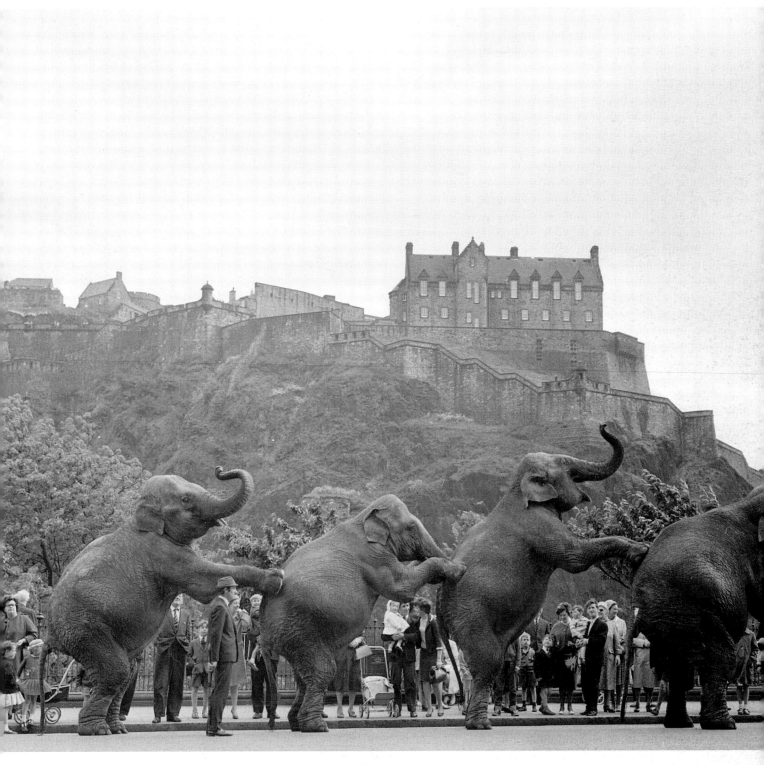

Trunk call: With the circus in town at Waverley Market, this parade of elephants in Princes Street Gardens was the perfect publicity stunt in June 1956

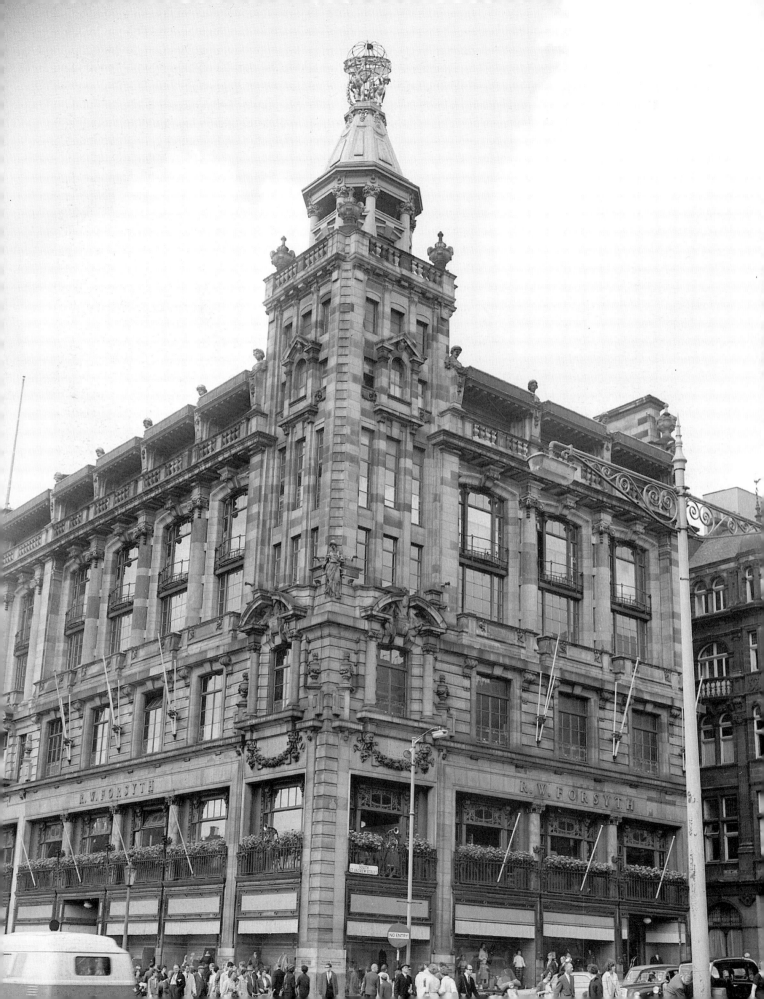

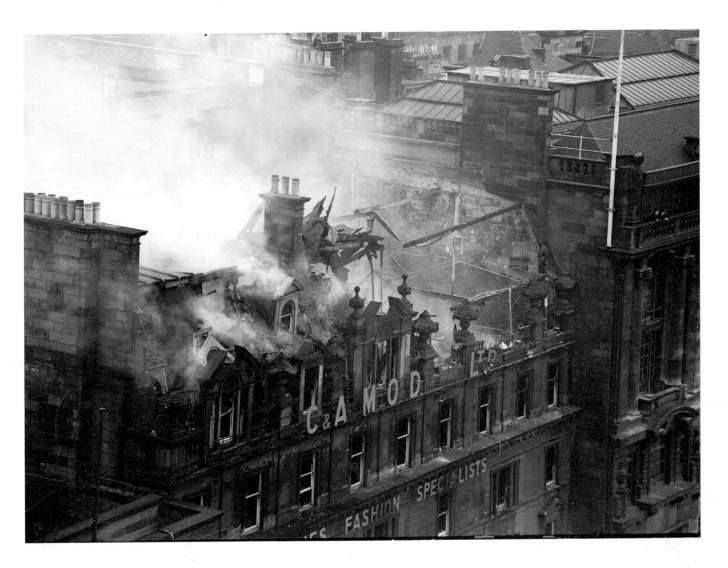

Smoke signal: When fire struck the C. & A. Modes department store in Princes Street in November 1955, *Evening News* photographers were quickly at the scene, and as this picture was taken, smoke was still drifting from the roof

Last picture show: Formerly the Monseigneur News Cinema, the Jacey became the last cinema to close on Princes Street when it ran its final reel in 1973

Top shops: The impressive exterior of R.W. Forsyth in Princes Street, pictured in July 1962, before it was bought over by the Burton Group in the early 1980s as a new home for its brands including Top Shop

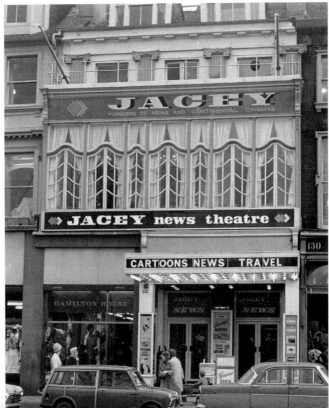

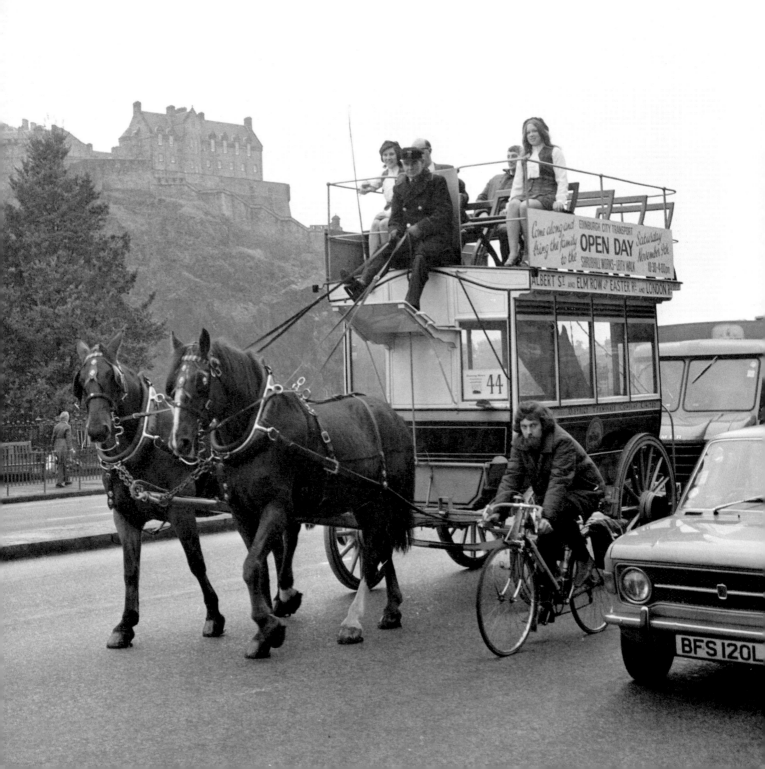

Transports of Delight

An old photograph which shows a tram will set me thinking of my early days in Edinburgh

Hannah Gordon, actress

For literally hundreds of years, the narrow cobbled streets of Edinburgh's Old Town were not subjected to levels of traffic any heavier than the stomp of sturdily-shod pedestrians or the occasional lumbering horse and cart. Even in the 18th century, when James Craig was planning the luxuriously appointed New Town, there was no need to make allowances for parking spaces. No one could have predicted the speed at which the coming transport innovations – the invention of the bicycle, the tram, the double-decker bus, let alone private cars affordable to most families – was about to revolutionise British society.

By the turn of the 20th century, transport was already at the top of Edinburgh's agenda, largely driven by economic necessity. Employers needed a pool of increasingly mobile, flexible workers to draw upon, and if overcrowded slums were ever going to be eradicated, it was recognised that people would still need transport back into the heart of the city from suburban housing estates.

For those already living in the suburban villages such as Gorgie, Morningside or Newington, the South Suburban Railway was the way to travel – at least until it fell victim to the notorious Beeching cutbacks in 1962. The Caledonian rail terminus, next to the West End hotel of the same name, lasted until 1965 before it too was shut down, leaving Waverley and Haymarket as the city centre's only stations.

To the visitors and shoppers on Princes Street, such changes to the railways took place largely unseen, but they could not have failed to notice significant changes in the vehicles trundling up and down this famous thoroughfare.

At the turn of the century, horse-drawn vehicles were being phased out and replaced by the first motorised bus, introduced in 1906, connecting the Mound to Corstorphine. The last horse-drawn trams were then serving Tollcross, Gilmore Place and Colinton, and were scrapped a year later.

After the horse-drawn vehicles, it was the age of the cable-car tram. Some 56 miles of cabling were laid around the city, nearly all operated by a steam engine in Shrubhill, off Leith Walk. In 1900, the longest cable-car tram route in Edinburgh was launched, connecting Waterloo Place with Nether Liberton. As the tram-cars gripped cables laid under the streets the pace of travel was far from swift – but at eight miles an hour, it was at least twice as fast as brisk walking. Edinburgh came to boast the fifth-largest cable-tram network in the world – but not for long.

Before losing its independent status to Edinburgh, Leith had led the way with switching from a horse-drawn service to electric trams in 1905. An electric service was introduced in Edinburgh in 1910 between Ardmillan and Slateford, to serve Gorgie Market, but most of the city would not make the transition until more than a decade later.

Horse power: A Victorian horse-drawn bus was still attracting attention during the *Evening News* Cavalcade in the 1970s

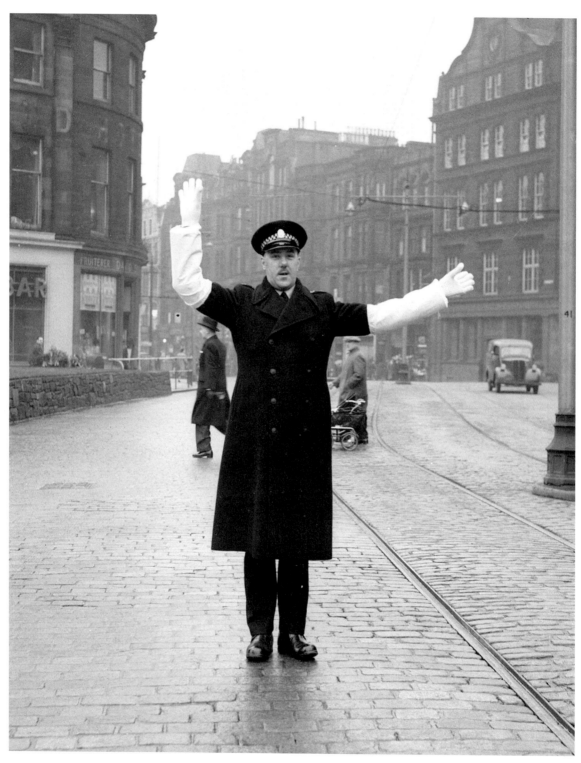

Hands on: A policeman on points duty at the West End of Princes
Street in the 1950s doesn't have to contend with the congestion
problems which would plague the city centre half a century later

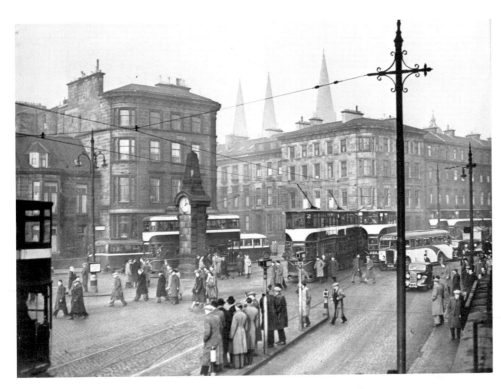

Transport hub: Trams, buses and cars all compete for space in the busy roads near Haymarket Station, pictured here in the late 1940s

Slow road: In the late 1930s, a horse and cart could take a leisurely trip along to the east end of Princes Street, without holding up the few cars which are on the road

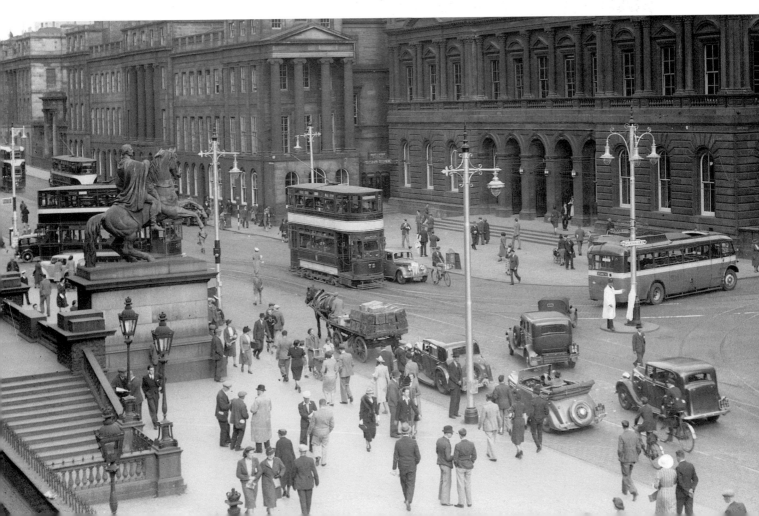

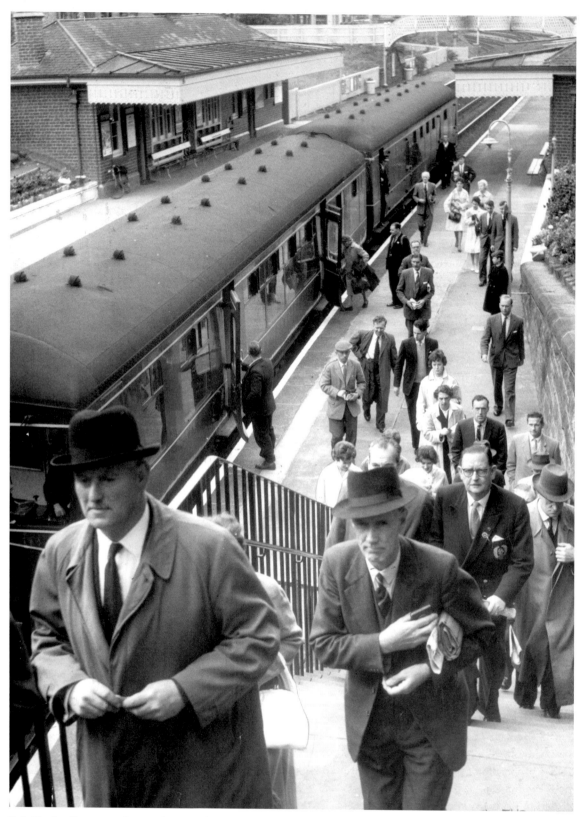

End of the line: These commuters were happy to take the train to
Morningside Station at the end of their working day in 1961, but the
station would be axed as part of the notorious Dr Beeching cutbacks

Caley sample: Officially called Princes Street Station, but affectionately known as 'the Caledonian' or 'the Caley', this west end railway station closed in 1965

The official transfer from cable-car trams to electric trams was far from smooth, however. In June 1922, students staged a demonstration to protest against Edinburgh Corporation's new-fangled service, launched between Pilrig and Liberton, and pelted the inaugural vehicles – which were full of town councillors and other dignitaries – with bags of flour. Their protests fell on deaf ears. The Corporation pressed ahead with its plans and the cable car trams had been completely phased out by June 1923. Ironically, despite the frosty welcome, the new electric trams would come to be very much loved by Edinburgh citizens.

In his autobiography, *On My Way to the Club*, broadcaster and campaigner Ludovic Kennedy spoke for many when he wrote:

I loved the Edinburgh trams . . . The yellow, slatted wooden seats, the whine and rattle, as they gathered speed, the driver's low-pitched bell to shoo people out of the way. I was intrigued too by the exotic sounding destinations which they and some of the corporation buses displayed:

Portobello and Balerno, Ratho, Joppa and Bo'ness. Ours was the Granton tram which knew when it reached the North British Hotel to go left down the Leith Walk and not straight on to Portobello or right up the South Bridge – though just how it knew I never discovered.

Former City Lord Provost John McKay, who served in the mid-1980s, has colourful memories of taking the tram to work at the Customs and Excise at Leith Docks:

You would see painters with their ladders climbing on board – for most people, the trams and buses were their only transport. Women would get on heading for the steamie at Leith Walk loaded with their washing. There was a big platform at both ends of the tram where the driver would sit and, of course when the tram stopped it didn't turn around, it was the driver who would get out and walk to the other end before setting off again. He left an ideal place for the women to put their piles of laundry.

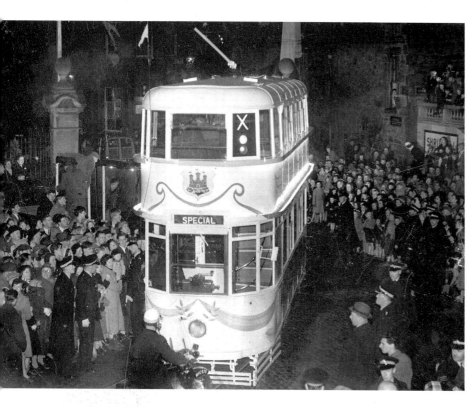

Last in line: After city councillors voted to scrap the trams, thousands turned out to watch the last – specially decorated tram – service in November 1956. All but one of the trams were taken to Coatbridge for scrap and later burned

Slush hour: It's snow go for commuters on Lothian Road waiting for the tram to take them out of the cold in February 1955

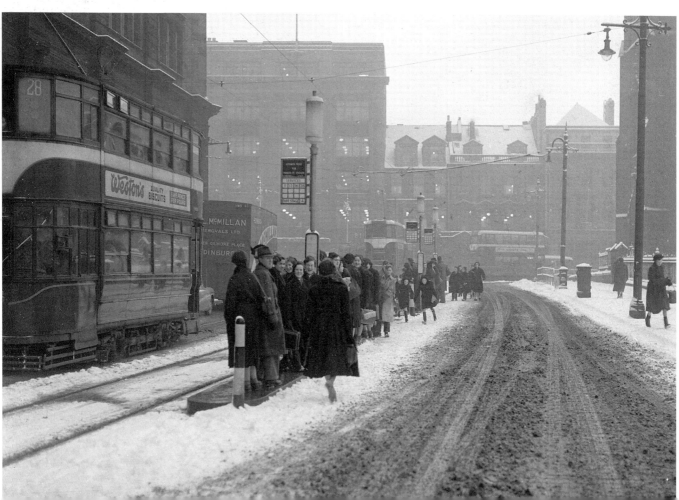

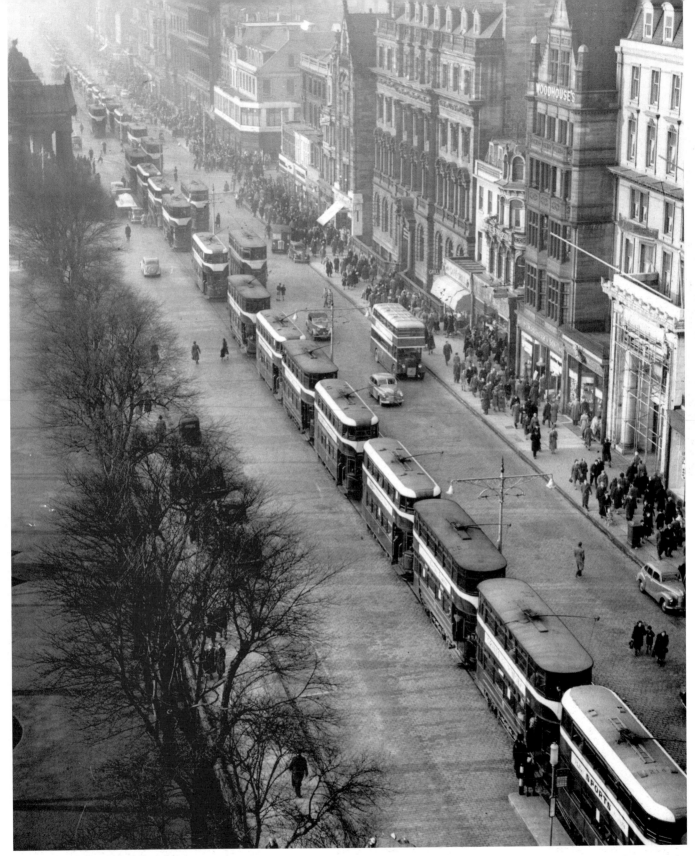

Lined up: It might look like a tram traffic jam on Princes Street, but this 1954 picture shows the trams brought to a halt by an electrical breakdown

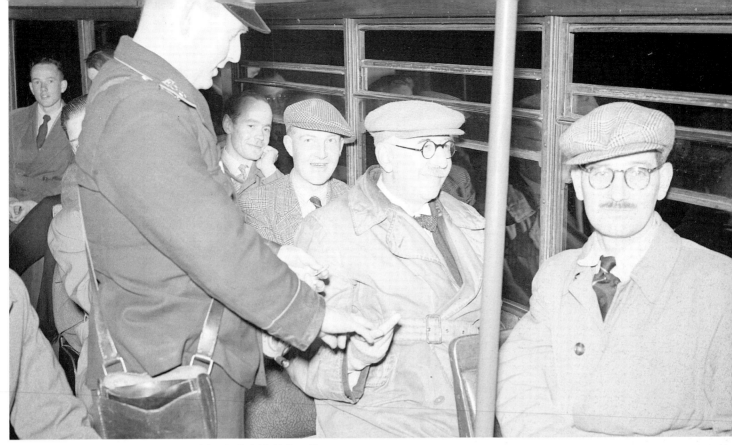

Last goodbye: Passengers look wistful as the final ticket is issued by the conductor on the Corstorphine tram service in July 1954

Actress Hannah Gordon, born in Edinburgh in 1941, has also spoken of her enduring fondness for trams, despite being knocked down by one when she was four years old and had spotted a friend on the other side of the street. 'It happened outside the Peacock Hotel. I belted across. The poor tramcar never stood a chance. I remember coming to some time later in my granny's bed, presumably not too much the worse for wear. An old photograph which shows a photo of a tram will set me thinking of my early days in Edinburgh.'

By the early 1950s, however, trams were beginning to seem out-of-date, cumbersome and expensive just at the time when the city needed to expand its public housing and its public transport links. 'Transport in Edinburgh expanded to suit the expanding city,' Gavin Booth, an Edinburgh transport historian:

'It started in the 1930s with the creation of Craigmillar and Pilton. It just wasn't practical to build new tramways, which were very expensive. So they brought new bus services into these areas. This restarted in the 1950s after the War. Buses were more flexible.

The other thing that sounded the death knell of trams was the nationalisation of the electricity supply. It made sense to run electric trams when the Edinburgh Corporation produced its own, but when the South of Scotland Electricity Board (SSEB) took over, it was not quite so economical.'

And so, in 1952, councillors voted 31–21 to abandon the electric trams in favour of a new fleet of Corporation double-decker buses. When the last tram rolled into the depot at Shrubhill, in November 1956, huge crowds turned out to say their good-byes. Thousands had watched a procession of trams from the terminus at the Braid Hills to Morningside, where the last, specially decorated, tramcar, driven by James Kay, was waiting to make the final journey.

One of a kind: The only remaining tram was displayed at a transport museum in the city, but is now on show at the Crich Tramway Village in the Midlands. This 1983 picture shows the tram on the back of a lorry bound for Blackpool.

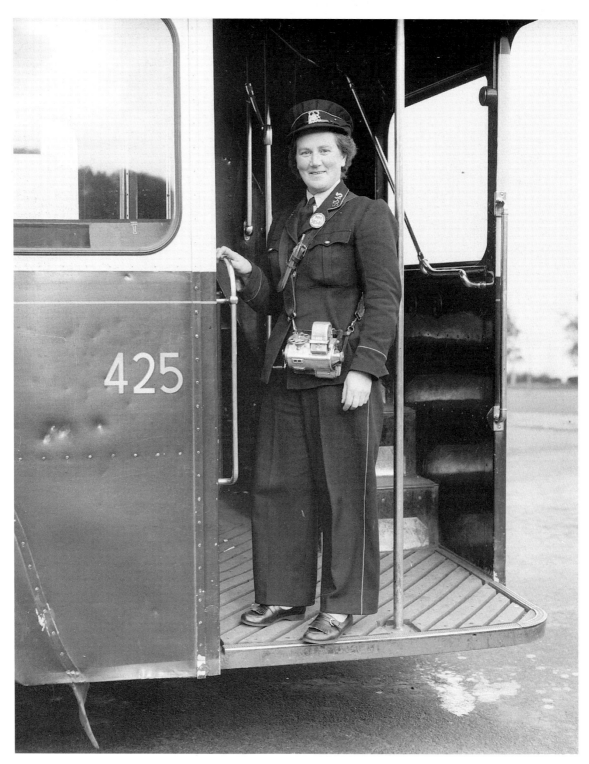

Decked out: The trams were replaced by a fleet of modern double-
decker buses, as this picture from October 1956 shows. The buses
came complete with 'clippies' like Miss Jessie Skimming to
dispense the tickets

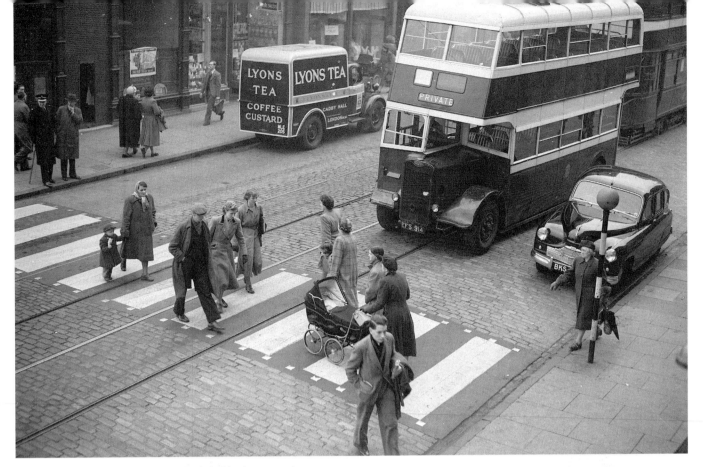

White lines: Pedestrians exercise their right of way as a zebra crossing is trialled at Nicolson Street in January 1959

Having grown up in Edinburgh with the trams, Gavin Booth appreciates why so many people turned out to watch:

On an emotional level, I still miss the trams. I was brought up travelling to school by tram, and as a result you become very attached to them, and they probably helped develop my interest in transport.

Edinburgh had 360 trams at the network's height, running 20-odd tram routes all over the city – the furthest they ran was to the Maybury Junction, to Fairmilehead and to Musselburgh. Many of the old tram routes still survive as bus routes. People get confused if you start changing the numbers. The longest route was the 12, which went from Corstorphine to Joppa, not that different from the bus route today, and because it went to the Zoo, it was very popular. Edinburgh had quite different trams from

Glasgow. Glasgow's were big and flashy and Edinburgh's were more what you would expect from Edinburgh – lots of wood and leather.

For half a century, the bus has remained the only form of public transport in the city and not without the occasional glitch. As drivers got used to the double-deckers, some were caught out by the height of the vehicles, and after it was discovered the buses had trouble getting up the steep Mound in harsh winter weather, 47 miles of electric wire were laid to heat the road and prevent the formation of ice. But within a few years, this system also failed, and the council reverted to using old-fashioned salt.

Somehow the double-decker with the 'clippie' issuing tickets and keeping passengers in line never had the same allure as the tram, partly because the dream of car ownership became a realistic prospect as the decades rolled by.

Meter reading: The dreaded parking meter arrived in the city – this one was installed outside the City Chambers in 1960 for demonstration purposes only, but they would quickly spread around the city

Platforms: The finishing touches to the old St Andrew Square bus station were being carried out when this picture was taken in 1957

Gavin Booth says it was still out of reach for most people in the 1950s, but cars were more accessible from the 1960s onwards:

In the 1950s there was still not an expectation that you would have a car – the people who had cars were those who could afford them, like the professional classes. The idea of families having cars did not start taking off until the 1960s and 70s when prices came down and models such as the Mini allowed people to buy a relatively inexpensive car. The building of motorways gave people an incentive.

The opening of the Forth Road Bridge in 1964 opened up Fife from both directions.

It was a huge thing. People had been agitating for it for decades, certainly since the 1930s. When it came it was very exciting. Previously there had been car ferries from South Queensferry, but those literally stopped as soon as the bridge was opened.

The suspension bridge attracted attention from all over the world, and writing in the Cockburn Association newsletter in 1974, Martha Esplin reminisced about the awe-inspiring scale of the construction.

I went up the Forth Road Bridge tower just after it had been topped out. The cage lift took three minutes to ascend the 500 feet, long enough to develop claustrophobia, vertigo and pneumonia. Once out on top though, it was sheer elixir to the soul, with the view clear from the Ochils to the Bass Rock. I was so carried away, I walked back down the main cable catwalk. From the roadway nowadays, I prefer not to wonder why I did.

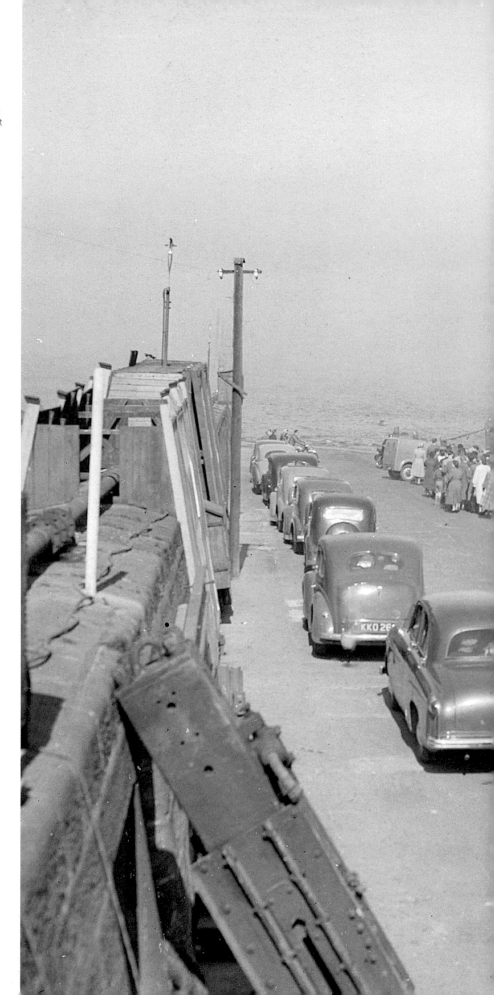

Sea Fife: The only way to get to Fife in the fifties was to take the train or the ferry. But the service stopped when the Forth Road Bridge opened in September 1964

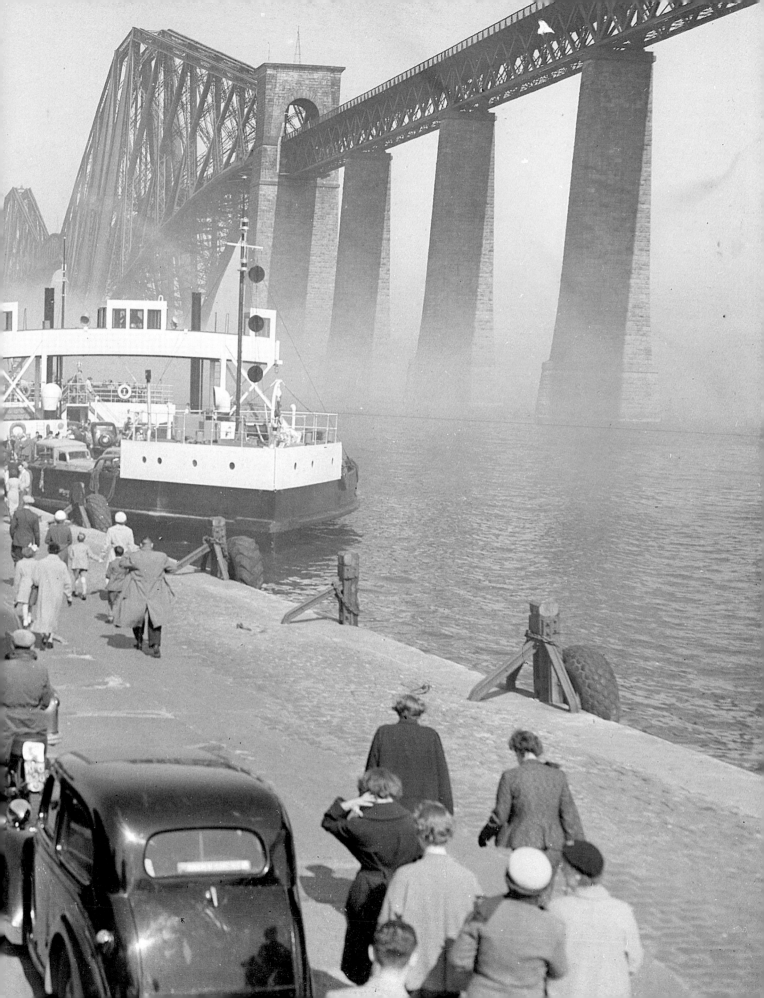

Bolted: A horse yoked to an Irish jaunting car takes fright during a cavalcade of horse-drawn vehicles held at St Cuthbert's Co-operative Association in Albyn Place in July 1949

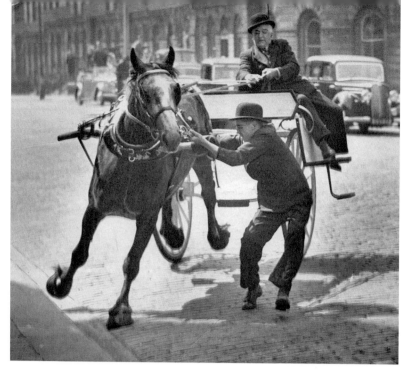

Float on: The St Cuthbert's horse-drawn milk floats were a familiar sight around the Capital – here it's not former milkman Sean Connery, but John Middlemass delivering the morning pinta in February 1963 on George IV Bridge

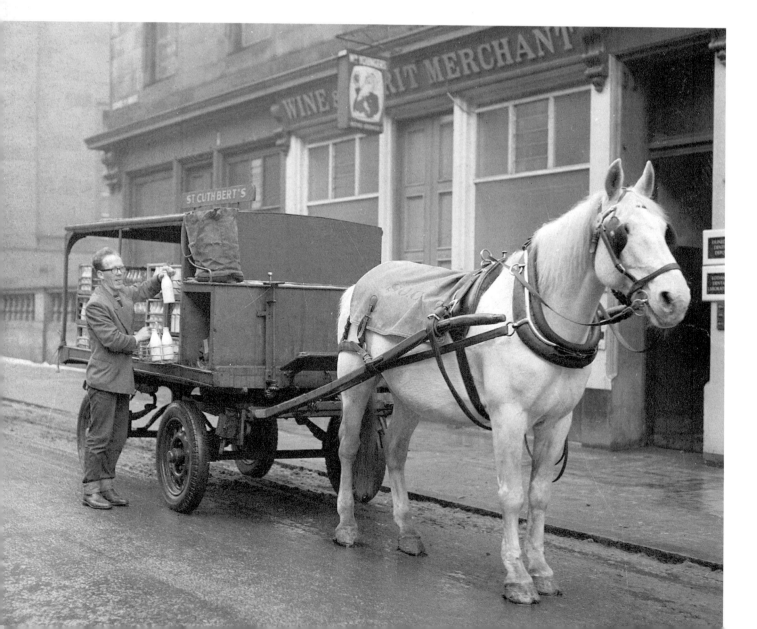

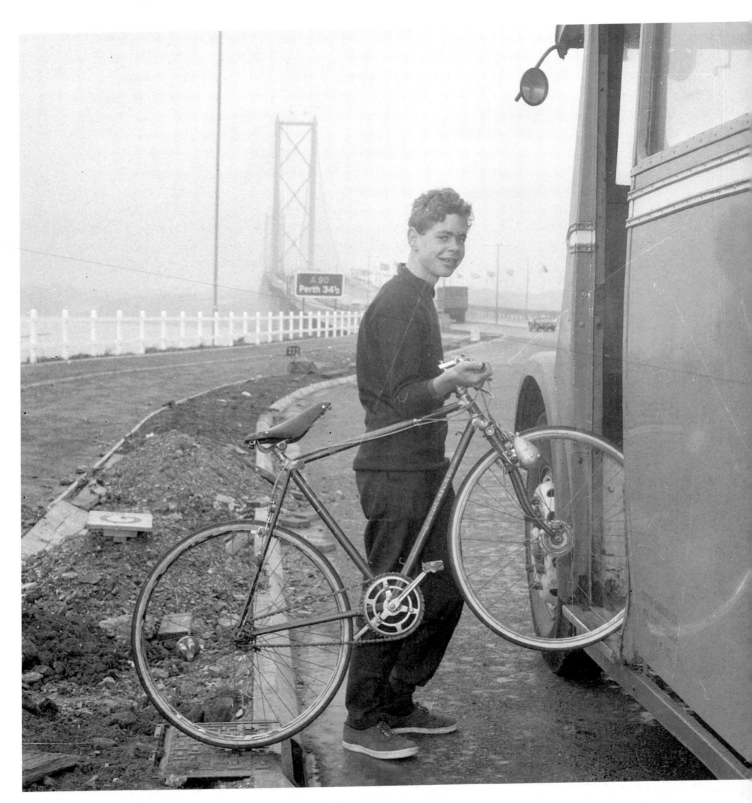

Bike ride: Before the footpath was complete on the Forth Road
Bridge, cyclists like Charles Isaacson could board a courtesy bus

With the opening of the bridge, the car was becoming king of the road at last. Car ownership – and congestion levels – were destined to grow exponentially. But Edinburgh's attempts to plan for future congestion were destined to fail. A report by the renowned architect and town planner, Sir Patrick Abercrombie, had recommended not only the Inner Ring Road, but also ripping out Waverley Station and the railway lines in Princes Street Gardens, and building a new station at Morrison Street, near Haymarket. Abercrombie also suggested that Princes Street should become a triple-deck road, with local traffic on the top deck, parking on the second level and through traffic on the bottom tier, re-routing the A1 to enter the centre of Edinburgh through the southern part of Holyrood Park and building a freight railway underneath the Meadows.

Abercrombie was well aware that his plans might provoke protests. He said in the introduction to his blueprint: 'There can be few cities toward which the inhabitants display a fiercer loyalty or deeper affection . . . the planner who dares to propose improvements must go warily and expect sharp and informed criticism and even abuse.'

In the end, the only significant recommendation that was acted upon was the scrapping of the trams. Gavin Booth says it is very fortunate that Edinburgh did baulk at following Glasgow's example of road-building its way out of congestion problems.

The M8 in Glasgow is a very convenient road, but in building it, they tore the heart out of the city. In Edinburgh, quite rightly, they drew back from these huge road schemes. While it may have caught up with us more recently because the road system is creaking, it allowed us to hang on to our amenity.

They had all sorts of plans, which, looking back, were horrendous, but fortunately we held on to the city. The mood now is not to make it easier for the car, but to reclaim the city for the people.

And ironically for those who mourned the passing of the trams, they are making a comeback – the new services are due in 2009, in a bid to lure motorists out of their cars and onto public transport once again.

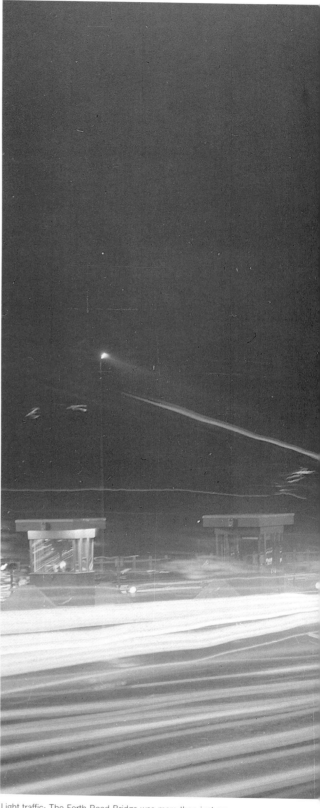

Light traffic: The Forth Road Bridge was more than just an important piece of transport infrastructure; it became a tourist attraction, and this picture shows why

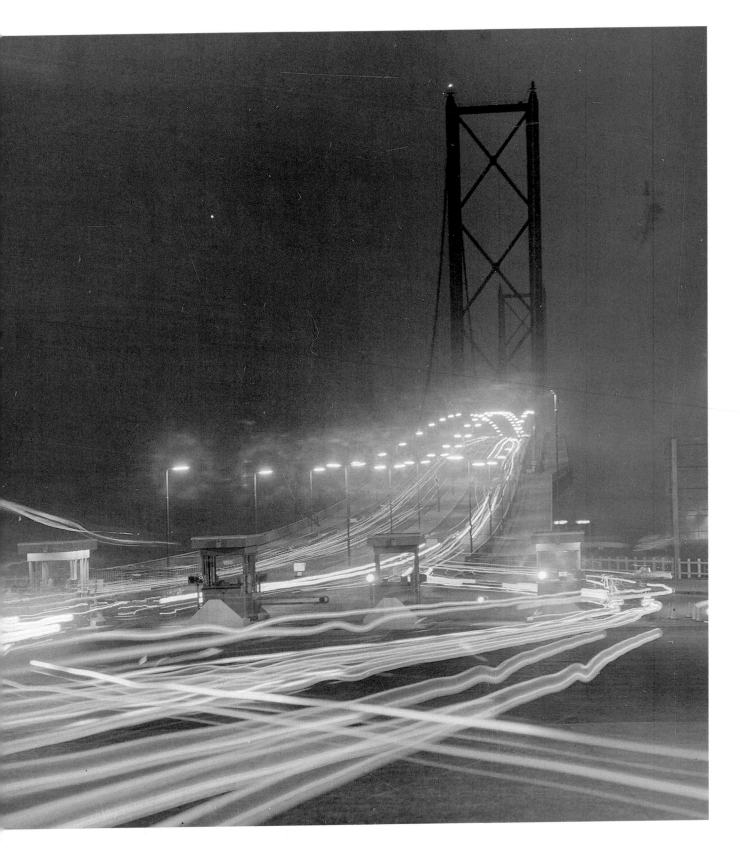

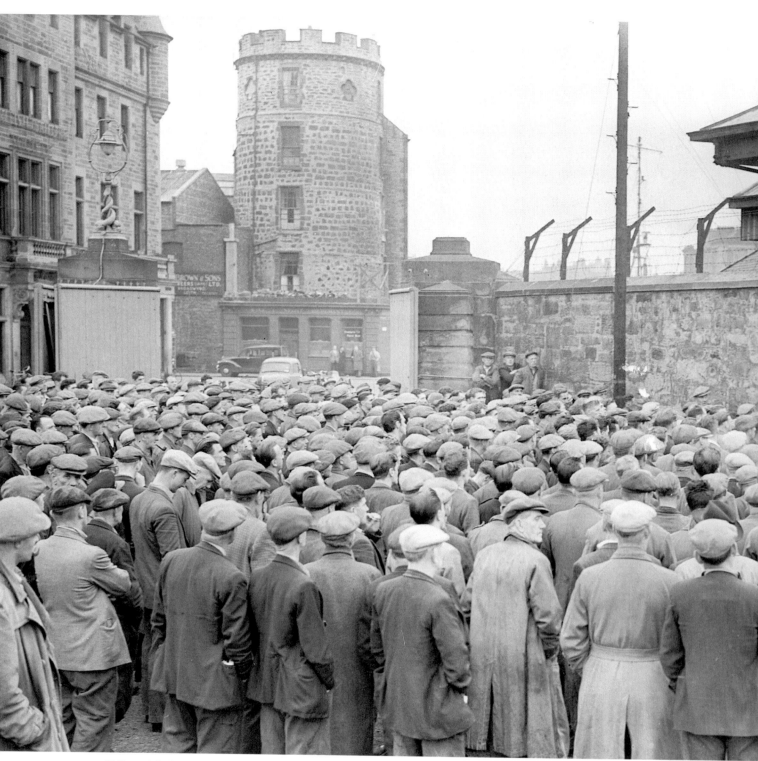

Striking out: Dockyard and shipyard workers have
downed tools and walked out on strike as this picture
was taken at Leith Docks in 1956

CHAPTER 3

Working Capital

O! it's nice to get up in the mornin'
When the sun begins to shine,
At four or five or six o'clock in the good old summertime;
When the snow is snowin'
And it's murky overhead,
O! It's nice to get up in the mornin'
But it's nicer to lie in yer bed!

Sir Harry Lauder,
Edinburgh-born comedian and entertainer

As the Victorian age came to a close, Edinburgh was Scotland's capital city in name only. Glasgow was the country's economic powerhouse, fuelled by the profits of manufacturing and shipbuilding, and assured of its place as the second city of the British Empire. Shipbuilding was part of the bustle at Edinburgh's port of Leith – the Robb Caledon Shipyard survived into the 1980s – but compared to its neighbour in the West, Edinburgh never became such a heavily industrialised city. The capital's strengths lay in the service sector, including banking, insurance and law, and in the longer term, Edinburgh's economy would prove to be the stronger.

After the Second World War, Edinburgh began to thrive. The launch of the Festival in 1947 helped to sow the seeds of what would become a booming tourism sector. By the early 1950s, jobs were plentiful and wages were relatively high, with unemployment running at only three per cent. An army of workers was required to keep the capital running – delivering milk and coal, lighting lamps, sweeping chimneys, building new homes and

maintaining roads and the Forth Bridges, and keeping the city's shops well stocked with everything from basic essentials to the latest in fashion. And while Glasgow's industrial strength still outstripped that of Edinburgh, as would have been expected from a city of its size, the capital supported a significant manufacturing sector, with foundries, tanneries and factories dotted around the city.

In particular, Edinburgh was world-renowned for its printing and brewing industries. At its height, Auld Reekie was second only to Burton-on-Trent in the UK brewing stakes. By the end of the nineteenth century, thirty breweries were operating in the city, a line of them stretching from Slateford, west of the city centre, to the Cowgate, to Drybrough's of Craigmillar on the eastern outskirts. Their locations were dependent on an underground supply of soft brewing water that flowed from the Pentland Hills to the south, and the distinctive smell of hops and malt hung in the air over much of the city.

One of the largest and most successful operations was the Fountain Brewery, opened in 1856 at Fountainbridge by William McEwan. By the

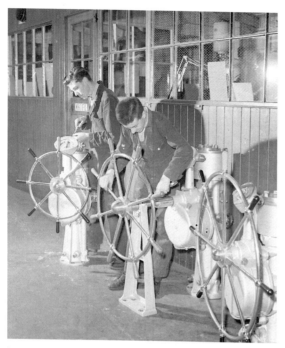

In gear: Apprentices fit wheels to the deck posts of a ship's steering gear at Brown Brothers' Rosebank Works in Edinburgh, pictured in June 1958

early 1900s McEwan had secured most of the trade in the north-east of England and was exporting his brands all over the world. By the 1960s, the brewery had not only merged with Youngers, but had become a key component of the Scottish and Newcastle empire.

Transport historian Gavin Booth, who worked with Scottish Omnibuses from 1961 until 1988, remembers the days when the breweries dominated the city. 'The Edinburgh I remember was one of breweries, factories that were dirty and smoky with the most distinctive smells. You really did used to see the smoke hanging over Edinburgh, the city really was "Auld Reekie".'

Even as late as the mid-1960s, the brewing industry employed 4,500 people in the city – roughly one per cent of the population. But technological improvements and increased competition saw that number dwindle to a handful by the 1980s. Following the closure of the Fountain Brewery in the

summer of 2005 the only significant working brewery remaining in Edinburgh is the Caledonian on Slateford Road. Professor Geoff Palmer, of Heriot-Watt University's Institute of Brewing and Distilling, says he misses the aroma of hops and malt at Fountainbridge. 'The Fountain Brewery was a wonderful old big-city brewery, the likes of which Scottish culture will not see again.' While brewing may have all but disappeared in the city, its legacy is present in the landmarks paid for by its profits, such as the McEwan Hall in Bristo Square named after William McEwan. The Scottish Parliament at Holyrood is built on a former brewery site, gifted to the people of Edinburgh by Scottish and Newcastle.

Near McEwan's Fountain Brewery, another manufacturer was an established landmark for more than 100 years. Founded in 1856 by Henry Lee Norris, a wealthy American who was seeking to exploit the patents for vulcanising india rubber, the North British Rubber Company employed 9,000 workers at its peak. The company produced everything from hot-water bottles and Wellington boots to tyres and sports accessories, including golf balls. Its designers were reputed to have invented the conveyor belt – as well as a boon for manufacturers, *The Generation Game* wouldn't have been possible without one – and creating the first detachable pneumatic tyre.

A hooter sounded five times a day at 6.55 am, 7 am, 12.55 pm, 1 pm and 5 pm to call and dismiss workers to and from shifts and lunch breaks. Among the thousands who lived by the siren's call was a certain Thomas Connery, destined for world fame as an actor, and of course better known by his stage name Sean. In *Stretch A Mile*, a book produced many years ago by Gorgie-Dalry Living Memory Project, workers recalled their experiences, and Johnny Smart remembered his first day in the factory as a 16-year-old. 'The first thing that hits you is the smell. It was caused by the dust, a kind of French-chalk dust and you could see that flying all around the departments. It stopped the rubbers from sticking together,' he said.

Launch pad: The Robb Caledon shipyard in Leith was still busy in 1975, when the world's largest deep-sea salvage tug, the SA *Wolraad Woltemade*, was launched

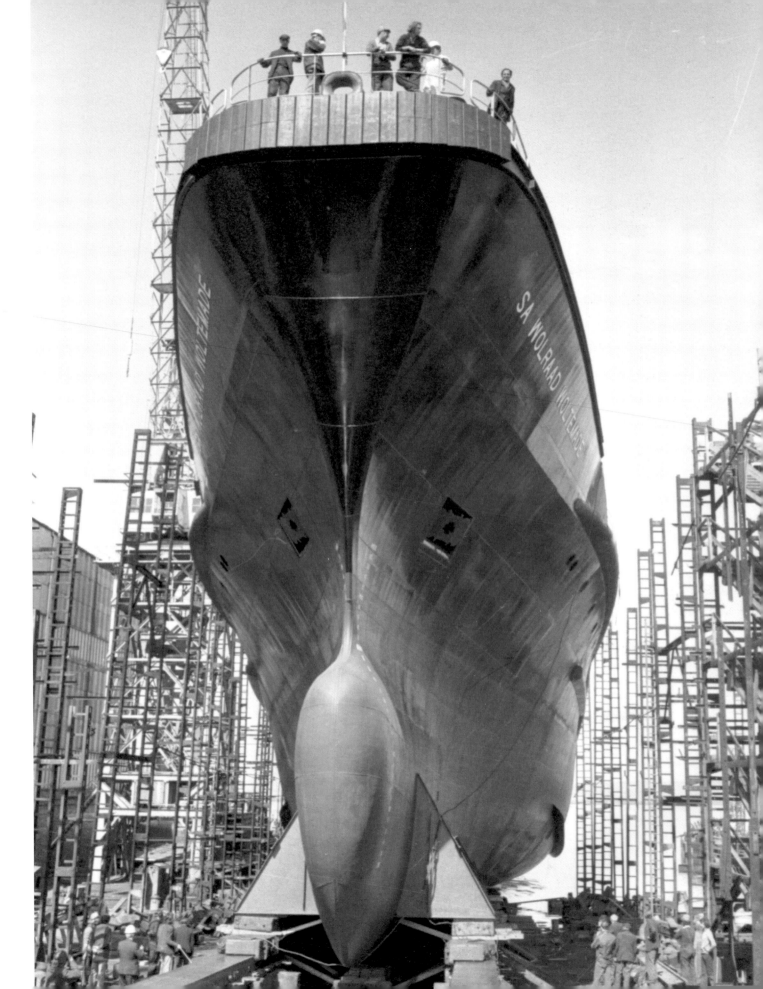

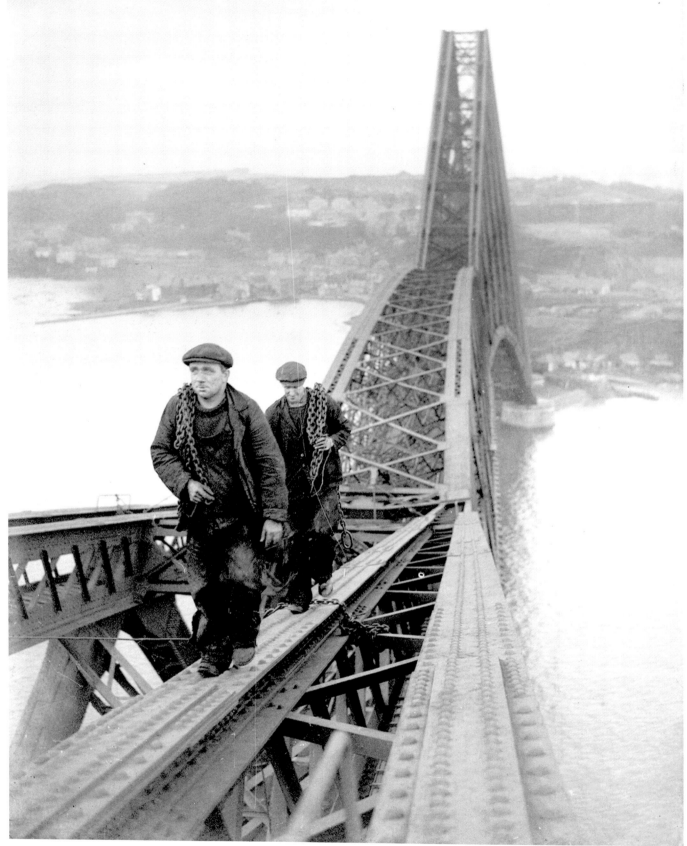

High life: The maintenance of the Forth Bridge is never done. Here
John Ritchie of North Queensferry and Alexander Paton of Dalmeny
walk up one of the cantilever girders of the famous bridge in 1950

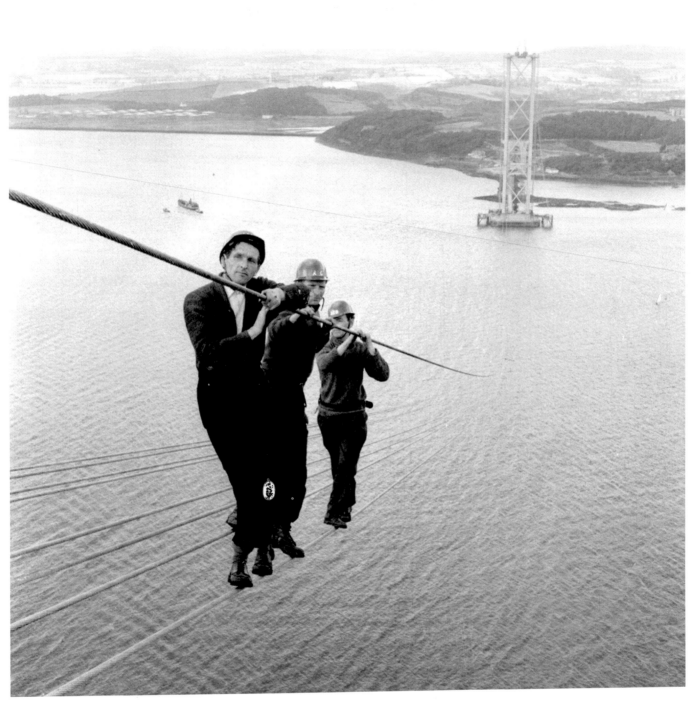

Hanging on: The construction of the Forth Road Bridge, which was
officially opened in 1964, was a hazardous business, as this picture
taken in 1961 clearly demonstrates

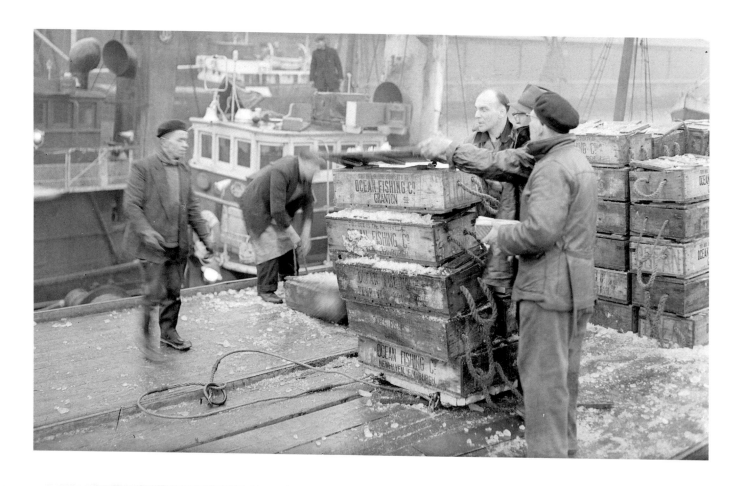

Catching on: Fisherman unload Ocean Fishing Company boxes packed full of fish in ice at Leith Docks in 1953

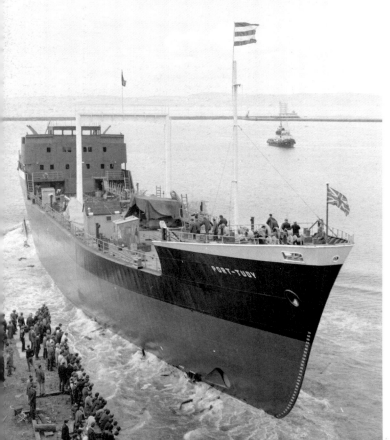

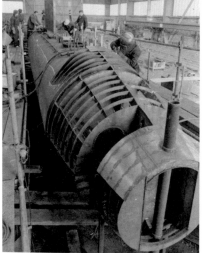

Under the sea: Workers at Robb Caledon put together a submarine in January 1984, shortly before the shipyard closed for good

Waved off: The 3800-ton Port-Tudy is launched from Leith Docks on 13 September 1969

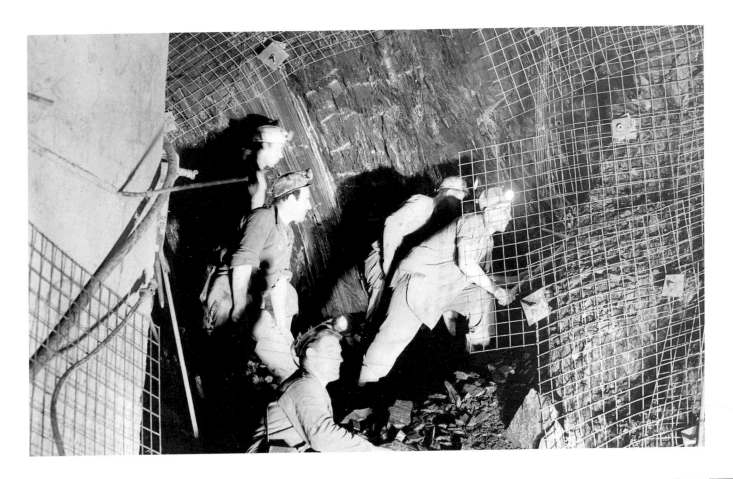

Going under: Until the
Thatcher era, mining was a
major source of employment
for men working in pits near
Edinburgh, like the Lady
Victoria mine in
Newtongrange, pictured in
1960. It employed around
2000 men and women
before it closed in 1981

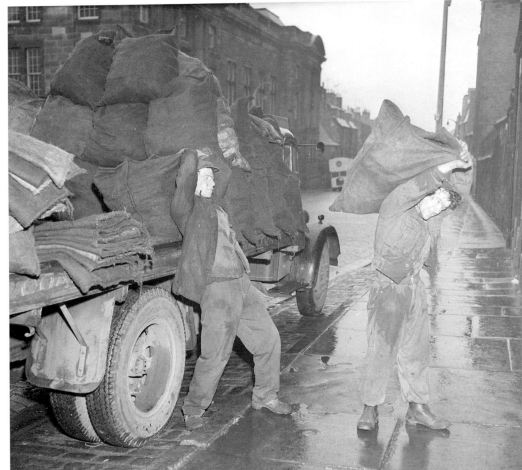

Lifted: For decades before the
arrival of central heating, families
across the city depended on the
delivery of sacks of coal by men
like these, pictured in March 1964

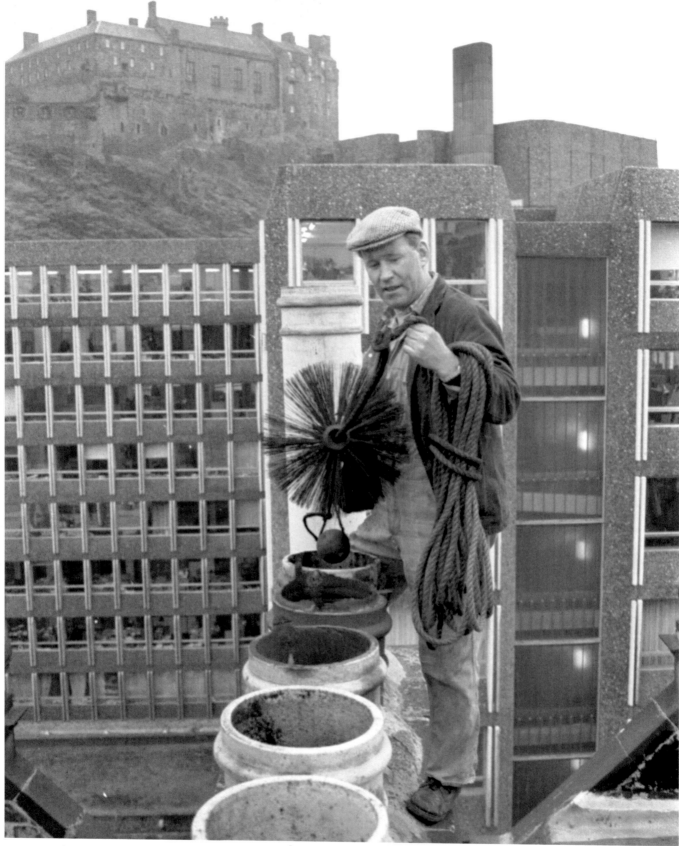

Clean sweep: Even in 1985, when Mike McLenaghan was pictured on the rooftops of Lady Lawson Street, chimney sweeps were still needed to clean out Auld Reekie's flues

Working long shifts from 7.30 am to 5 pm at the rubber factory, Mr Smart added that workers were extremely eager to escape the factory at lunch- and home-time. 'If you were walking past the gate at 12 pm or 5 pm, you were likely to get stampeded. As soon as that gate opened they just bolted, scattered in all directions.' The workforce also protested when the management enlisted experts to attempt to improve efficiency. 'They were called industrial engineers, but everybody knew them as time-study men. They wanted to introduce a more demanding system and the women wouldn't accept. They were quite right because they were hard-working women. Well, the outcome was that the women went on strike – but not before throwing one of these boys into the canal!'

The smell of rubber would pervade not only the air around the factory, but the clothes and hair of the employees, as another worker, named only as Miss Hegarty, recalled. She said the smell was so bad that if you took a chocolate bar home in your pocket it became inedible, and there was also no hiding where you worked for a living. 'We were horrified when somebody would say "I know you work in the rubber mill because I can smell the rubber off your hair". We couldn't smell it but they could,' she said.

Production moved to Newbridge in 1967 as the company came under the Uniroyal umbrella. The factory site, next to the Union Canal, was bought by Scottish and Newcastle and used to produce even more beer. And if the pungent smells of hops and rubber were associated with Fountainbridge, then the area around Powderhall was linked to the more tempting aroma of chocolate, emanating from Duncan's factory.

Evening News writer Bill Clapperton has recalled that the effect of the scent was 'seriously detrimental to our studies at Broughton School, if the wind was in the right direction. The powerful, alluringly rich pong of Duncan's hazelnut bars, walnut whirls and Parisian Creams hung in the air – a tantalising perfume we could smell and breathe in deeply . . . but couldn't eat. God only knows what it must have been like living in the surrounding tenements!'

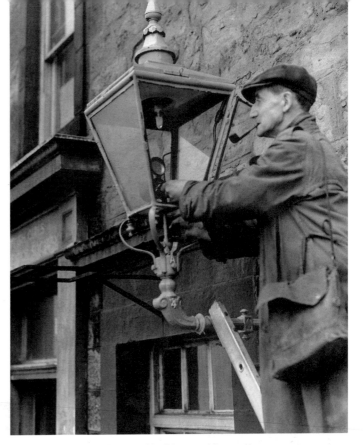

Gas light: By the late 1950s, when this picture was taken, gas lamps across the city were being phased out to make way for electric lighting

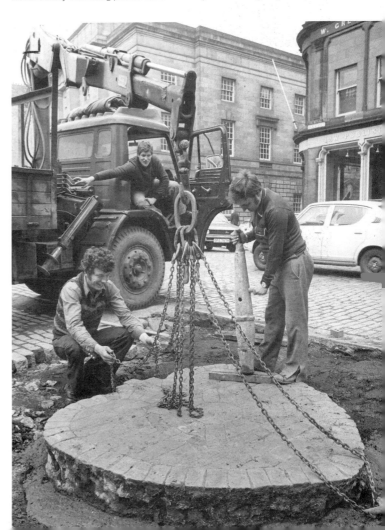

Heart of stone: The famous Heart of Midlothian is relaid in its traditional spot on the High Street in May 1978 after work to replace cobbles. The setts mark the entrance to the old Tolbooth jail, demolished in 1817, which was immortalised in the Sir Walter Scott novel, *Heart of Midlothian*

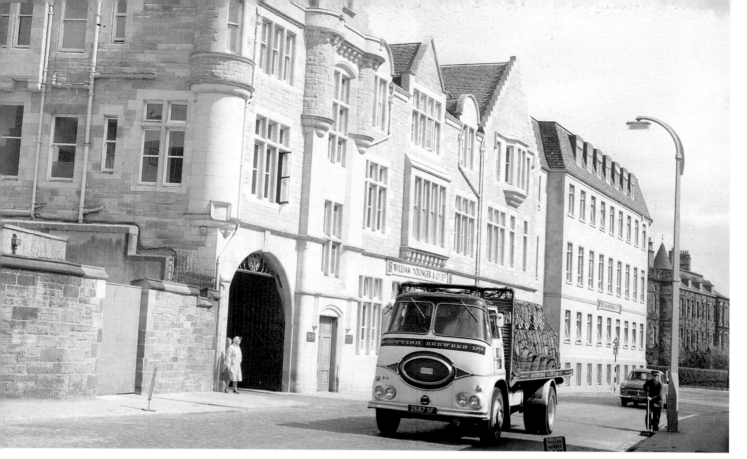

Barrel of halfs: The headquarters of William Younger and Co., pictured in 1960, were
eventually knocked down to make way for the new Scottish Parliament building at Holyrood

Duncan's was founded in 1884, establishing a factory at Beaverhall Road some 11 years later, and it was claimed that Duncan's was 'the Scots word for chocolate'. It became part of Rowntree's in the 1920s, but after a management buy-out, it transferred production to Motherwell in the late 1980s – ironically renamed as Duncan's of Edinburgh.

Thousands of people were also employed by the engineering and mining sectors. Des Loughney, secretary of Edinburgh Trade Union Council, was among some 2,500 people employed in the early 1960s by East Pilton-based Parsons Peebles, which manufactured electrical motors and transformers. Loughney recalls that the working conditions were hard, certainly by 21st-century standards.

Industry was substantially different even then compared to now. As a union rep I was involved in campaigns to improve health and safety at

work. In my part of the factory it was well known that hardly any workers, after a lifetime of work in the industry, survived beyond retirement age.

I and others had the impression that this was largely down to the very long hours and poor conditions experienced during the Second World War, when the company was an important war-related manufacturer. In the 1970s, we campaigned about the level of sound – my own hearing has been damaged after working for seven years in the industry.

Gavin Booth has vivid memories of the city's industrial past.

Places like Fountainbridge, Dundee Street and Leith were all very different to how they are today . . . Edinburgh's industry was built in these places that were not out in the suburbs, but were pretty well right where people lived. It meant that tens of

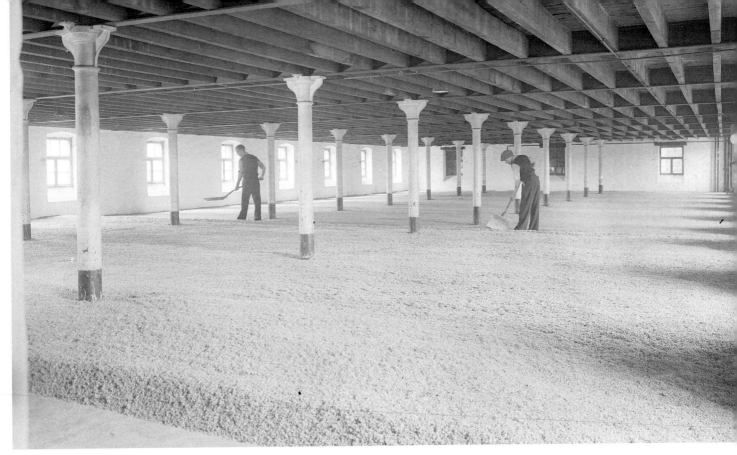

Brewing up: Men are hard at work at Drybrough's in Craigmillar, pictured here in 1955. It was one of a string of breweries across the city, most of which have ceased production

thousands of people lived close to the rubber factories, the shipyards and the breweries. Of course, there was no such thing as flexible working – people worked the hours that the factory wanted, usually 8 am until 4 pm

When the whistle blew at the end of the shift, there would be a mass exodus of people stampeding through the factory gates, a tremendous rush of bodies. They also had to take the holidays they were told to take: usually the Edinburgh Trades, when the whole factory would close.

Miles Tubb, a reminiscences worker with Edinburgh's Living Memory Association, says it is difficult to comprehend how many big employers have disappeared from the city.

It seems remarkable now to think that in the 1950s some 3,500 people were employed alone at the North British rubber mill at Fountainbridge. Can you imagine all those people coming out of work at the same time? Then there was the likes of Duncan's, the chocolate factory at Powderhall which had about 1,500, mostly women, starting and finishing work together. From the early-1950s to the mid-1960s, the brewing industry alone employed 4,500 people, and there were 20,000 working in engineering. Before Gilmerton Colliery closed in 1961, it employed some 700 people. There were 1,100 in the woollen trade, while the likes of Ferranti was much, much bigger. But places shut down and moved out, and there are few firms around today that have such numbers working in one place.

Many of the industries that dominated life for so many working people in Edinburgh have all but disappeared, but not in the minds of those employed by them.

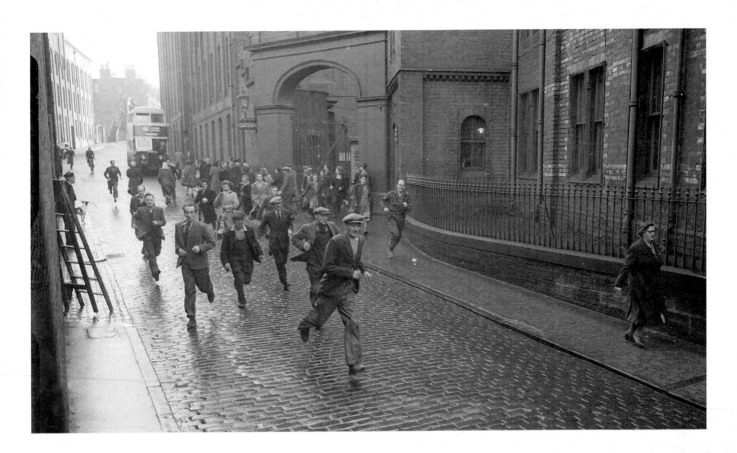

Making a break: Workers at the North British Rubber Company don't hang about as their shift ends at the Fountainbridge factory in November 1951

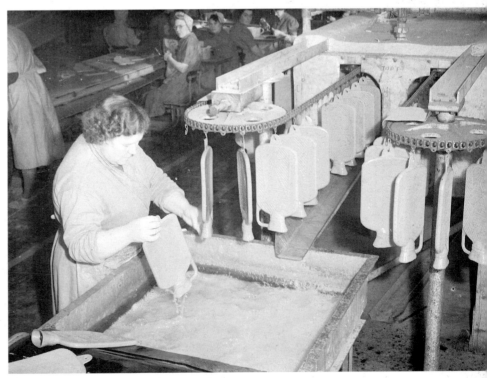

Bottling up: These women at the North British Rubber Company, pictured in 1953, are making hot water bottles, but the factory was famed for a range of products including Wellington boots, tyres and golf balls

Roll over: Apprentice cooper David Smith is rolled in a barrel by his fellow workers as part of an initiation ceremony at the Arthur Bell cooperage in October 1968

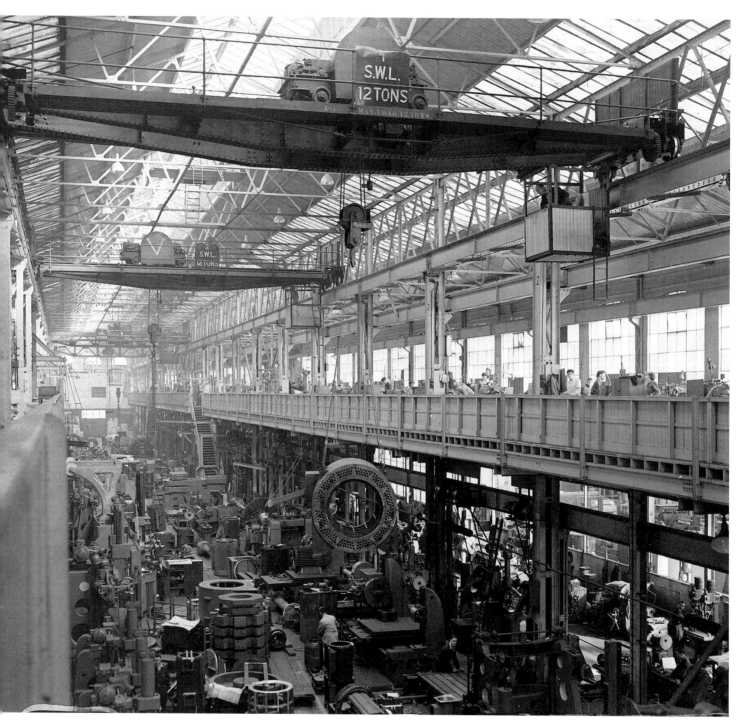

Metal works: Manufacturers of electrical motors and transformers, East Pilton–based Parsons Peebles, pictured here in 1955, employed 2,500 by the early 1960s

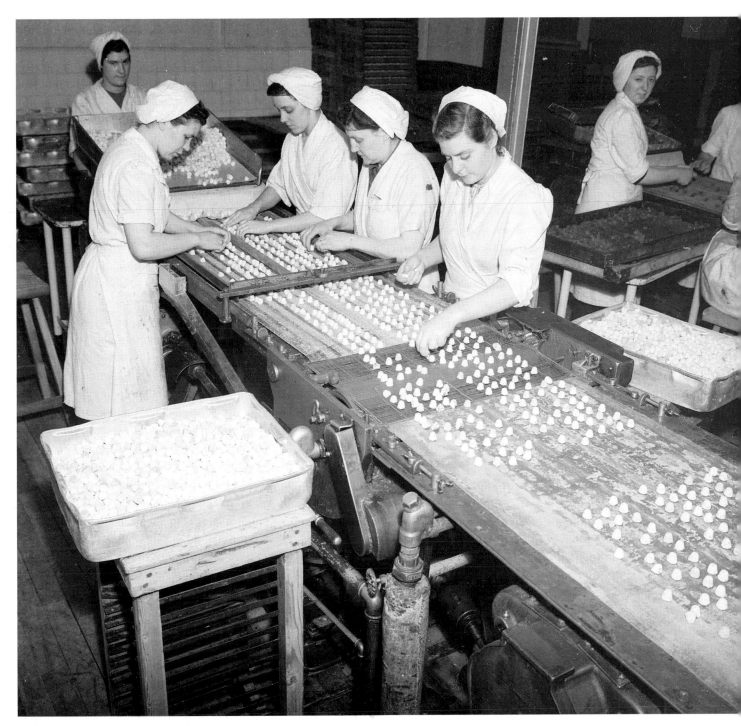

Life was sweet: Women are hard at work making sweets at Duncan's chocolate factory on Beaverhall Road, part of the Rowntree empire, when this picture was taken in 1952

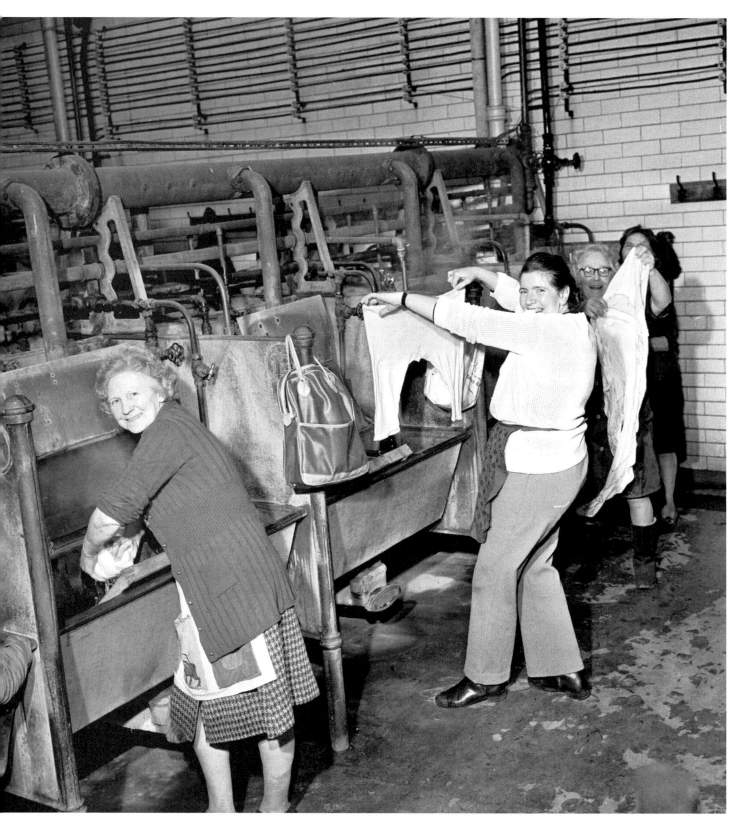

Women's work: Using the 'steamie' like this one in Bonnington
Road, picture in 1973, was part of running a household
before washing machines became affordable for most people

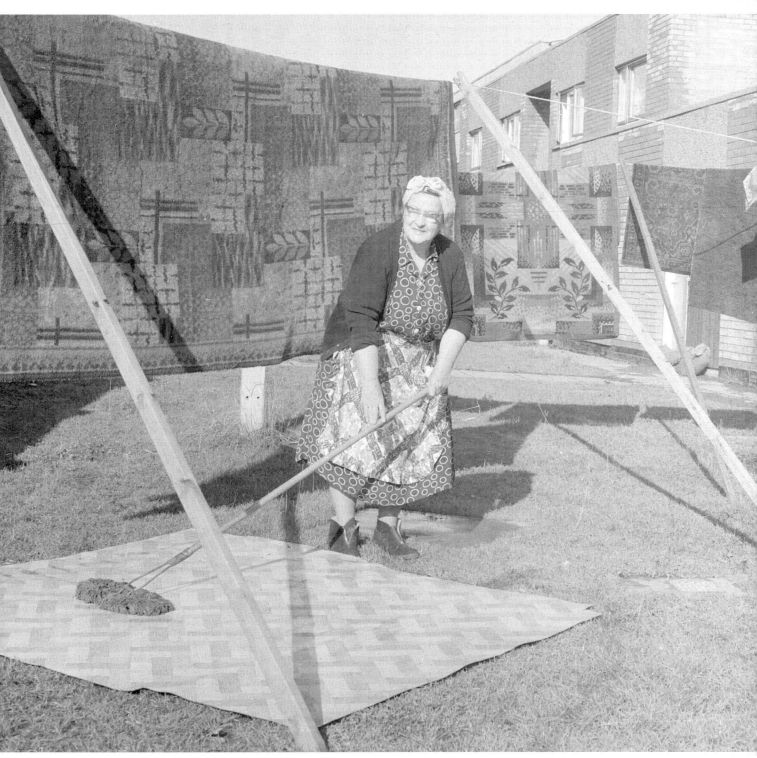

Cleaning up: After flooding at her home at Greendykes Crescent in July 1965, Mrs Janette Gourlay had some mopping up to do in her back garden

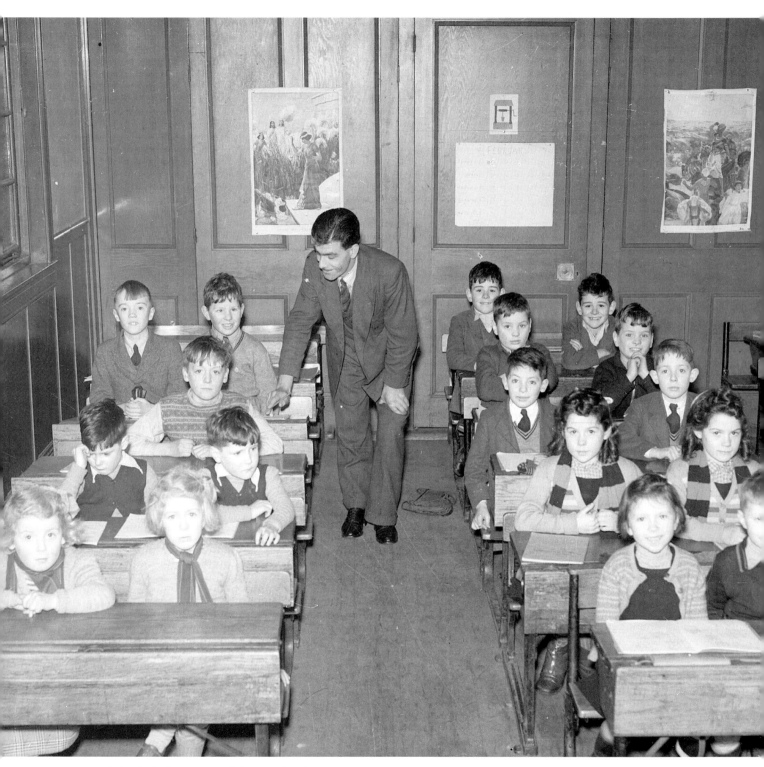

Seeing double: Row upon row of twins were pictured
at St Cuthbert's School, Slateford Road, in 1952

CHAPTER 4

A Child's Garden

[I have] a rooted conviction that children are only tolerable after their baths and on their way to bed

Joseph Patrick Murray,
founder of the Museum of Childhood, Edinburgh

In the days before television and computers changed lifestyles beyond recognition, children had to look elsewhere for entertainment. With castles, palaces, woodlands, rivers, hills and beaches within easy reach of most families' doorsteps, Edinburgh was an adventure playground for youngsters. Before concerns about traffic or 'stranger danger', most children could happily play outdoors, in back greens or in the streets near where they lived, playing games that had survived in the city for generations.

Girls could usually be found skipping rope, playing clapping games – singing rhymes like 'A sailor went to sea, sea, sea / To see what he could see, see, see' – and 'peevers', known outside of Edinburgh as 'hopscotch'. The peever was usually a small polished stone or an empty boot-polish or tobacco tin. The aim was to throw your peever to land in one of ten chalked-out squares on the pavement, then hop up the squares and collect the peever on the way back – without falling over or touching any of the lines, or you were out. As James Ritchie wrote in *Golden City*, a study of the games he observed children playing while working as a teacher: 'An Edinburgh street wouldn't look the same without this bold and lively geometry.' Boys preferred playing marbles or 'bools' – from the French boule – or playing cowboys and Indians, hide-and-seek, tig or 'chasie'.

Sadly, many of the games Edinburgh children played have died out, although the Museum of

Childhood, which opened in 1955 in the city, has helped to ensure they are not completely forgotten. Ironically, a man who claimed to dislike children, an optician and town councillor, Joseph Patrick Murray, founded the museum. He chaired the Libraries and Museums Committee and persuaded colleagues to allocate some space at Lady Stair's House Museum to display toys and other objects reflecting the activities of past generations of children. He was inspired after learning that two dolls once owned by Queen Victoria were being sent to London because there was nowhere suitable to display them in Scotland. The project captured the public imagination and donations of childhood artefacts flooded in, to the point that the collection became so big that it was moved to its own building on the High Street and Murray left the council to become its full-time curator.

Murray, who said he had 'a rooted conviction that children are only tolerable after their baths and on their way to bed', insisted that the museum was intended to reflect social history – 'This is not a children's museum; it is a museum about them' – but inevitably it became a huge draw for the city's youngsters. It is likely that many of them would have been nonplussed by the curator's descriptions of some of the exhibits. Take, for example, these words about a mechanical bear dating from the early 1800s: 'What with the passage of the years, to say nothing of the hazards of nursery life, it is now

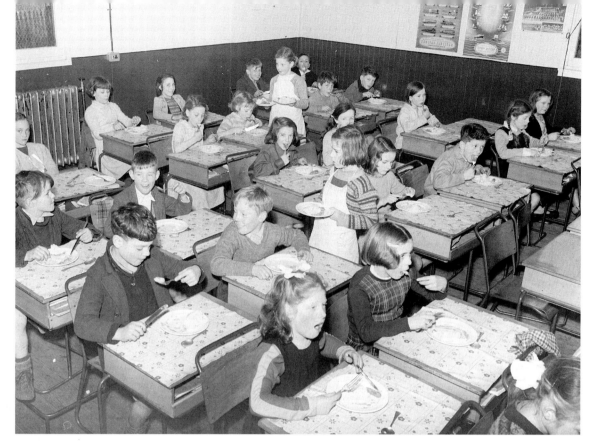

Dinner time: No school canteens for the pupils at Peffermill School, who take lunch at their desks in November 1954

impossible to obtain a clear idea of what the toy did in its prime. At present [1961] its outlook is obstinate.'

Those youngsters unimpressed by the toy version might have preferred to visit real animals, either when the circus came to the Waverley Market in Princes Street, or at Edinburgh Zoo, which was founded in 1909, opened its gates at Corstorphine in 1913 and became a hugely popular draw for city children. Education of youngsters was at the core of the Royal Zoological Society of Scotland's original charter, which stated that its principal objective was 'To promote, facilitate and encourage the study of zoology and kindred subjects and to foster and develop amongst the people an interest in and knowledge of animal life.' A zoo favourite for generations of Edinburgh children has been the penguins. The zoo was the first place where penguins were ever seen outside of the South Atlantic, thanks to the arrival of three king penguins from a Christian Salvesen whaling expedition which

docked in Leith in 1914.

Leith was perhaps the only part of the city waterfront which did not attract children, as when the capital's unpredictable weather permitted, youngsters would flock to beaches at Cramond, Silverknowes, and of course, Portobello. In its heyday, Portobello was the city's entertainment Mecca for children and young people across the city. Margeorie Mekie, whose book *Old Portobello* (published by Stenlake) recalls the seaside town in its heyday, writes:

There was a ballroom that doubled up as a skating rink, a small zoo, kiosks advertising Ferguson's Rock, cafés and shops selling Kiss Me Quick hats. There were Punch and Judy puppet shows and the Salvation Army played outside the baths on a Sunday. People would take short trips on board the Skylark until the 1960s, and there were still pony rides along the beach until not so long ago.

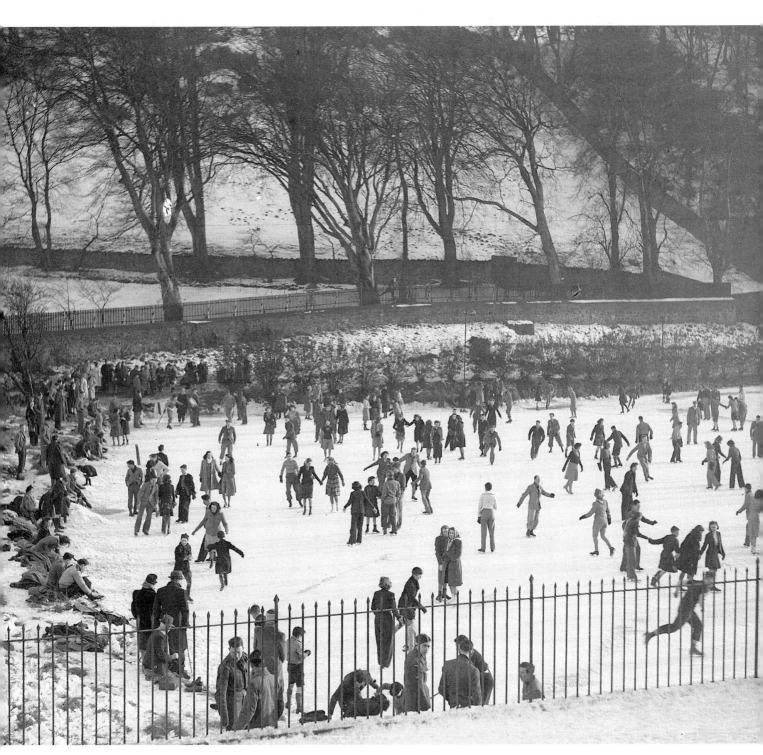

Nice on the ice: Ice skating on Craiglockhart Pond in February 1947

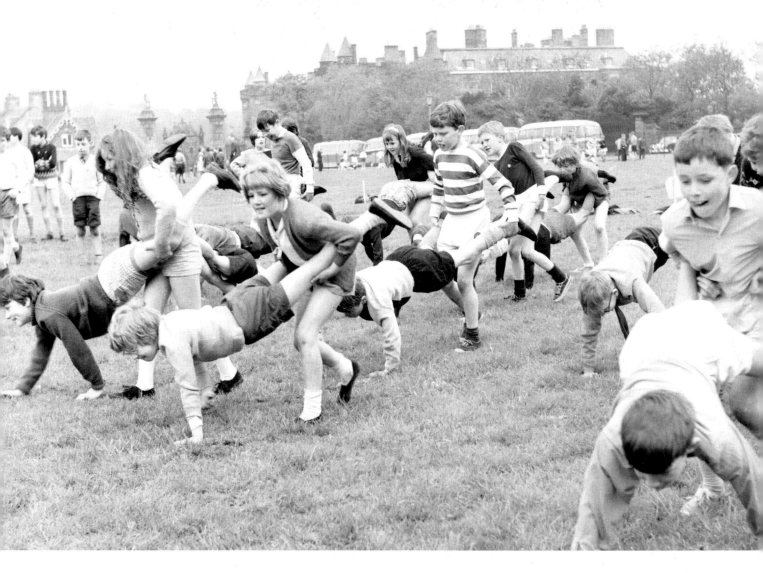

Summer fun: Children escape the confines of the classroom to take part in this 'wheelbarrow' race during the Abbeyhill School sports day in 1969

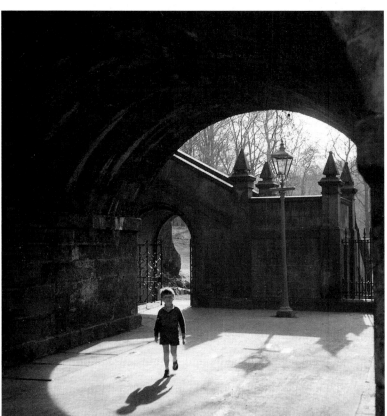

Shadow play: A little boy emerges from the shadows cast on the path to Saunders Street, Stockbridge, pictured in March 1957

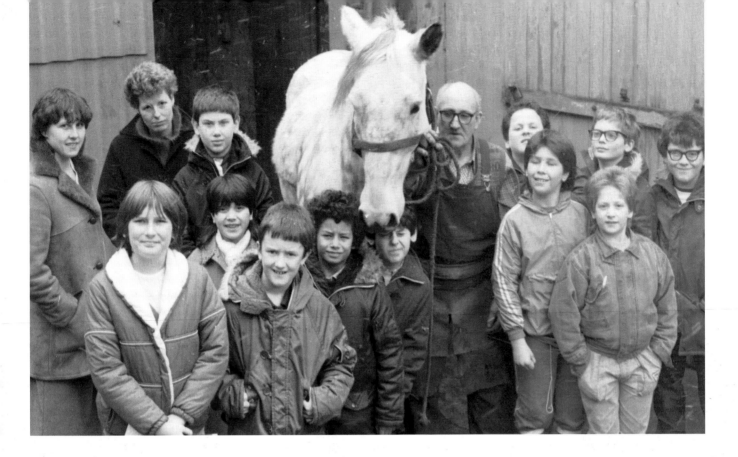

Children from Tollcross Primary School visited the Scotmid stables and met one of their milk horses in Grove Street Edinburgh, as the company announced the end of doorstep milk deliveries by horse in January 1985

Geometry: Youngsters in Lapicide Place play a game of peevers in July 1957, which James T.R. Ritchie said added a 'gay and lively geometry' to the streets of Edinburgh

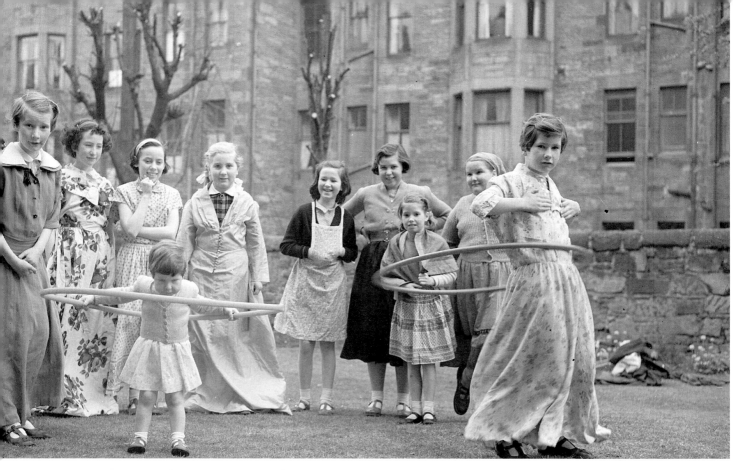

Round about: Marchmont children gathered for a back green concert in 1959, and Patricia and Lynda Walton demonstrated how to hula-hoop

An outdoor pool opened in 1933 and became a firm favourite with children and teenagers, as former city police constable Derek Allan recalls:

Portobello pool was very popular for boys meeting girls. It was right off the sea and it was freezing but it was usually packed. There was also a cold dip along at Portobello baths. The idea was you had a hot shower or Turkish bath and then dived into the dip, just maybe 8ft by 14ft, but, God, when you jumped in your heart would rise up to your throat!

Veteran Radio Forth DJ Bob Malcolm also has fond memories of childhood summers spent swimming in Portobello's outdoor pool. 'I remember I had to be fished out of Portobello pool on one particularly glorious summer's day because I was practically drowning. I think it might have had something to do with my swimming trunks . . . you see, mum had knitted them and the weight of the wool was dragging me down!'

It wasn't only families from Edinburgh and the Lothians who flocked to 'Porty', as it was affectionately called – former Deputy Lord Provost John Wilson vividly recalls the annual influx of Glaswegians on their summer holidays:

Weather seemed to be better back then, but, of course, you remember the good days and forget the bad. I remember the beaches being taken over during the Glasgow Fair until the coast became like a small part of Glasgow. They'd go to East Lothian and stay in campsites, often spending their holidays in old railway wagons lined up at Seton Sands, where they had paraffin lamps and not much else. It didn't seem to bother them. They brought their Glaswegian humour and really enjoyed themselves. No one bothered about the weather too much – you didn't know any different.

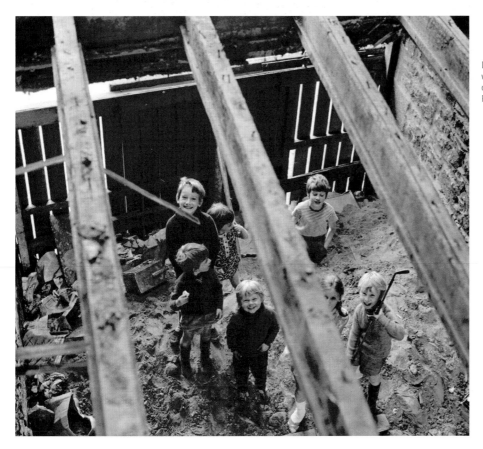

Dangerous games: These children were pictured playing in a condemned buildings in Heriot Place in August 1971

It's a showgo: Youngsters enjoy the snow on Bruntsfield Links on Christmas Day, 1961

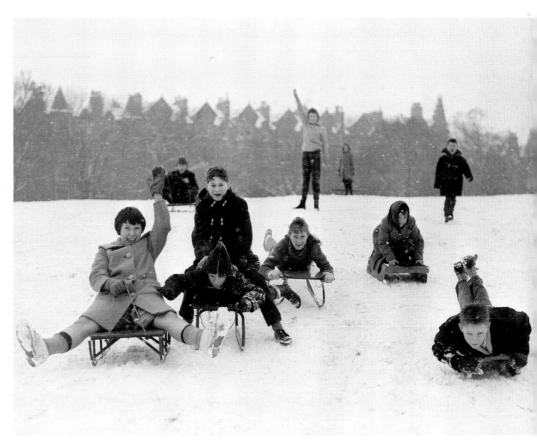

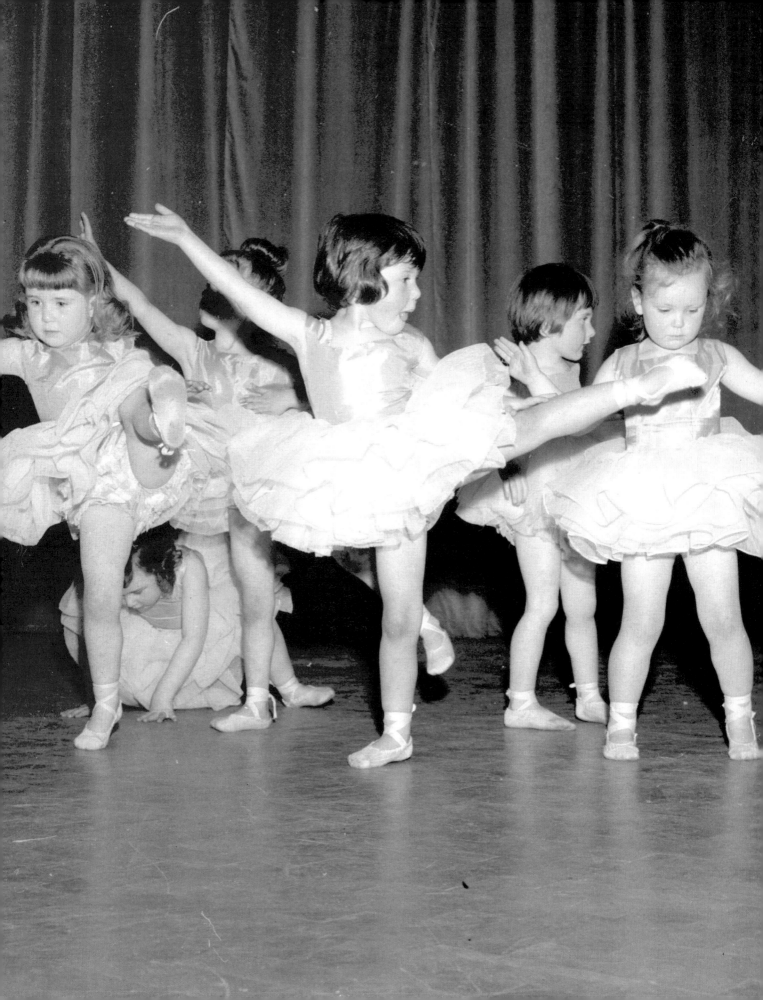

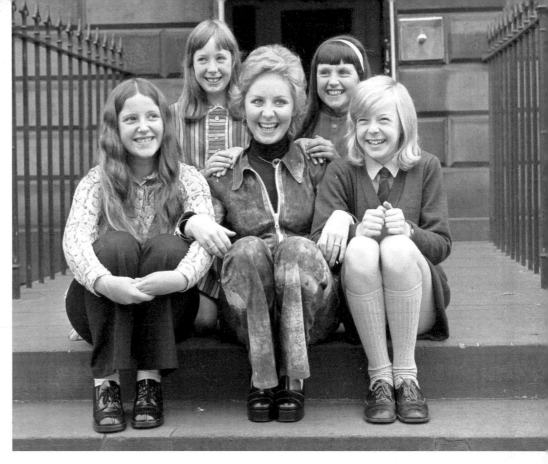

Kids first: Scottish pop singer Lulu with a group of children on the steps of the Royal Scottish Society for the Prevention of Cruelty to Children (RSSPCC, now Children 1st) in Edinburgh in September 1972

These young patients at Princess Margaret Rose Orthopaedic Hospital get a healthy dose of sunshine in April 1957

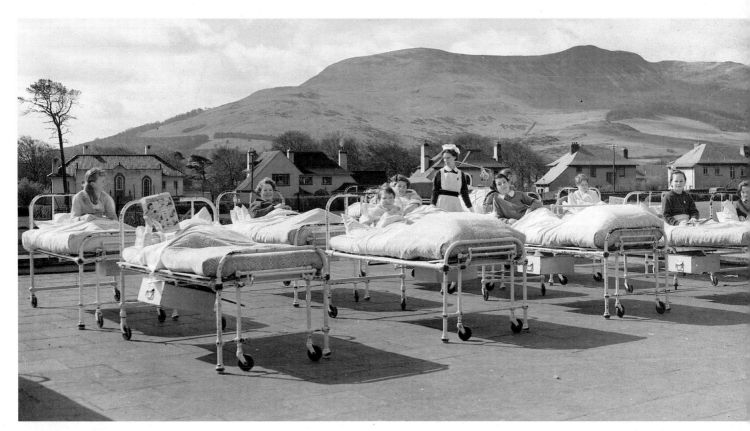

Tutu: Six little ballet dancers from Madame Ada's School of Dancing appeared in a show at Leith Town Hall in May 1964

See the
GUINNESS
animals at

EDINBURGH ZOO

Animal ad: These cartoon creatures were used to advertise the attractions on offer at Edinburgh Zoo

On parade: The penguin parade at Edinburgh Zoo remains a family favourite, as it was when this picture was taken in July 1962

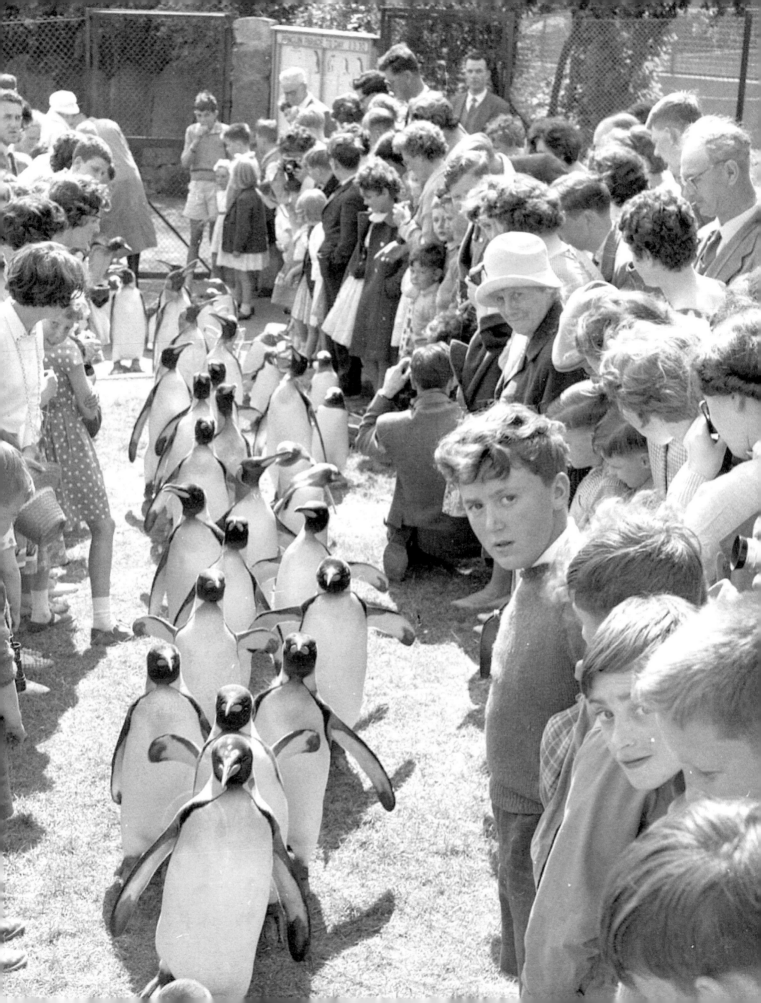

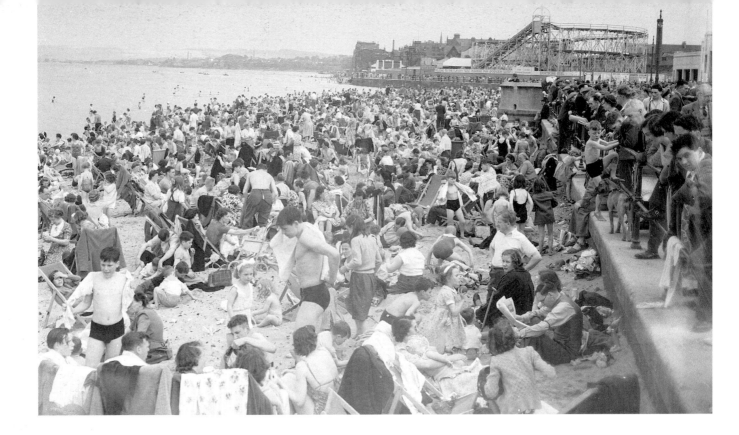

Cover story: In the days before foreign travel was affordable, Portobello's golden sands were virtually covered by the crowds, as this picture taken in May 1952 demonstrates

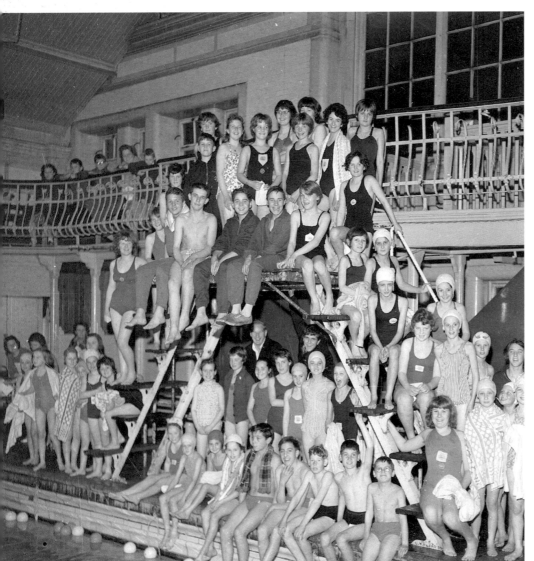

Pool pals: Dozens of children made a splash at the Leith Swimming Gala, held at the Victoria Baths in 1959

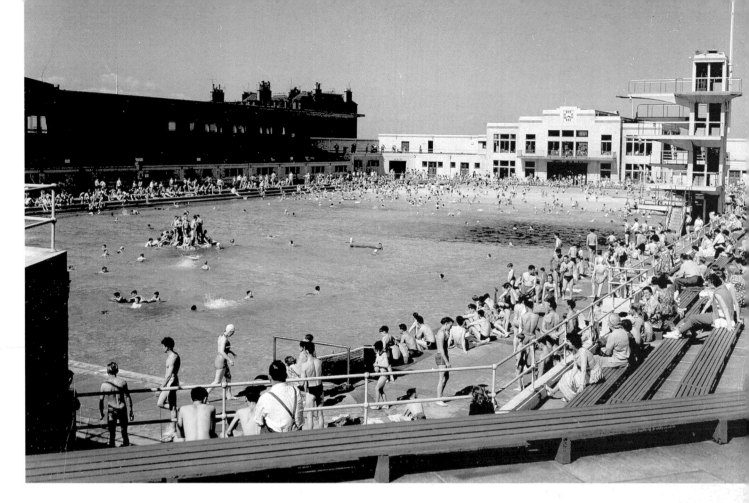

Porty Pool: The open air pool at Portobello was packed with swimmers and spectators when this photograph was taken in 1958

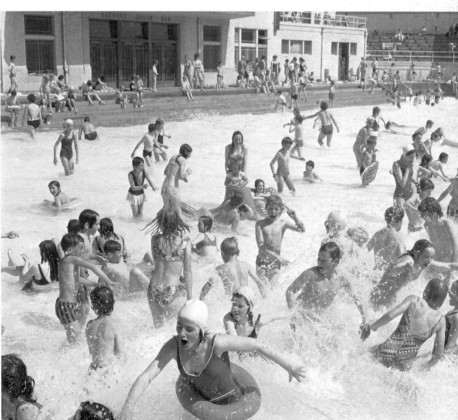

Take a dip: Families were glad to enjoy the summer sunshine at Portobello open-air swimming pool in July 1971

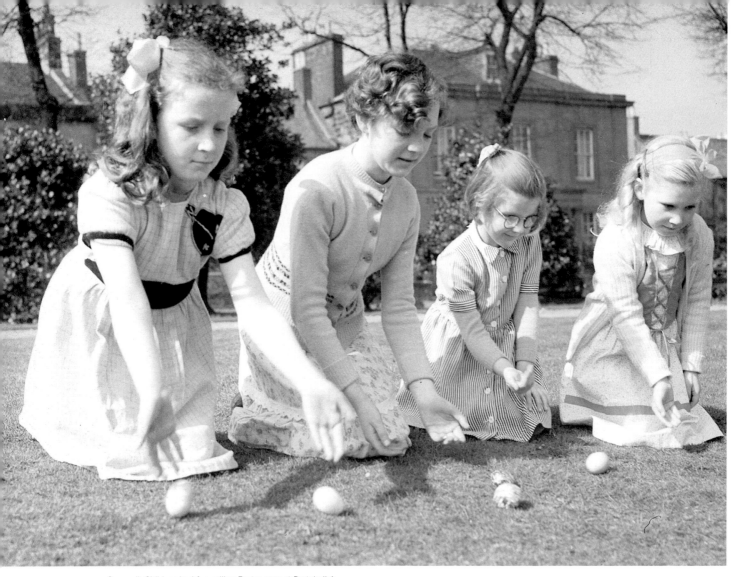

On a roll: Children had fun rolling Easter eggs at Portobello's
Abercorn Park in 1951

If the sun shone, then there was no shortage of cheap entertainment for children – boating on St Margaret's Loch in Holyrood Park, sailing model boats on the pond at Inverleith Park, or taking a dip in the Water of Leith at Saughton, or just sunbathing in Princes Street Gardens, provided the 'parkie' didn't object to you lying on the grass.

If the weather was cold enough to snow, then sledging was a winter joy. Bob Malcolm remembers the excitement of sledging down Corstorphine Hill or down a slope at Saughton Park – which he says was not for the faint-hearted. 'Unfortunately, there were rugby posts at the bottom of the slope so you had to steer well . . . or else!'

If the weather was cold, damp and miserable, then the cinema was the ideal refuge – particularly in the days when you could watch the film over and over again without being ejected by an irate usher – and the city boasted a vast selection of picture-houses, including the Jacey in Princes Street, the La Scala in Nicolson Street, the New Tivoli in Gorgie Road and the Lyceum at Slateford.

For those teenagers old enough to be interested in the opposite sex, the 'chummy' seats in the back row of many cinemas were ideal for courting couples.

While popcorn and sweets are now a staple of cinema-goers, sweets were in short supply during the

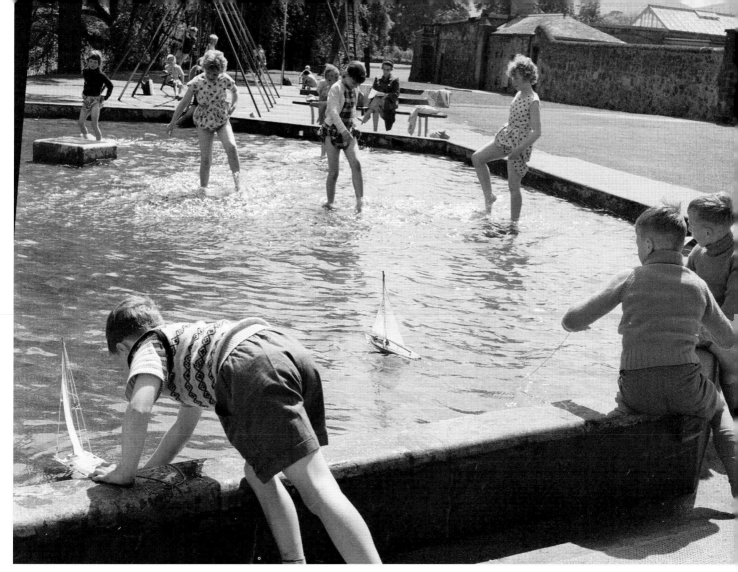

Messing about: Those youngsters without model boats to sail in the pond at Saughton Park cooled their heels in the water in July 1963.

war years, due to the rationing of sugar. When rationing finally ended in the 1950s, children celebrated by queuing up for a poke of their favourites, like soor plooms or cinnamon balls, at traditional sweetie shops like Casey's on St Mary's Street. But the favourite shop in the city was almost certainly the iconic department store, Jenners – its toy department was a cornucopia of what every child dreamt of finding in their stocking on Christmas morning.

Life was far from carefree for many city youngsters, many of whom grew up in the shadow of the Second World War. Schooling was strictly regimented, with discipline enforced where

necessary by the belt or tawse, which was not phased out until the 1980s. Poverty also forced many children to go to work before or after school to earn some extra money, often helping to deliver milk or papers. With most children leaving school at the age of 15, and few going on to further study, the transition into adulthood and the responsibility of full-time work, parenthood and housekeeping, was swift for most. But at least they could forget their cares by using their hard-earned wages to kick up their heels in the city's dance halls. And for those who had grown up in the war years, entertainment in Edinburgh was about to arrive on the world stage.

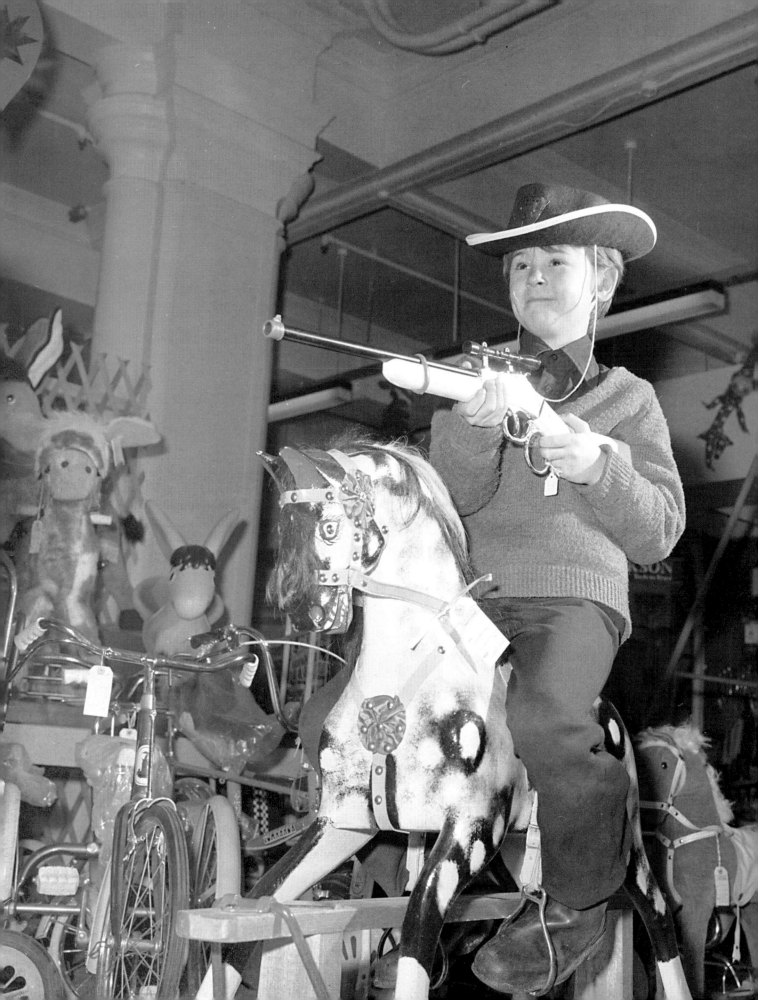

Sweet memories: In 1953, children rejoiced as sweet rationing came to an end – and emptied their piggy banks to splash out on treats like toffees and soor plooms

Doing the rounds: John Banyard and Margaret Book, a young milkman and papergirl, meet on their early morning shift in October 1959

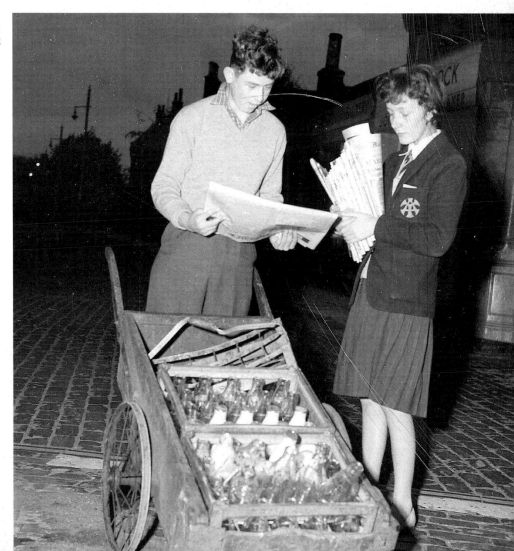

Toy box: Every child's fantasy could be found in the vast toy department of Jenners in Princes Street, as this little boy was happy to discover in 1977

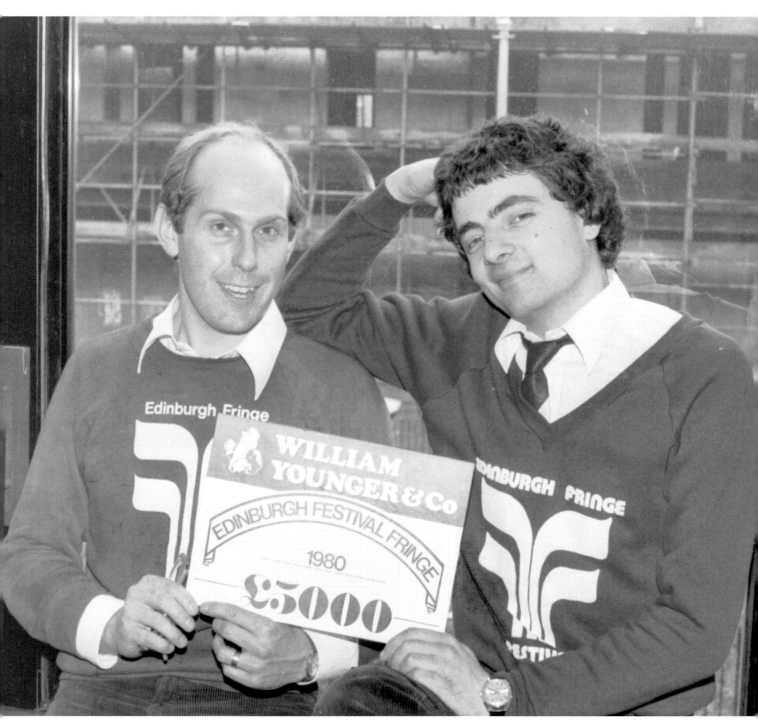

Bean counter: In the days before his *Blackadder* and *Mr Bean*
successes, Rowan Atkinson performed at the Fringe and was happy to
help its director Alistair Moffat at a press conference in 1980

CHAPTER 5

A Festive City

The idea is a new one for Edinburgh, but I feel confident we will succeed in establishing our fair city as one of the pre-eminent European festival cities.

John Falconer, Lord Provost of Edinburgh

In the summer of 1947, the people of Edinburgh were still reeling from the impact of the Second World War; times were especially hard for the countless families who had lost loved ones in the conflict, or whose men had returned from battle irrevocably changed by the horror of their experience.

Remarkably, Edinburgh would become the unlikely venue for an event which would not only partially heal the wounds that had torn Europe apart for the second time in half a century, but also put the city firmly on the world map. It is largely thanks to the inauguration of the Edinburgh International Festival that the city has – gradually – shaken off the shackles of its Presbyterian past and emerged as a cosmopolitan European capital.

The idea for the Festival came from Vienna-born Rudolf Bing who was looking for a venue where he could extend the season of the Glyndebourne Opera, of which he was general manager. While some accounts say that the city was chosen largely because its buildings had survived the war, Edinburgh is said to have inspired Bing because it reminded him of Salzburg, the birthplace of Mozart, and home to Europe's most prestigious festival. Despite his choice of Scotland's capital, Bing knew almost nothing about the country north of the border; he frequently committed the ultimate *faux pas* of constantly referring to Edinburgh as being in England.

Not everyone in Auld Reekie was terribly

impressed by the prospect of an influx of international visitors to the city. Could Edinburgh, still subject to strict food and petrol rationing, actually cope with hordes of tourists? Many hotels had still not reopened after the war, while others still had windows blacked out from wartime.

Nevertheless, reluctantly or not, thousands of people opened their homes to visitors, with 6,000 beds being made available in private households after an appeal by Lord Provost John Falconer. Special arrangements were made with the Ministry of Food to ensure that there would be sufficient supplies to cater for the culture vultures.

Flags were hoisted around the city, baskets of flowers were attached to tramway stands and traffic islands in the West End; Haymarket and the precincts of the Usher Hall were transformed by elaborate floral displays. The Government also gave permission for the Castle to be floodlit as the city played host to the Glyndebourne Opera, the Liverpool and the Vienna Philharmonic Orchestras, the BBC Scottish Orchestra, the Sadler's Wells Ballet and the Old Vic performing Shakespeare's *Taming of the Shrew*.

With unwitting prescience, the Lord Provost said: 'The idea is a new one for Edinburgh, but I feel confident we will succeed in establishing our fair city as one of the pre-eminent European festival cities.' Falconer could not have known that the Festival was destined to grow and to become the world's biggest

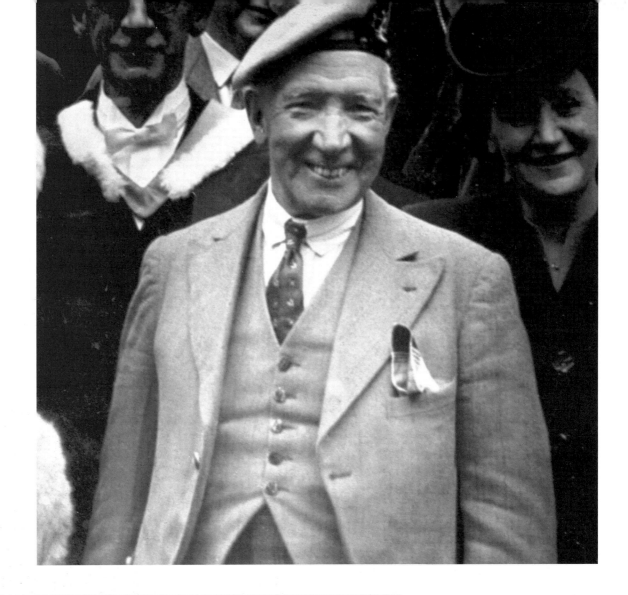

Happy Harry: Edinburgh's first superstar, Sir Harry Lauder, pictured here in 1948, became the first UK entertainer to sell a million records

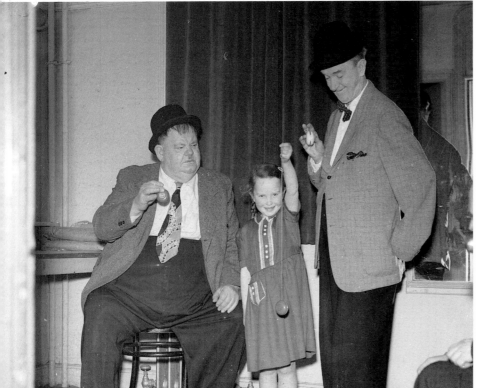

Another fine mess: Oliver Hardy and Stan Laurel were snapped entertaining a young fan backstage at the Empire Theatre in the early 1950s

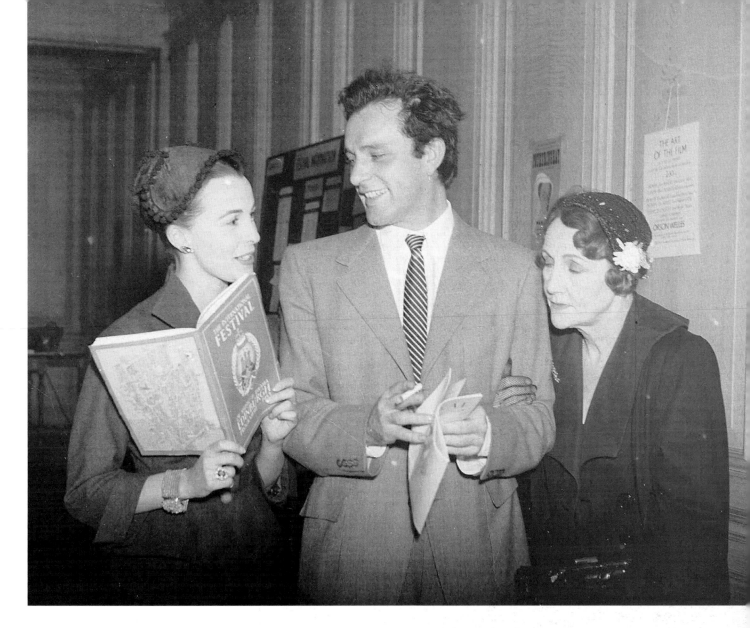

Programmed: Claire Bloom and Richard Burton, pictured here in 1953, were among the famous actors attracted to the Edinburgh Festival in its early years

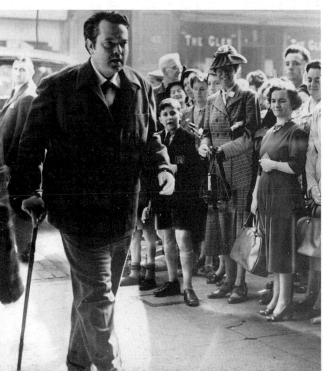

Cameo role: *Citizen Kane* director Orson Welles strides up to the Cameo cinema during the 1953 Festival to give a lecture

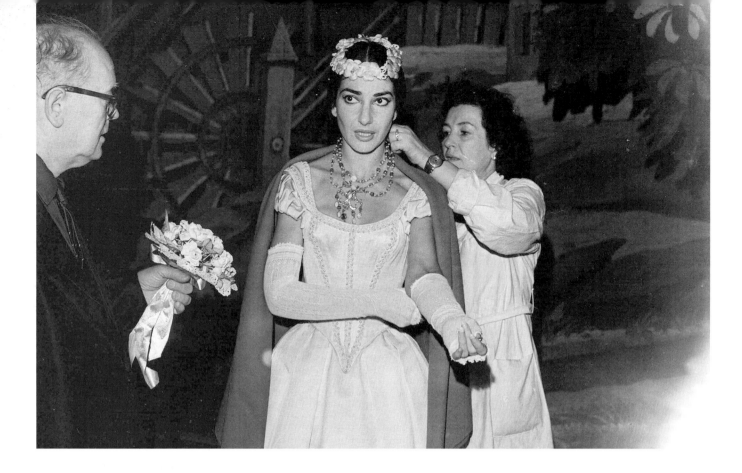

Diva: World famous opera singer Maria Callas performed at the Edinburgh Festival in 1957, playing Amina in *La Sonnambula* with La Piccola Scala opera company

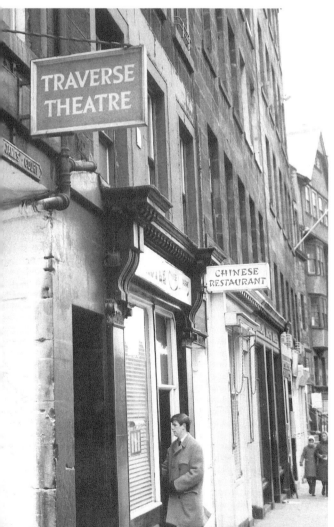

Stamp of approval: Sixties icon Terence Stamp was wrapped up against the Edinburgh weather on a visit to the capital in January 1968

Theatre loyal: Before finding at permanent home next to the Usher Hall, the Traverse Theatre began life tucked away in James Court at the Lawnmarket, pictured here in 1966

Smelling good: French sex symbol Brigitte Bardot takes a break from filming at Dirleton, East Lothian, in 1966

celebration of the arts, attracting people and performers from all over the planet. But in her *History of the Edinburgh Festival*, Eileen Miller said that the Festival quickly lifted the city from its post-war gloom.

Edinburgh had probably never seen so many brightly-coloured frocks and, at night, long after the theatres and restaurants had closed, Princes Street was still thronged with people, many in full evening dress, enjoying the cool night air and admiring the magnificent vista of the Castle on one side and the elegant new Town on the other . . . After the grim years of war, Edinburgh had suddenly come alive.

Many Edinburgh people remained to be convinced, however. Former city councillor Moira Knox, who convened the culture committee in the mid-1960s, recalls: 'Far more people go to the Festival now than did back then. Going to the theatre was more popular among Glaswegians in those days – it was a way of life for them. But theatre wasn't regarded in quite the same way here. And many locals saw the Festival as being for visitors, not for them. Of course, that has changed now.'

Veteran *Evening News* journalist John Gibson, whose role has seen him rub shoulders with dozens of celebrities down the years, agrees: 'The Festival was seen by many as being too elitist. Come the Sixties, it was all long-haired stuff – not for the likes of most folk.'

It would take a long time for local people to engage with the Festival as something for them, and not only for tourists. As early as 1951, there were moves to launch an alternative, anti-establishment arts celebration – the Edinburgh People's Festival. Founded by singer songwriter and poet Hamish Henderson, it fell victim to the anti-Communist backlash in 1954.

However, the city's Festival successes were enhanced by the growth of the Fringe – inspired when more performers turned up in 1947 than there was room for – and the addition of the Military Tattoo to the festival calendar in 1950, and the *Evening News* Cavalcade in 1976.

Unsurprisingly, celebrities were increasingly drawn to the city at the centre of the arts. Legendary film stars Brigitte Bardot, Richard Burton, Bing Crosby, Marlene Dietrich, Bette Davis, Peter Fonda, Oliver Reed and Orson Welles, all graced the Capital with their presence, as did the opera diva Maria Callas.

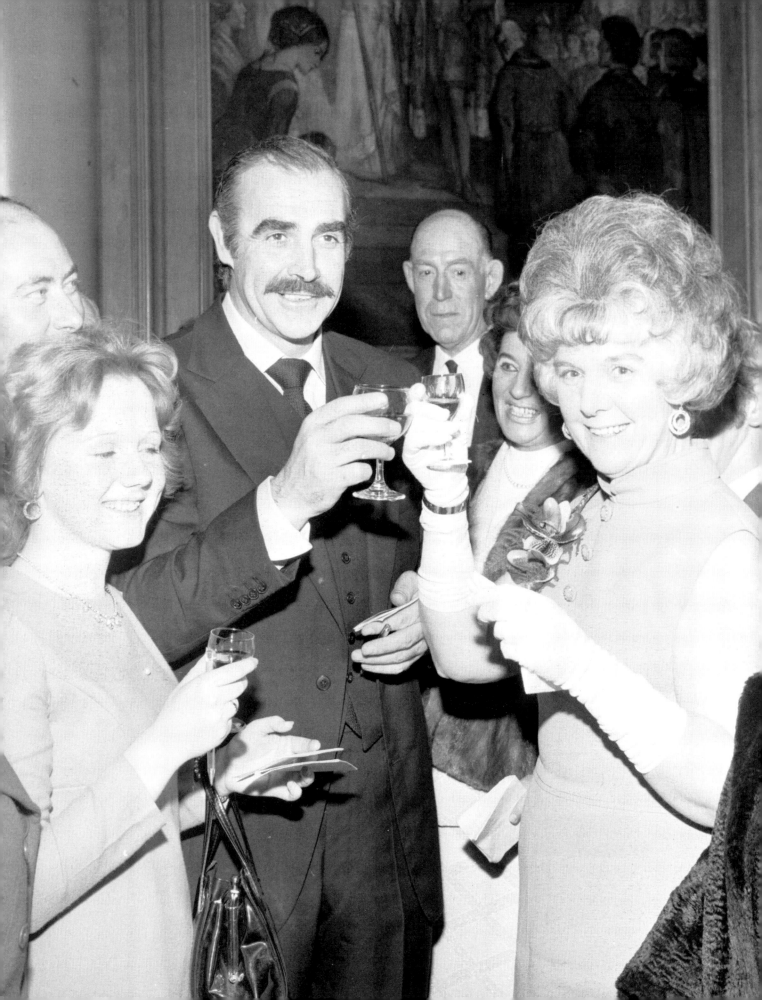

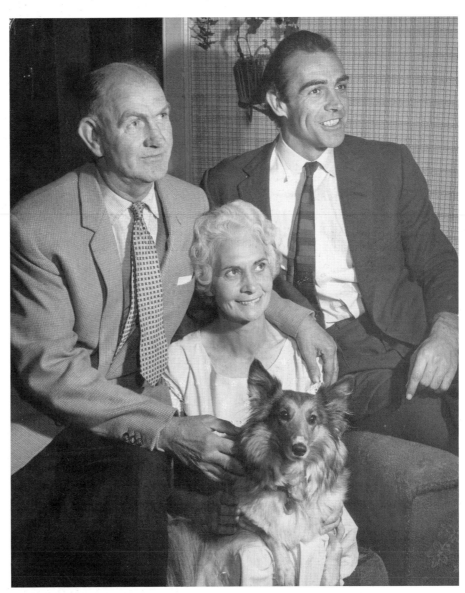

Famous son: Sean Connery, the city's most famous son, is pictured with his parents at their flat in Fountainbridge in 1962. The flat was later demolished to make way for a brewery

Big Tam: Sean Connery, the original James Bond, finds another fan in Lady Provost Janette McKay at the premiere of *Diamonds are Forever* in January 1972

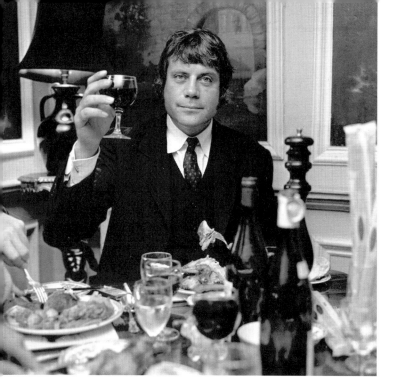

Legendary: One of Hollywood's original screen legends, Bette Davis, was still dazzling with her smile when she visited Edinburgh in October 1975

Home-grown stars who were guaranteed to attract adoring crowds included Portobello-born comic superstar Sir Harry Lauder, the original – and most Edinburgh people would agree – the best James Bond, Sir Sean Connery and diminutive comedian Ronnie Corbett. And, as befitted the capital of Scotland, Edinburgh continued to attract visits from the Royal family. In 1938, Queen Mary visited the city and planted a tree at Little France, in memory of Mary, Queen of Scots, who had set up camp there in the 16th century with her – mostly French – courtiers.

Following the Coronation in June 1953, crowds lined the streets of Edinburgh to cheer the arrival of the newly-crowned Queen Elizabeth II and her consort, Prince Philip, as they visited the city, and the Royal couple established the tradition of an annual summer stay at the Palace of Holyroodhouse. The Queen and her family would not always stand on ceremony when in Edinburgh, however; Her Majesty has been spotted walking her corgis in Holyrood Park, wearing a simple headscarf and overcoat. But not even a visit from the Queen herself could come close to match the excitement of the arrival of a different sort of aristocracy – the princes of popular music, The Beatles.

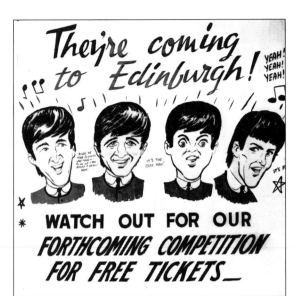

Fab news: This fun poster featuring caricatures of The Beatles was used to advertise the pop group's visit to Edinburgh in 1964

Flying visit: The Beatles arrive at Edinburgh's Turnhouse Airport in 1964, unaware of the mania that would greet them in the city centre

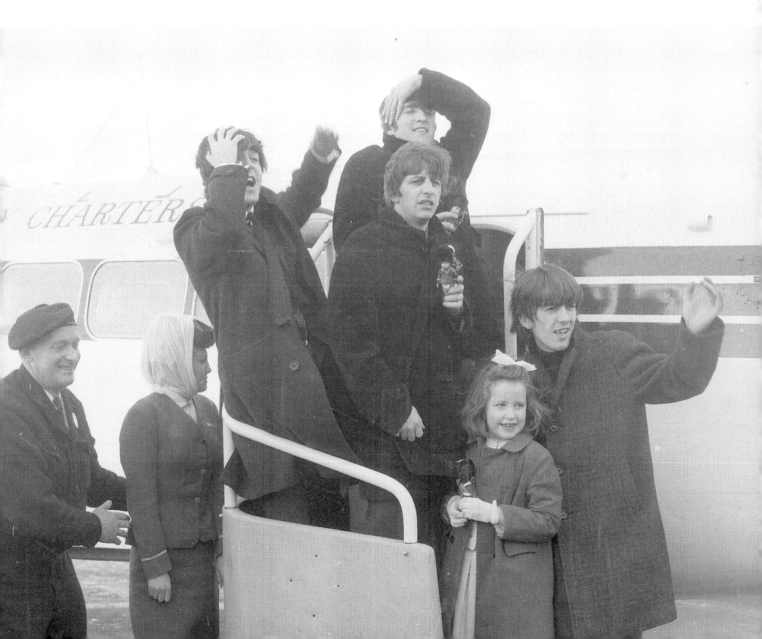

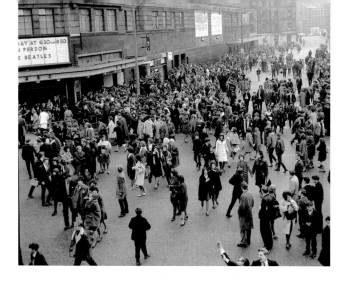

ABC: Crowds of eager fans besieged the
ABC Cinema in Lothian Road as The
Beatles came to town in April 1964

Supergroup: The Fab Four – Ringo Starr, Paul McCartney,
John Lennon and George Harrison – sign autographs for
their young fans at the ABC

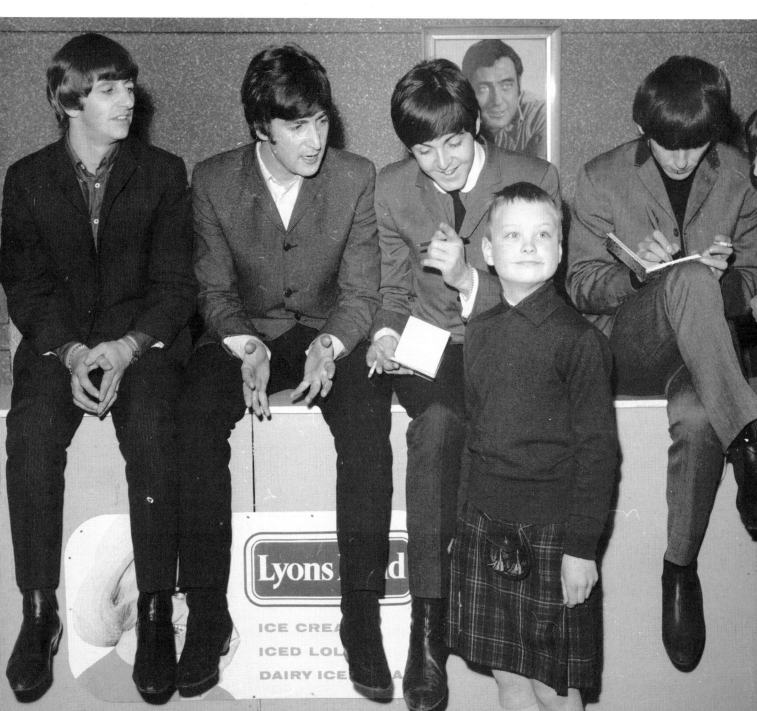

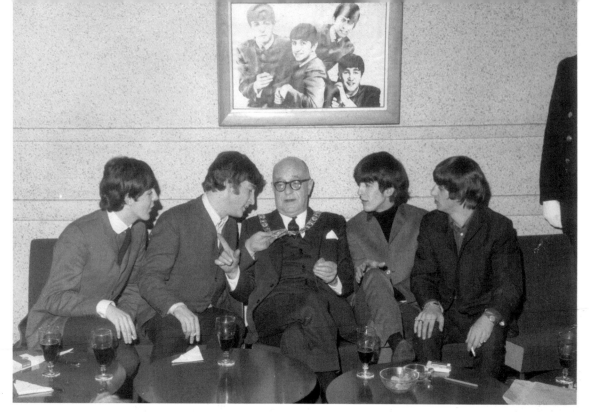

Chain gang: John Lennon admires Lord Provost Duncan Weatherstone's
chain of office during the Beatles' time in Edinburgh

Retired police officer Derek Allan was on duty on 29 April 1964 when The Beatles arrived in Edinburgh, and it is an experience he will never forget.

They came to the Regal Cinema – we still called it that even though it was by then the ABC – in Lothian Road . . . The scenes were incredible. There were people camped out for at least a week before. Then, when they opened the doors, all these people just got up and ran for it. Well, nearly all – there were one or two in the queue who decided that they didn't care that much for The Beatles after all, and they set about just lifting all the stuff the others had left lying around!

Evening News columnist John Gibson also has vivid memories of that April day, as he was one of the favoured few to be granted an audience with the 'Fab Four'.

The then Lord Provost, Duncan Weatherstone, was there with his chain of office around his neck.

I remember him asking John Lennon if The Beatles were going to do anything for the city because they were making so much money. Lennon responded by saying he'd do something for the city in return for the chain around his neck . . . Outside, there were incredible scenes that no one was really prepared for. The St John's Ambulance people didn't know how to cope with screaming women fainting everywhere and ended up just laying them all down in the foyer!

Gibson recalls that the emergency services were also needed on another occasion, when John Lennon arrived at the Caledonian Hotel to meet American singing sensation, Guy Mitchell.

He invited the press up to his suite for interviews when he announced he was going to have a barbecue. He set about lighting the fire, but didn't realise the fireplace hadn't been used for years and was blocked off. There was smoke pouring out of the windows and billowing across Lothian Road!

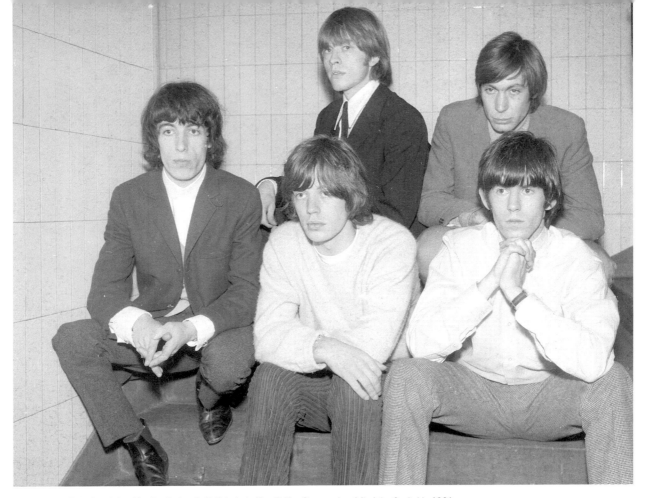

Swinging sixties: The Beatles' main British rivals, The Rolling Stones, also visited the Capital in 1964.
Clockwise from left: Bill Wyman, Brian Jones, Charlie Watts, Keith Richards and Mick Jagger

For young people in Edinburgh, the excitement of a visit from The Beatles remained unsurpassed – at least until the emergence of Edinburgh's own super-group, the Bay City Rollers. Ironically, the Rollers, who chose their name after sticking a pin in a map of the world, were formed in 1967 as a Beatles covers' band. By the early 1970s, the tartan-clad group, comprising Les McKeown, Stuart 'Woody' Wood, Alan and Derek Longmuir and Eric Faulkner, were causing teenybop mayhem with hits, including 'Shang-A-Lang' and 'Bye Bye Baby'.

But pop stars weren't always needed to bring excitement to the city. Before the emergence of the discotheque in the late 1970s, young people in Edinburgh found their fun – and met their future partners – at the dance hall.

The biggest in the city was the Palais de Danse in Fountainbridge, while other favourites included the Eldorado in Leith, the New Cavendish at Tollcross, the Excelsior in Niddry Street and the Plaza in Morningside.

Derek Allan fondly recalls many enjoyable evenings spent at the Palais in Fountainbridge:

It was where everyone seemed to go to see the big bands, like Harry Roy, who played all the dance tunes of the day. There was a big input of Americans from Kirknewton and they'd all be at the Palais doing the jive and the jitterbug.

There was also a revolving stage: first the big band would come on and then they rotated around and the night usually ended with a quartet. Crowds there could be huge. I remember us having trouble controlling some of the crowds, maybe fifty or sixty young men hanging about outside or trying to queue-jump to get in.

Rollercoasters: The Bay City Rollers were the biggest band to come out of Edinburgh – here at the height of 'Rollermania', Stuart 'Woody' Wood and Alan Longmuir prepare to go on stage at the Odeon in April 1975

People might think there is trouble today with the young people, but there were incidents back then too. The 10 pm 'swirl' – when every pub shut at 10 pm – meant you saw more drunks per square inch back then than you ever would today!

Author Margeorie Mekie was also a Palais regular in the 1950s and remembers it as a glamorous venue: "It had the most beautiful ladies' powder rooms and the biggest crystal ball on the ceiling above the dance floor that sparkled as it turned. All the Americans from Kirknewton gathered in "Yanks corner", and there was a balcony where you could have something to eat and some soft drinks – there was no alcohol.'

There is no doubt that enthusiasm for dancing in the city, particularly in its 1950s heyday, was fervent.

One Ronnie: In a rare picture without his sidekick Ronnie Barker, Edinburgh comedian Ronnie Corbett is pictured cooking at home in December 1967

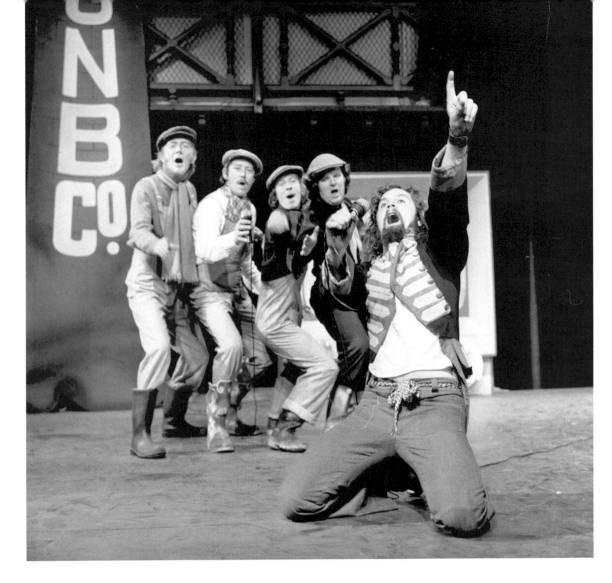

Big Yin: Comedian Billy Connolly was a star of *The Great Northern Welly Boot Show* at the Waverley Market during the Fringe in August 1972. [In picture, Kenny Ireland (chorus, right) Bill Paterson (chorus, 2nd right) and Billy Connolly (in front)]

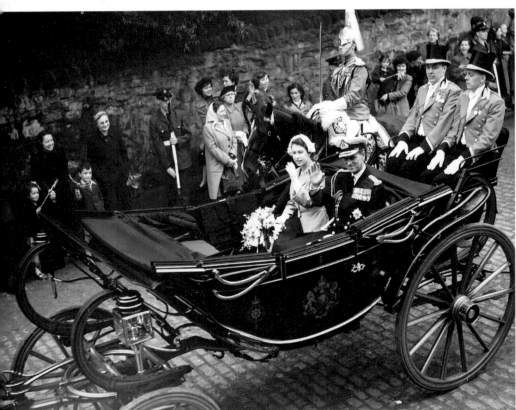

Her Majesty: The newly crowned Queen Elizabeth II and Prince Philip are pictured on a state visit to Edinburgh shortly after her coronation in 1953

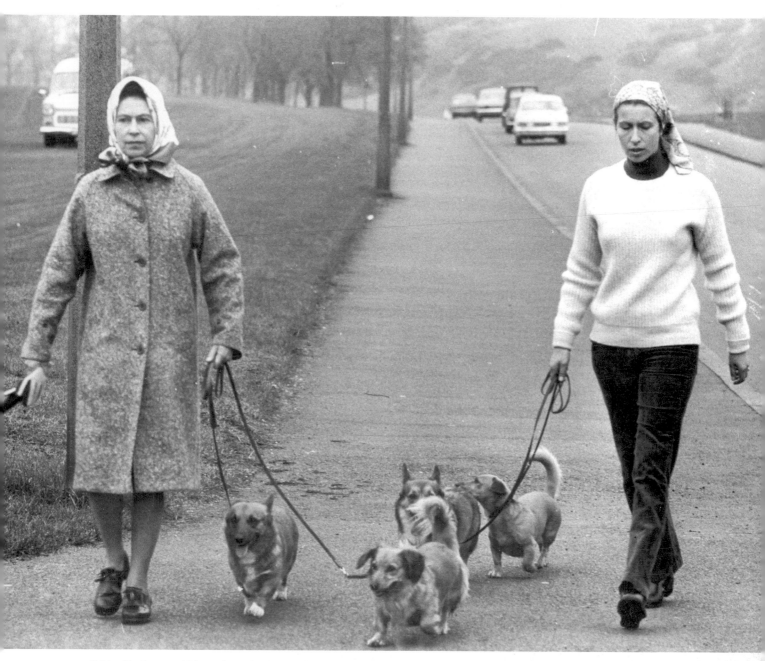

Walkies: The Queen and Princess Anne take the corgis for a walk in
the park – the Queen's Park, of course – in October 1976

Zhivago: Egyptian-born actor Omar Sharif, the star of *Dr Zhivago*, arrived in Edinburgh for the
Cutty Sark International bridge tournament at the George Hotel in January 1973

Quick dip: Actress Diana
Quick, in Edinburgh for the
Festival, takes a dip in the
sea at Portobello in August
1966

Classy act: Actress Joan Collins brings some glamour to
Edinburgh in October 1979

Beat generation: Edinburgh University students dance at the Beatnik Ball, held at the Palais de Danse, at Fountainbridge, in November 1965

Mr Edinburgh: Norman Rough attracts some admiring glances after winning the Mr Edinburgh title at the Palais de Danse in January 1966

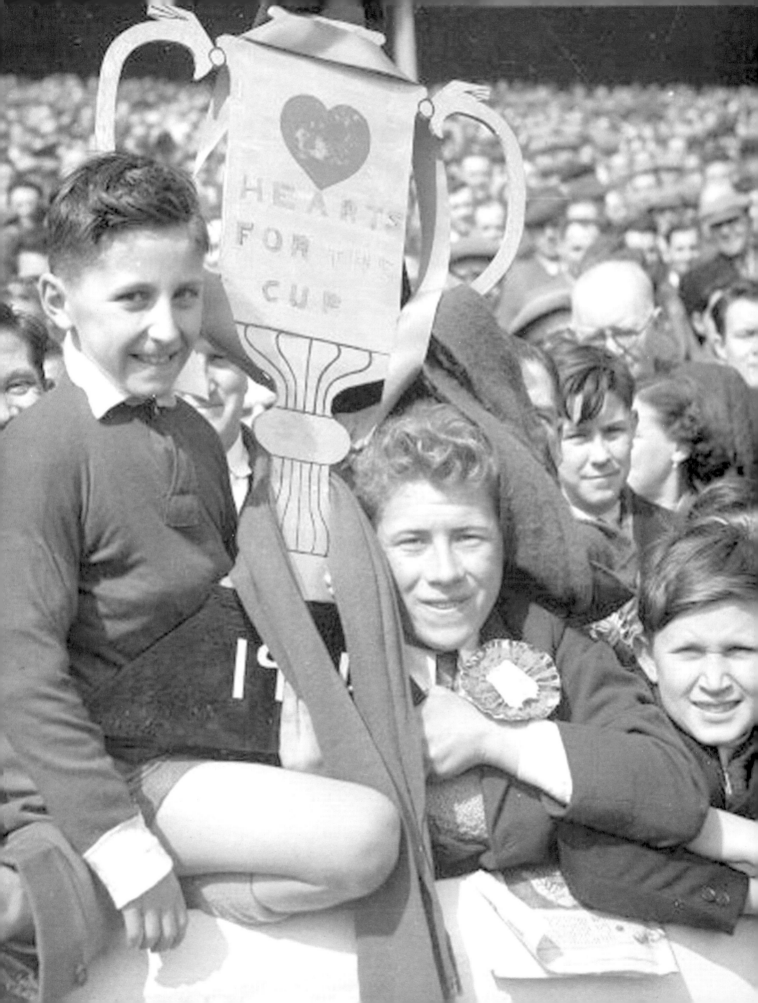

CHAPTER 6

Sporting Chances

That a city the size of Edinburgh could support two football clubs with the proud histories of Hearts and Hibs is a sure testament to the Capital's enduring love of the beautiful game. The clubs' histories began in 1874 with the founding of Heart of Midlothian, named after a dance hall near Dumbiedykes frequented by the founders; a year later, Hibs were established by Irish immigrants in Leith, taking the name from the Roman word for Ireland, Hibernia.

Early success came more quickly for Hearts. The club, which moved to a permanent home at Tynecastle in 1886, was a founder member of the Scottish League in 1890 and went on to secure an impressive two League titles and four Scottish Cup wins between 1895 and 1906, including a 3–1 win over Hibs in the only Scottish Cup Final ever to be held outside Glasgow, at Logie Green in 1896. Hibernian didn't win the League until 1903, and won the Scottish Cup in 1887 and 1902.

By the late 1940s, however, the tables had turned. Hibernian's star was in the ascendancy after winning the Scottish League in 1948. But the best was yet to come, largely thanks to a group of players dubbed the 'Famous Five': Gordon Smith, Bobby Johnstone, Lawrie Reilly, Eddie Turnbull and Willie Ormond, who, ironically, was widely believed to have been on the brink of signing for Hearts.

They first played together on 21 April 1949, in a friendly against Nithsdale Wanderers and scored eight goals between them. With the Famous Five on

side, Hibs soon became a force to be reckoned with and were famed for their attacking football, winning the Scottish League in both 1951 and 1952. Hibs also made football history by becoming the first British club to play in European competition; in 1955, Hibs were invited to take part in the first Champions Cup, and reached the semi-finals.

Retired policeman Derek Allan, who grew up in Slateford near the home of Hearts in Gorgie, but ended up supporting Hibs, remembers the thrill of going to Easter Road stadium during the club's golden era: 'The crowds were really amazing. You'd look out at a sea of faces. There was no crowd segregation back then, you had Hearts and Hibs supporters standing side by side, and back then drink hadn't yet been banned. Yet, there really wasn't that much trouble.'

Hearts were not about to let their city rivals outshine them for very long, however, and it was soon the Gorgie club's turn to bask in the glory. The Scottish Cup returned to Tynecastle in 1956, and League Championship wins followed in 1958 and 1960; the club also won the League Cup in 1954, 1958, 1959 and 1962. The time of the 'Terrible Trio' – Alfie Conn, Jimmy Wardhaugh and the legendary Willie Bauld, the striker who came to be known by fans as simply 'The King' – had arrived.

Still regarded as the club's greatest-ever player, Bauld signed for Hearts in 1946, and sealed his first team debut in October 1948 by scoring a hat-trick in

Up for the cup: During the Scottish Cup final at Hampden in 1956, a young fan cheers on his team with a cardboard cup

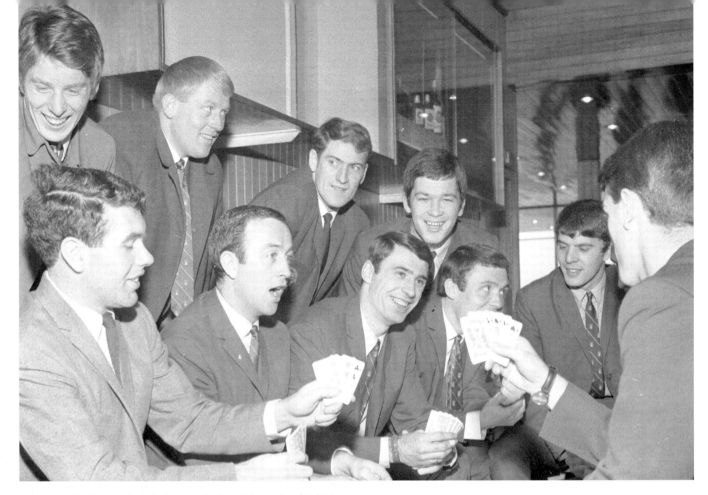

Full house: Hibs footballers pass the time playing cards before leaving for Naples to play in the Inter-Cities Fairs cup in November 1967

a League Cup tie against the holders, East Fife, who were beaten 6–1. This was the first time the Terrible Trio had played together, but over the next decade they would score more than 500 goals.

After playing for Hearts for 15 years, Bauld was given a testimonial by the club in 1962 with a game against Sheffield United, but the cost of the match ball was deducted from his pay-out. The football legend was so affronted that he refused to return to the stadium for almost 14 years. When he did make it back to Tynecastle, unsurprisingly he received a standing ovation from thousands of adoring fans. And when Bauld died suddenly in 1977 at the age of just 49, huge crowds of those same fans turned out in Gorgie to watch his funeral cortège pass by.

Neither Hearts nor Hibs have since recaptured the magic of those glory days, but there have been some highlights to sustain the hopes of die-hard fans

over the years. In 1972, Hibs beat Celtic 2–1 at Hampden to lift the League Cup, thanks to goals from Pat Stanton and Jimmy O'Rourke.

Later during that decade George Best was signed to the Easter Road club at the end of his equally stellar and ill-starred career. The Manchester United legend came at a high price for Hibs – a fee in excess of £50,000 – and the deal saw Best netting £2,000 a game, a huge sum for the time. Not everyone was impressed: Edinburgh minister the Reverend George Grubb, of Craigsbank Corstorphine Church, denounced the club's largesse: 'I fail to see that any footballer is worth that amount of money.' Initially the fans disagreed. Attendances soared as Best shone on the pitch – when he turned up for matches. His long-standing battle with alcoholism made him notoriously unreliable, and he parted company with the club after two seasons.

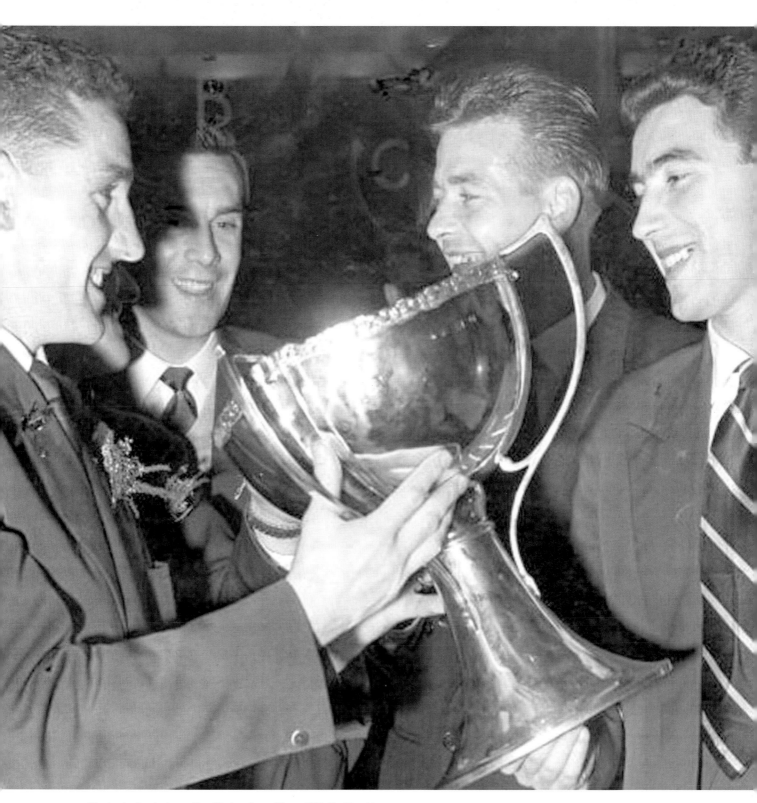

Play to win: Hearts players Dave Mackay, Jimmy Murray, Willie Bauld and Ian Crawford celebrate with the League Cup after beating Partick Thistle 5-1 in 1958

Hearts and goals: Jimmy Wardhaugh was a hero
to Hearts fans in the 1950s and 60s, but was
also happy to play the role of husband and
father, as this 1954 picture shows

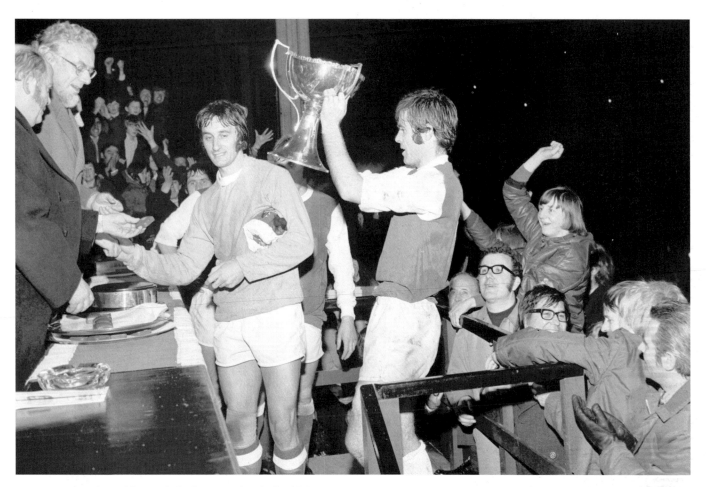

Cup winners: Hibs captain Pat Stanton receives the Scottish League
Cup after beating Celtic at Hampden in December 1972

A decade later, Hibs fans had few reasons to be cheerful when the then Hearts chairman Wallace Mercer suggested that the two clubs should merge – sparking a high-profile 'Hands Off Hibs' campaign – but spirits were lifted when the League Cup returned to Easter Road in 1991.

Hearts had even longer to wait for the silverware to be returned to Tynecastle, but the waiting made their 1998 Scottish Cup win over Rangers all the sweeter. Thousands of people thronged the streets of Gorgie – including the then Lord Provost, Eric Milligan – to celebrate the success of ex-player Jim Jefferies' side. The team proudly displayed the Cup on an open-top bus journey through the centre of the city.

Photographs of Councillor Milligan celebrating

by swigging from a bottle of Buckfast provoked some controversy at the time, but he later said it was no accident. 'I knew what I was doing – I knew that would get my picture on the front page and people would see it and say, "Oh look, the Lord Provost is just one of us." And they were absolutely right.'

While football has undoubtedly dominated headlines during the last century, Edinburgh has nurtured a host of sporting heroes. Rugby has always been popular in the city: the world's first rugby international was played between Scotland and England on the cricket field of the Edinburgh Academy in 1871, and the game has a proud tradition at schools like George Heriot's and George Watson's, where the rugby legends, Gavin and Scott Hastings, were taught.

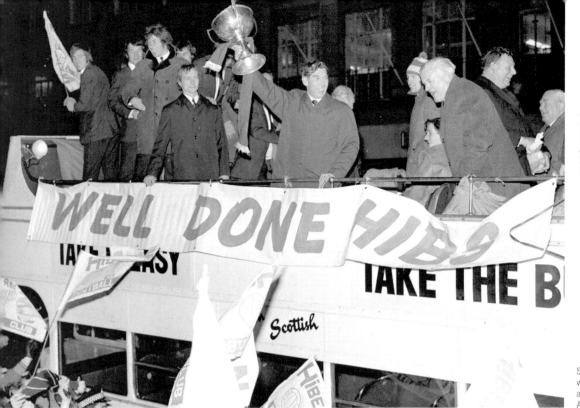

Cup Winners: Hibs footballers on the team bus bringing the Scottish League Cup home after their win against Celtic at Hampden in December 1972. Eddie Turnbull holds up the cup

Standing room: These football fans were tightly packed into the terraces at Tynecastle to watch Hearts play in April 1954

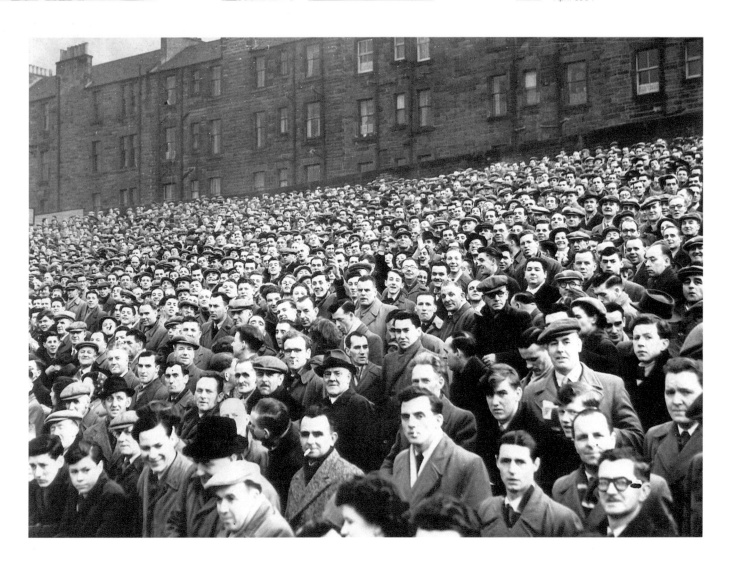

Famous five: Hibernian's Famous Five are reunited at Easter Road in
May 1979. From left to right, Gordon Smith, Bobby Johnstone,
Lawrie Reilly, Eddie Turnbull and Willie Ormond

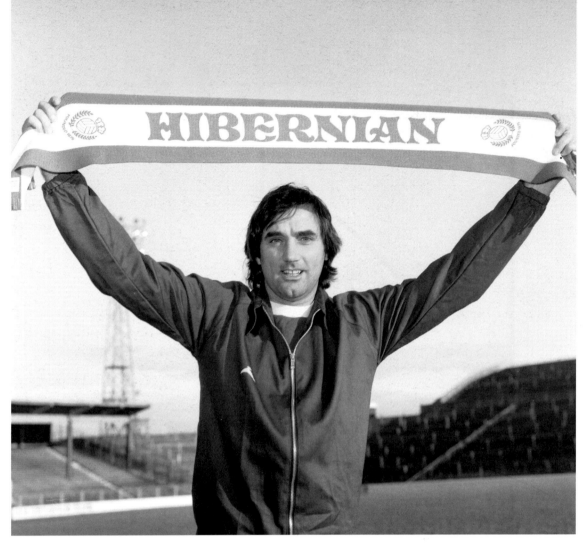

The Best: Football legend George Best with a Hibs scarf at Easter Road in November 1979

Scott Hastings has recalled that his schooling at Watson's was crucial in forging the ambition to achieve success on the pitch: 'There was great tradition and rivalry associated with those games against other Edinburgh schools, and in fact, the rivals you would come up against as a nine-year-old – people like Jeremy Richardson, who played for Edinburgh Academy – you would still be playing 20 years later.'

Perhaps the toughest contact sport of all is boxing, and Edinburgh-born Ken Buchanan excelled at it, winning the world lightweight championship in 1970, after a gruelling match in searing heat of up to 100 degrees against title-holder Ismael Laguna in Puerto Rico.

The city also has a proud history of athletic achievement. Olympic champion Eric Liddell, who made history by refusing to run on the Sabbath, graduated from Edinburgh University in 1924, the same year that he won 400m gold in Paris. The university organised a special crowning ceremony for the occasion, using a wreath of oleaster leaves – the closest that the Keeper of the Royal Botanic Garden could find to olive leaves – as a nod to the Ancient Greek origins of the Olympics. As Liddell stepped forward to receive his Bachelor of Science degree, the audience rose and cheered, and after the ceremony he was carried shoulder-high to St Giles' Cathedral.

Almost half a century later, Edinburgh would play host to the Commonwealth Games. In 1970,

Scrum together: Rugby was in the blood for the three Hastings brothers, Scott, Gavin and Graeme, pictured in December 1983

Handy Andy: Andy Irvine was handy with the boot on many Murrayfield occasions throughout the seventies

Right on cue: Stephen Hendry started taking pot shots on the snooker table at a young age. He turned professional in 1985 and would go on to win the World Championship a record seven times

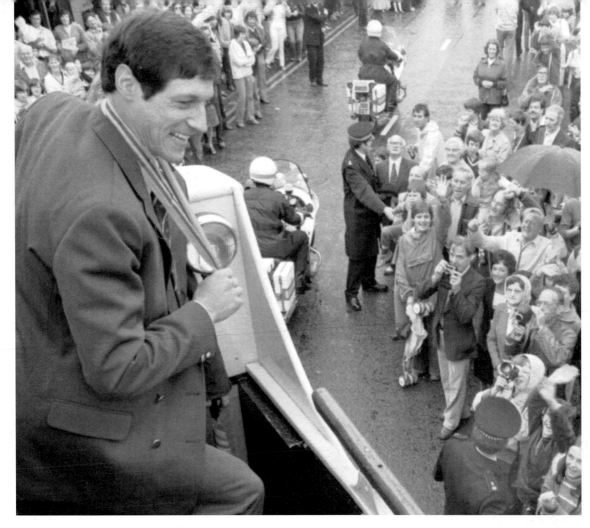

Olympic champion: 100m gold medallist Allan Wells shows off his gold medal to the crowds which greeted the open-top bus at the corner of Princes Street and North Bridge in August 1980

athletes from all over the world descended on the Capital for the IXth Games, which had required the building of new sports facilities, including the Royal Commonwealth Pool, and the million-pound Meadowbank Stadium, which replaced the old speedway track on the site – the end of an era for the Edinburgh Monarchs, who subsequently transferred to their current home at Armadale Stadium in West Lothian.

The hosting of the Games was a major coup for the city, and was largely thanks to the tireless campaigning of then Lord Provost Herbert Brechin and Councillor Magnus Williamson, who recognised that the event would boost Edinburgh's

international profile, and increase tourism. Officially opened by the Duke of Edinburgh, the start of the Games attracted 31,000 spectators, and 1,700 athletes from 42 countries took part in the opening ceremony. In what came to be known as the 'Friendly Games', Scotland accrued a respectable medal tally of six gold, eight silver and 11 bronze medals.

The 1970s would see the emergence of two superstars from Edinburgh – swimmer David Wilkie, who won gold in the 200m breaststroke at the 1976 Olympics in Montreal and sprinter Allan Wells, who took 100m gold at the Moscow Olympics in 1980, and remains Scotland's greatest-ever sprinter.

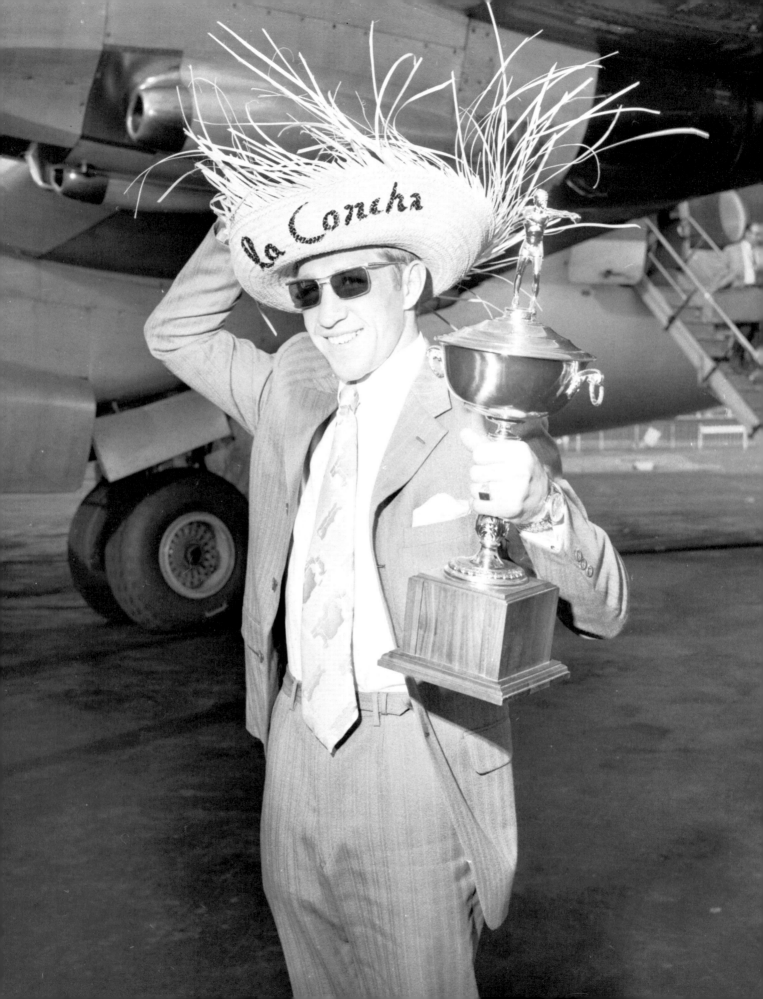

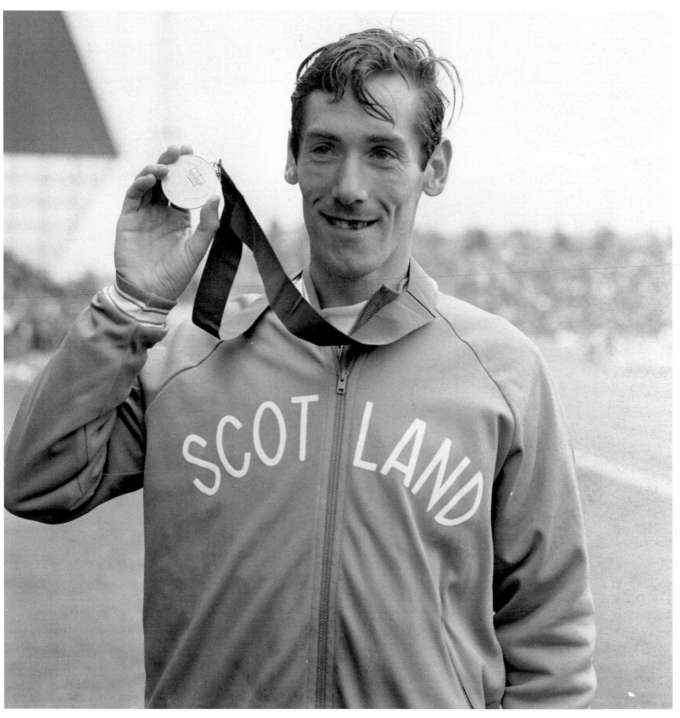

Gold standard: Scottish athlete Lachie Stewart with his gold medal,
won in the Commonwealth Games 10,000 metres final at Edinburgh's
Meadowbank Stadium in July 1970

Box clever: Boxer Ken Buchanan arrives back in Edinburgh
with a few souvenirs – after beating Ismael Laguna in San
Juan to take the World Lightweight title in September 1970

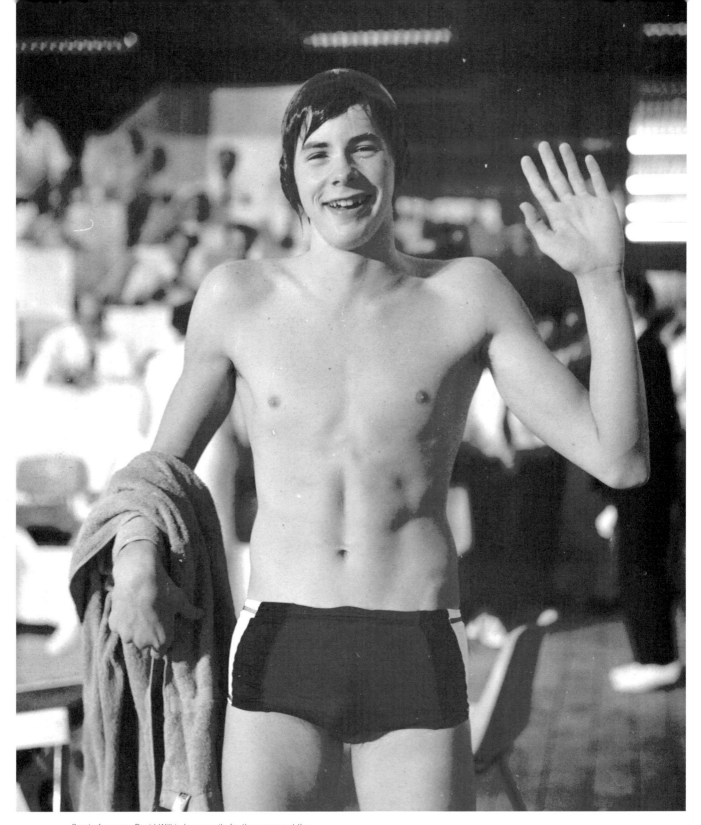

Crest of a wave: David Wilkie has a smile for the camera at the
Commonwealth Games in July 1970, six years before he would strike
gold at the Olympics

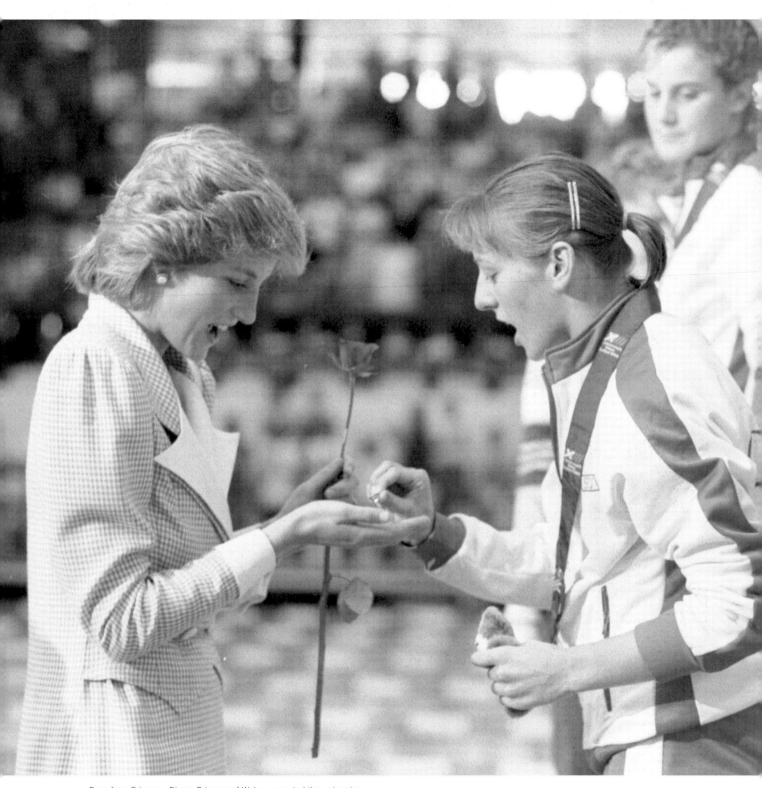

Rose for a Princess: Diana, Princess of Wales presented the swimming
medals at the 1986 Commonwealth Games. Here bronze medallist Kathy
Kellerman, of Canada surprises the Princess with a small keepsake

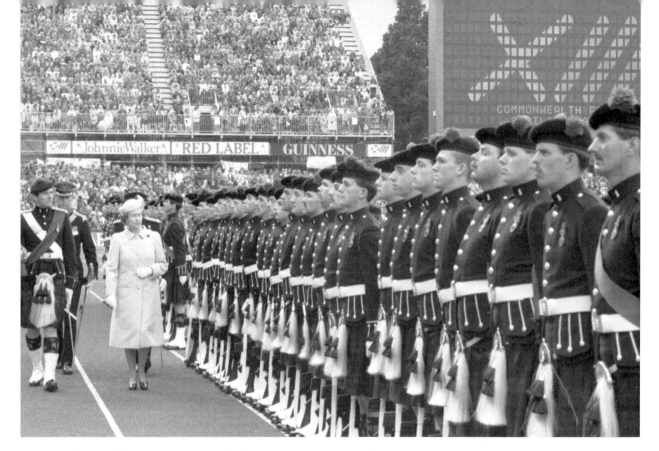

On guard: The Queen reviews her guard of honour at the closing ceremony of the Edinburgh Commonwealth Games in 1986, held at Meadowbank Stadium

In 1986, the Capital would become one of only two cities to host the Commonwealth Games a second time. The only other to boast the double honour is Auckland in New Zealand, but not without some controversy.

When the cost of staging the Games, including upgrading the city's sports facilities, soared to £4 million over budget, it was doubtful if the event could proceed. But media tycoon Robert Maxwell stepped in financially and 'saved the Games'. How much of the shortfall was paid out of the 'bouncing Czech's' own pocket, or was simply written off by frustrated creditors has been the subject of much speculation.

The Games themselves were also marred by a political boycott. After Prime Minister Margaret Thatcher refused to take sanctions against South Africa, 32 nations pulled out days beforehand.

Olympic medallist Sir Sebastian Coe has recalled: 'It never stopped raining, I caught flu and I had to pull out before the final. The stadium tended to be cool and windy ... conditions that suit your rugby team much more than they suit athletics meetings.'

But at least there was some success on the track at Meadowbank to lighten the mood. Liz McColgan, or rather Liz Lynch as she was in 1986, took gold in the 10,000 metres. It was to be Scotland's only athletics medal of the games, and a highlight of McColgan's impressive career. 'That was the most emotional I've been after any race,' she has said. 'It was the greatest feeling coming up for the medal from this underground tunnel that led into Meadowbank Stadium. All I could hear was the crowd chanting "Liz Lynch, Liz Lynch, Liz Lynch ..."

"It was the most amazing thing that I've ever known.'

And for the people of Edinburgh, her triumph provided another great sporting moment to add to the memories.

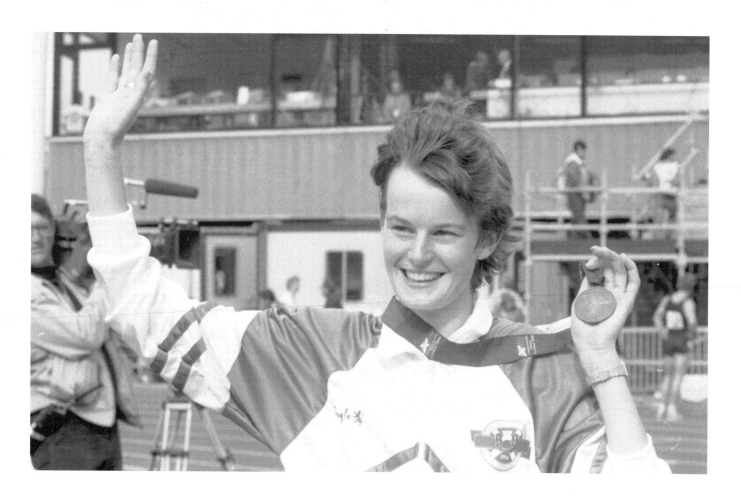

On track: Athlete Yvonne Murray wins a bronze medal in the Women's 3000m in the 1986 Commonwealth Games, held at Meadowbank Stadium

Golden moment: Runner Liz McColgan – then Liz Lynch – savours winning Scotland's only athletics gold medal at the 1986 Commonwealth Games

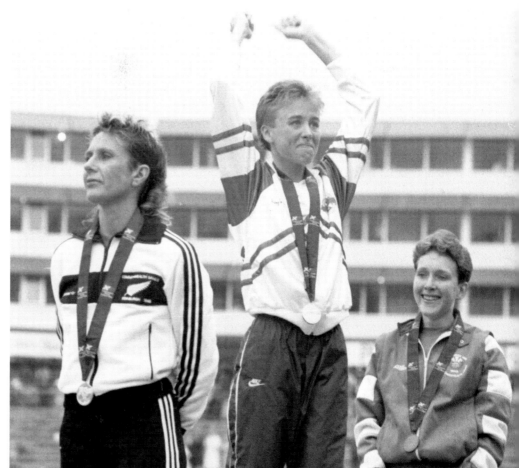

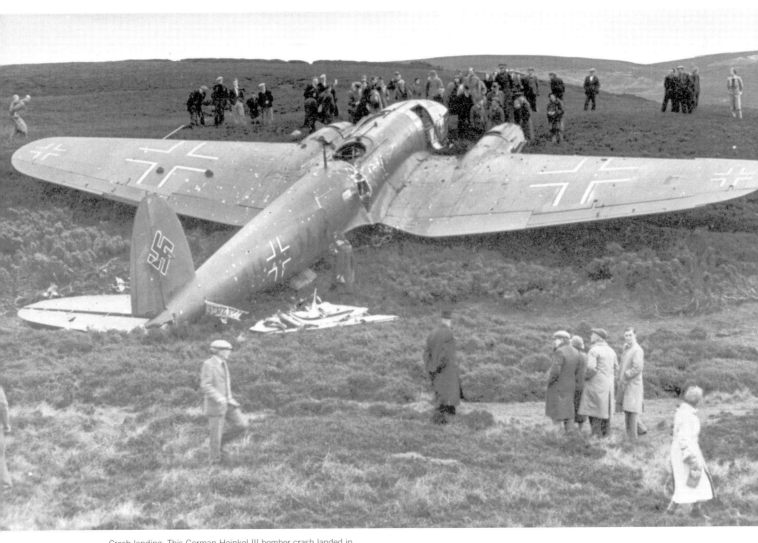

Crash landing: This German Heinkel III bomber crash landed in
the Lammermuir Hills near Edinburgh in October 1939 after
being shot down over the Firth of Forth

CHAPTER 7

The War Years

Over the centuries, Edinburgh was the focal point for countless conflicts and skirmishes with – usually the English – enemies. When the Second World War came, thanks to military advances, particularly in aviation, the threat was far greater than could ever have been imagined by the founders of the medieval fortress on Castle Rock.

While the Blitz laid waste to London and many other British cities, Edinburgh was left relatively intact by the Nazi bombardment, but the Capital did not escape completely unscathed. The first terrifying onslaught came on the afternoon of 16 October 1939, just a few weeks into the war, when 14 Heinkel and Dornier aircraft carried out a daylight raid. The city had been bracing itself for attack, owing to the proximity of the naval base at Rosyth and the strategic importance of the Forth Bridge and the port of Leith.

Yet no warning sirens sounded, and citizens were left wondering if the planes flying overhead were part of a practice run by the RAF. Unfortunately the raid was all too genuine; the enemy forces were attacking warships in the Forth, while HMS *Edinburgh* and HMS *Southampton* were at anchor, east of the Bridge.

Four assaults were made on the ships, with ten or twelve bombs being dropped, and two small boats which were tied to HMS *Edinburgh* sank. After a counter-attack from fighter pilots from the Edinburgh and Glasgow squadrons of the Auxiliary Air Force, three of the bombers were brought down; one ditched into the sea near Port Seton, East Lothian, and another off Crail, in Fife; a third was destroyed in the Pentland Hills, south of Edinburgh. A fourth was brought down by anti-aircraft fire from two land batteries and the two warships, and it crashed into woods behind North Queensferry.

Three of the four-man Luftwaffe crew brought down off Port Seton were later rescued by a local fishing boat, the *Dayspring*, and one of the Germans gave his gold ring to the skipper, John Dickson, as a gift of thanks.

The German raiders were chased over the city, and one eyewitness reported: 'At times the planes were so low that people could easily see the swastikas on the German ones and the roundels on the others.' During the raid, 16 Royal Navy men were killed and 44 wounded. Two captured German airmen later died of their wounds and were buried with full military honours in Portobello Cemetery, on 21 October. A few days later, two more Germans were killed when their plane was brought down near Gifford, East Lothian.

These were only the first of 14 Luftwaffe raids on the city during the war, which killed 20 civilians and injured a further 210. The first casualties came in July 1940, including an 18-year-old girl who was killed despite being inside a communal air-raid shelter in a back garden in Leith. Again without warning, a plane had flown out of the clouds,

Enemies buried: German pilots are given full military honours at St Philip's church in Portobello.
They had been shot down over Edinburgh in October 1939

coming in low to drop a single bomb, and circled before releasing eight more.

A tenement in George Street, Leith, suffered a direct hit and Alex Marshall, one of the residents, who managed to escape together with his wife, described the impact to reporters: 'We were lifted from our chairs nearly to the ceiling. We somehow scrambled out, then battered on the neighbour's door below and got her out with her five-year-old son.' The *Evening News* also reported that a child had a miraculous escape after a machine-gun bullet tore through a pram.

Only a few days later, another raid was launched on Granton, the site of the gasworks, which the Luftwaffe had photographed as part of their intelligence work, and during the following month, unexploded bombs had to be cleared in Portobello.

On 13 September, a bomb was dropped on the lawn of the Palace of Holyroodhouse, having missed the historic building by a few yards. There were signs that Edinburgh citizens were keeping their spirits high, however. As a royal gardener commented: 'I've just redesigned the garden: now

the Nazis have dug it up again!'

Later that month, a two-storey block was bombed in West Pilton. Another bomb struck a bonded warehouse in Duff Street in Dalry and the flames from burning casks of whisky leapt a hundred feet into the air. In October, four bombs fell on the city. Roofs were damaged in Marchmont, and two of a stick of four bombs fell on open ground at Edinburgh Zoo in Corstorphine.

On 13 and 14 March 1941, 100 incendiary bombs fell on Abbeyhill, and in April, a landmine shattered the roof of Leith Town Hall, destroying the infant annexe of David Kilpatrick's School. Tenements in Largo Place were also hit, and several residents were killed. In a raid which had dropped just two landmines, three churches, dozens of shops and hundreds of house were damaged. In May, four men were killed and an elderly woman died of shock on her way to hospital after incendiary devices fell on Milton Road and Portobello. The final raid on Edinburgh came in August 1941, when two people were killed and four injured in the Craigentinny area of the city.

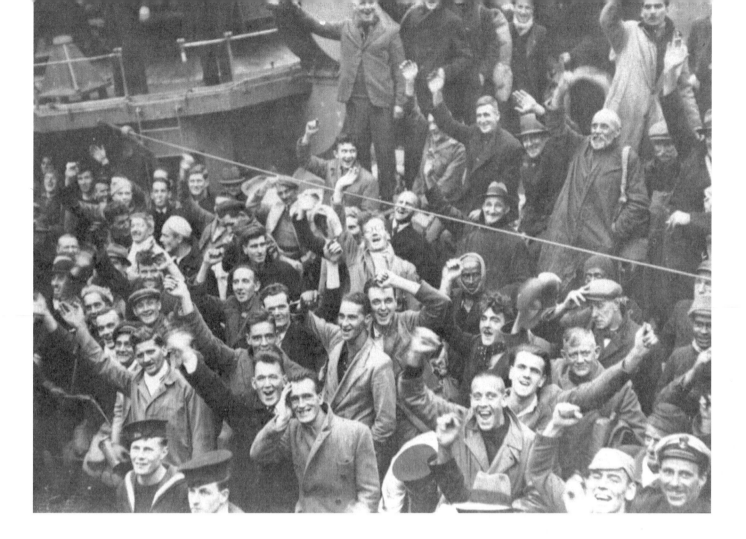

Home again: Crowds of Edinburgh people cheer as the HMS Cossack arrives at Leith, carrying British prisoners from Altmark in February 1940

Minesweeper: This picture shows the deck of a German minesweeper which surrendered to the Royal Navy in the Firth of Forth in May 1945, towards the end of the war

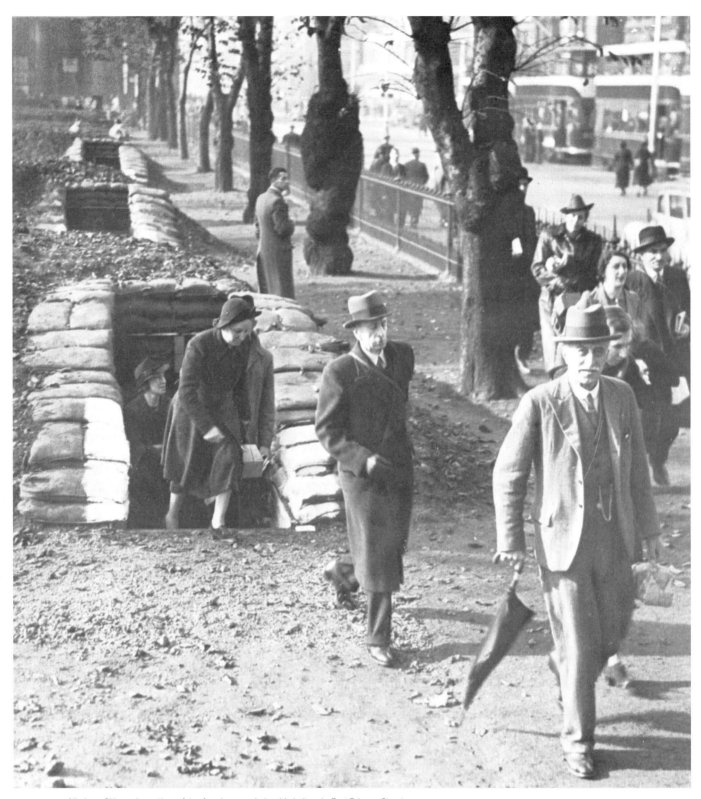

All clear: Citizens leave the safety of underground air raid shelters in East Princes Street
Gardens during the war, but warning of bombing raids did not always come in time

Up and away: A barrage balloon is
tethered at the Forth Bridge near
Edinburgh during the Second World War

Rubble: Part of David Kilpatrick's school in Leith was hit by a
bomb and reduced to little more than rubble after a strike by the
Germans in April 1941

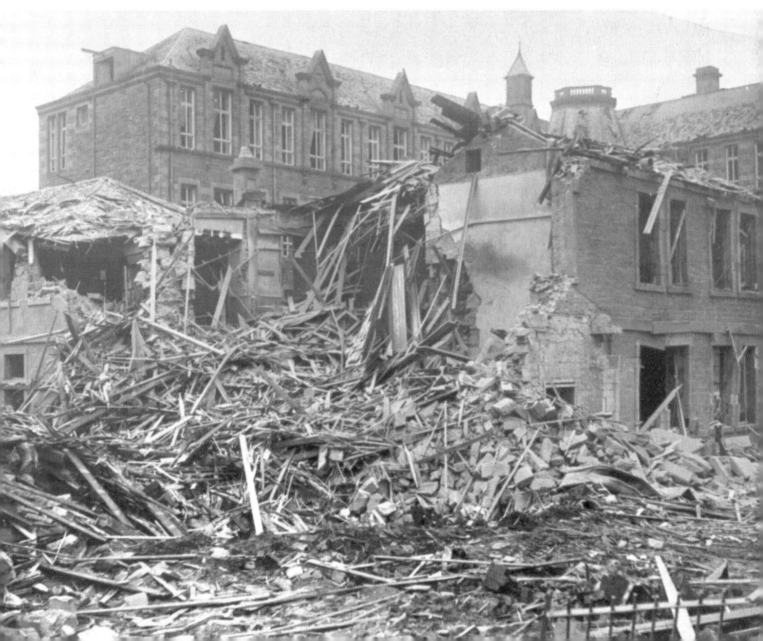

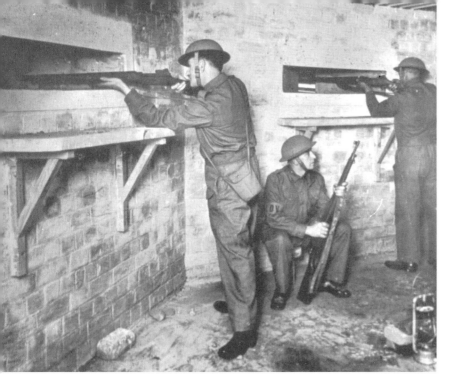

Dad's Army: Local defence volunteers
at a pill box in Dean Bridge helped to
guard the home front during the
Second World War

On the march: The Women's Land Army were on parade
in Edinburgh during the Second World War

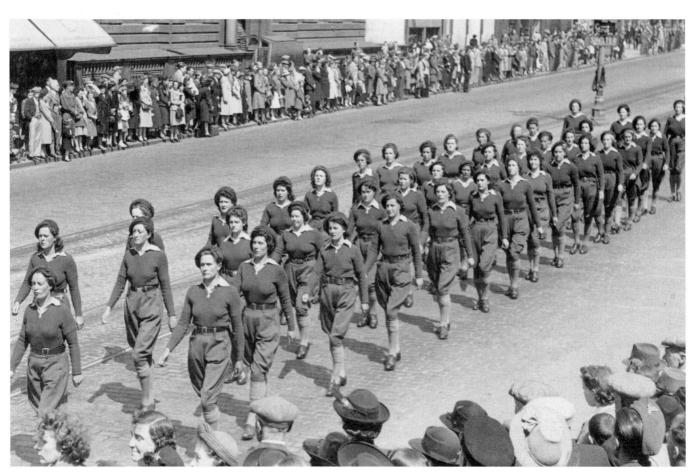

While the bombings killed relatively few people in the city, some 30,000 children were evacuated from Edinburgh to the comparative safety of rural towns and villages across Scotland. Those with relatives in the country were sent to stay with uncles and aunts or grandparents, while others were sent to reception areas in Banffshire, Berwickshire, Clackmannanshire, East Lothian, Fife, Moray, Nairn, Peeblesshire, Roxburghshire, Selkirkshire and West Lothian. Children from Trinity Academy went to Turriff and Macduff; Craigmillar children went to Daviot and Nairn; those from Portobello went to Findochty, Buckie and Cullen; Stenhouse children went to Keith, Dufftown and Aberlour, South Morningside's to Abernethy and Newhaven's to Fort William and Spean Bridge.

Many of the city children actually enjoyed their stay in the country, as one evacuee, Douglas Rae, has recalled after leaving Balgreen Halt Railway Station.

The following three years turned out to be some of the happiest I have known. Mind you, it was a very strange experience at the beginning: I was nine and lots of families were lined up in the playground at Balgreen School and taken to the station. We were given gas masks and labels and put on the train for a destination unknown. It turned out to be Gifford, just twenty miles from Edinburgh. We marched down the little main street from the station to the village hall, with all the locals hanging out of windows and standing in doorways to get a look at us.

It wasn't just children who left Edinburgh, however. At the outbreak of war in September 1939, the *Evening Dispatch* reported efforts to safeguard the Capital's oldest citizen: 'As a precaution against air raids, Edinburgh's oldest resident, Mrs Mary Madeline Sharp, aged 102, to-day [sic] left the city for the country. Her home is at 19 Queen Street. At 2 o'clock this afternoon, she was carried to a car with the assistance of neighbours. A small crowd of well-wishers gathered round to say au revoir.'

Meanwhile there was no shortage of volunteers to join up for active service, according to the newspaper. 'Only a few seconds after the doors of the recruiting office in Cockburn Street were opened at noon today, young men were inquiring about [the] joining up procedure.' The same edition of the paper reveals that women too were eager to play their part: 'Thousands of Edinburgh women have called at the Women's Voluntary Services Centre at the City Chambers in the last two or three days, asking if there is any way in which they can give assistance in the present emergency. Voluntary workers have been busy from early morning till late at night at the centre dealing with the numerous applications for all kinds of duties.'

Indeed preparations for the outbreak of war had begun as early as December 1937. To cope with the expected air assaults, wardens had been trained, drills organised and air-raid shelters, including a tunnel under Scotland Street in the New Town, had been investigated. Trenches and shelters had been dug in parks, including Princes Street Gardens, and there was space in public shelters for 30,000 people, with room for 110,000 more in shelters erected in private gardens.

As war was confirmed, the *Evening Dispatch* carried stern advice to Edinburgh citizens from the Chief Air Raid Warden: 'In case of an air-raid warning at any time, the proper course of action is to seek shelter at once. Everyone is advised to carry his or her gas mask on every occasion. The nightly black-out must be complete. Henceforth householders who allow lights to shine from their windows will definitely be prosecuted.'

The Capital's industries rose to the challenge, and some 42 naval vessels were built at Robb's shipyard in Leith. Meanwhile the North British Rubber Company did its bit and set up its own cadet force, complete with a major. As employee Johnny Smart recalled in the company history, *Stretch A Mile*: 'There was a joke made about the cadets. The uniforms, they said, were made of rubber so that

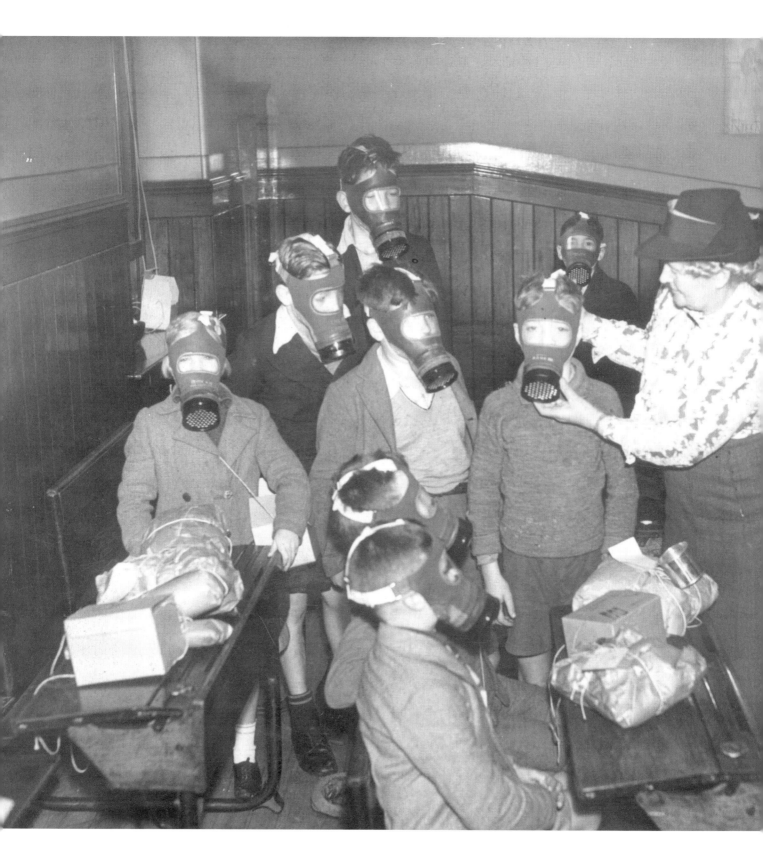

Masked: In preparation for bombing raids, children at South Bridge Primary School are fitted with their gas masks on 28 August 1939

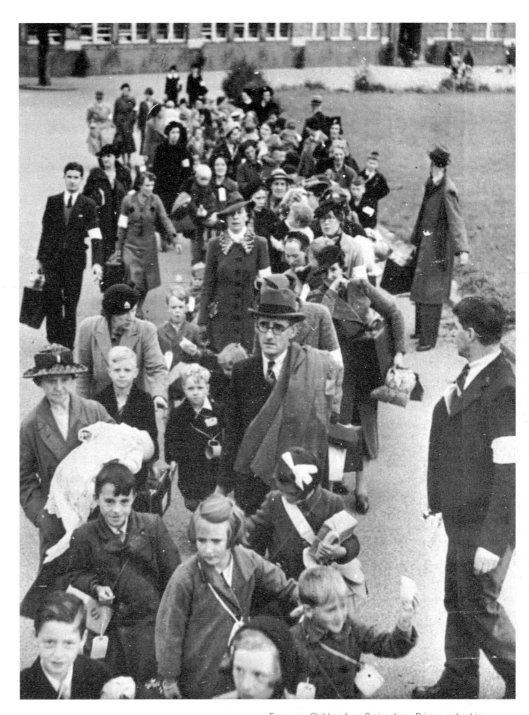

Evacuees: Children from Craigentinny Primary school in Edinburgh were evacuated to Inverness-shire days before the outbreak of war in September 1939

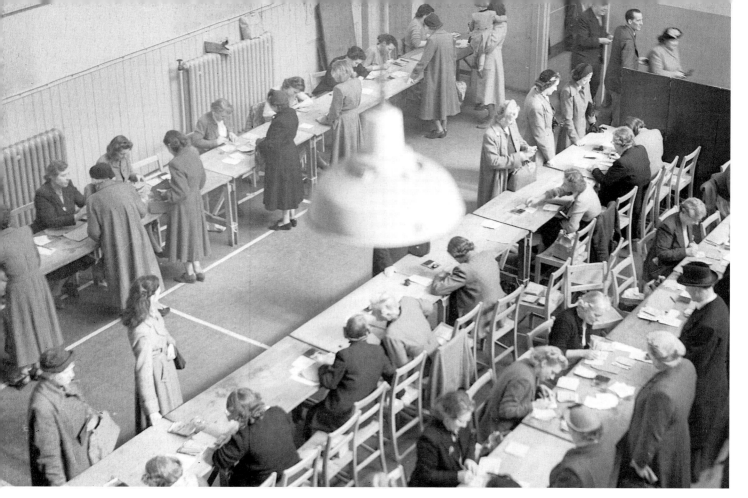

Rationed: Edinburgh people receive their ration books during the Second World War, as the conflict starts to have an impact on essential food supplies

when the enemy shot at them the bullets bounced back and killed them.'

For everyone in the city, life went on in the shadow of war. Black-outs, air-raid warnings and the carrying of gas masks were all constant reminders of the need to defend the home front. Railings were removed in parks and public squares across the city to answer the national appeal for scrap iron. Rationing of even basic foods, which began in January 1940 with restrictions on butter, sugar and bacon, followed by meat, tea, jam and cheese in 1941, called for cooks and housewives to eke out their ingredients sparingly. Cakes for special occasions were still possible if families and friends clubbed their coupons together.

Many children grew up not only without sweets but also lacking many items now very much taken for granted. Some had never seen bananas, and

when they finally reappeared in the shops, they were unsure whether or not to eat them with the skins still on.

Finally, in May 1945, the war ended. Victory had been anticipated since late 1944, and floodlighting had been installed in Princes Street Gardens for the celebrations. On VE Day, 8 May, the city celebrated with bonfires and street parties, all part of what Churchill described as 'the greatest outburst of joy in the history of mankind'. Servicemen and women danced eightsome reels to the pipes at the Mound.

Certainly the *Evening News* reported scenes of jubilation in the streets:

In pleasing sunshine last night celebrations in the streets of Edinburgh were continued and showed no signs of having diminished in enthusiasm. As

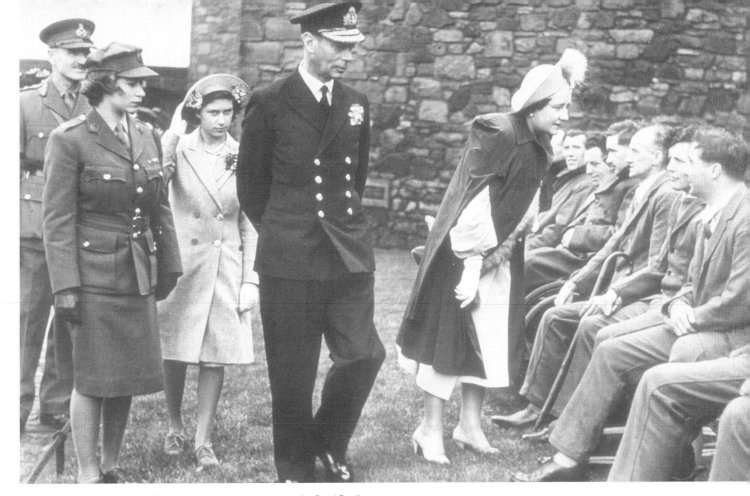

Honour: The Queen Mother stops to speak to veterans as the Royal Family visit the Scottish war wounded at Edinburgh Castle in May 1945

on the previous night, Princes Street was the rendezvous of the general revelry, and presented a colourful scene with flags and bunting on the north side blowing and flapping in the breeze, and the green sward of the Gardens opposite alive with crowds and multi-coloured groups of people sprawling in the sun.

The newspaper added that not everyone was aware of the revelry, however:

As the evening advanced, Princes Street itself became more and more congested and the overflow surged into the Gardens with the result that confusion reigned at some of the exits where hundreds were pressing their way in and out. At the floral clock a Canadian Army sergeant was responsible for a pedestrian jam – and he did not

know it! He lay sound asleep among the shrubbery, and hundreds of people elbowed their way to have a look at him . . . When dusk fell, celebrations became noisier, and the Mound and Princes Street Gardens became more densely crowded. Squibs, whiz-bangs [sic] and other rocket-like fireworks were brought into operation, and the 'bangs' which broke into the singing and dancing crowds went on until well after midnight.

The war was over and the Nazi threat to peace had been defeated; but life would never be the same. Britain's Empire was crumbling, and the end of the war heralded a new age, which would change Scotland's social landscape forever, and sow the seeds of the biggest political changes in almost 300 years.

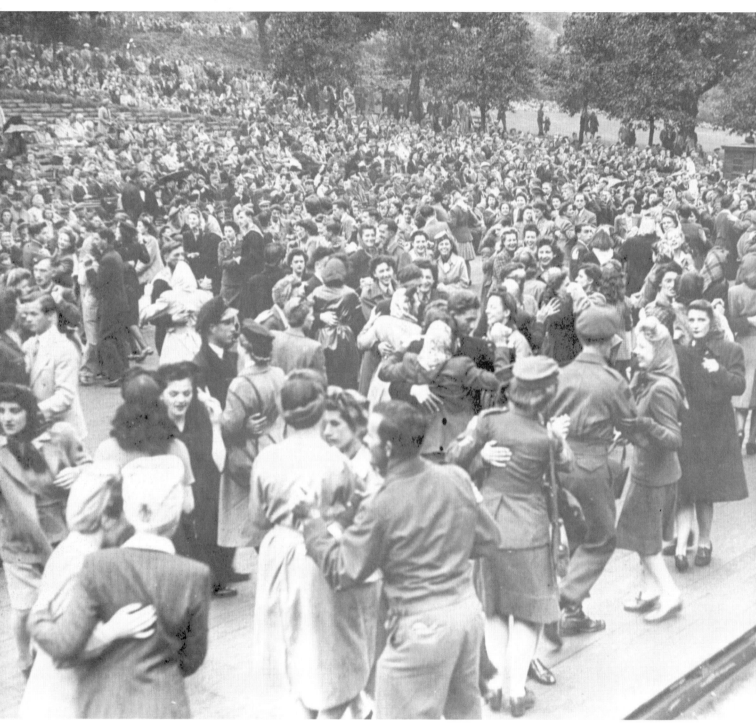

Victory: Hundreds of couples dance at the Ross Bandstand in Princes Street
Gardens, Edinburgh, as the Capital celebrates the end of the Second World War.

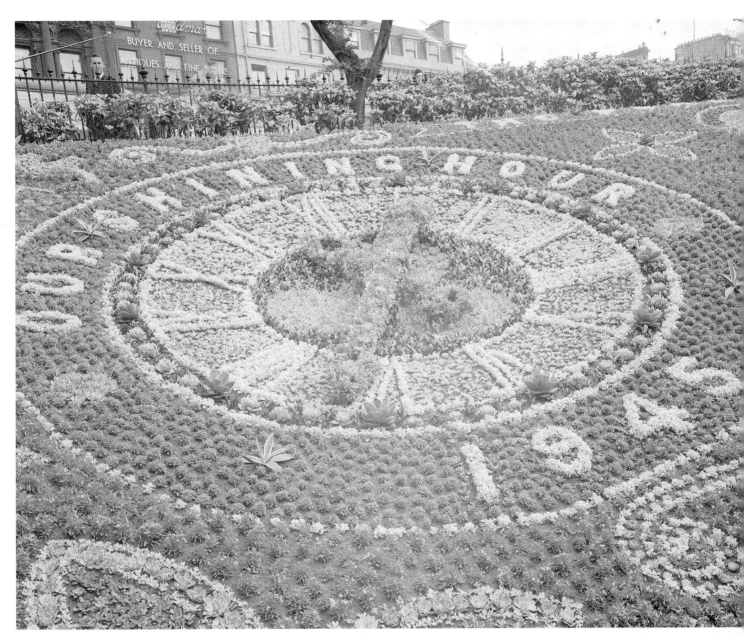

Shining hour: The Floral Clock in Princes Street Gardens
commemorates the end of the war

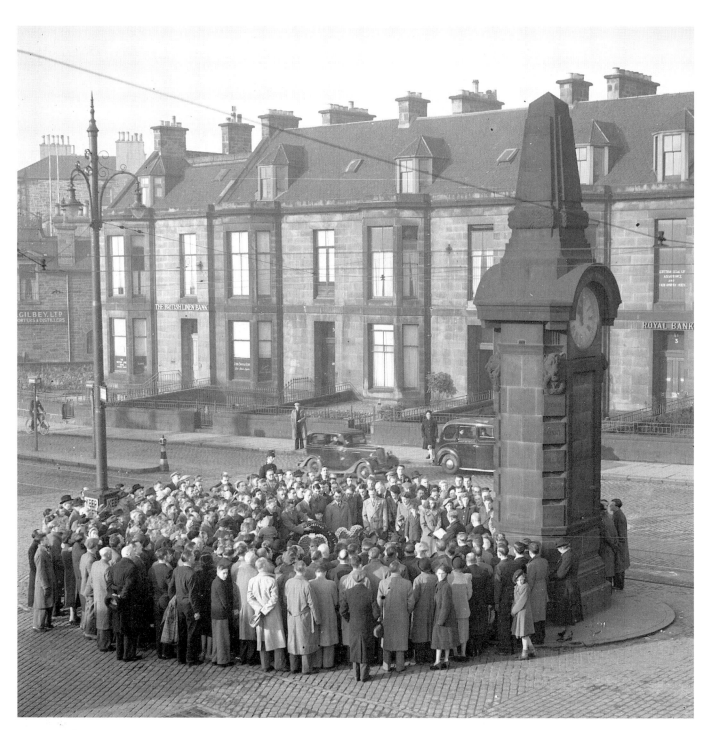

Crowds gather around the Heart of Midlothian War Memorial clock
at Haymarket on Remembrance Day 1950 to commemorate the
Hearts players who died during the First World War

Spitfire: This picture shows Edinburgh's Second World War Spitfire
memorial outside RAF Turnhouse after renovation in 1986

CHAPTER 8

A Political Capital

There shall be a Scottish Parliament . . . I like that.

Donald Dewar, First Minister

Not everyone in Scotland was always entirely happy about it, but Edinburgh's status as the capital city has been assured since at least the 15th century. Even after the Union of the Crowns in 1603, when James VI became James I of England, Edinburgh's exalted position was sealed when Charles I ordered a purpose-built parliament to be constructed just off the Royal Mile, with the foundation stone laid in August 1632. But the city's power was greatly eroded in the 1707 Act of Union, which dissolved the Scottish Parliament and brought political independence to an ignominious end.

It was not until 4 September 1939 that even the government administration of Scottish affairs was returned to Edinburgh. The architecturally imposing St Andrew's House on Regent Road became the new headquarters for the Scottish Office. Nationalist feeling had been growing, partly fuelled by the depression of the 1930s, which had hit Scotland harder than most of the rest of the UK. During the Second World War, support for the Scottish Nationalist Party steadily grew, and in April 1945 Dr Robert Macintyre won the party its first Westminster seat at the Motherwell by-election. The success was short-lived, however; Labour won the seat three months later at the General Election, and the SNP would wait almost two decades to win another seat.

Some Nationalist supporters soon found a dramatic way of venting their frustration at rule from Westminster, however, by removing the historic Stone of Destiny from Westminster Abbey. The sandstone block had served as the coronation stone for Scottish kings until 1296, after which it was taken south of the Border. In 1950, a group of SNP supporters stole the stone and smuggled it north. One of the Nationalists, Ian Hamilton, has recalled the night they arrived in Edinburgh with the stone. In No Stone Unturned (1952) he wrote:

As I looked up at that close mass of history, I thought that we too might have played our part . . . We might have done something to bring nearer the day, when with great joy and pageantry, the King drove up the Royal Mile to open the Scottish Parliament, while the crowds cheered and the guns of the half-moon battery roared salute. Perhaps we had done something to quicken our dead capital. I did not know, but I knew that we would go on trying until death closed our eyes.

It would take another half a century for Hamilton's dreams to come – partially – true. The Stone of Destiny was returned to Edinburgh in 1996.

By the early 1970s, the SNP was gathering further support. 'Blonde bombshell' Margo MacDonald's victory at Govan was followed by seven MPs who sat at Westminster in 1974. Their campaigns, using the slogan 'It's Scotland's Oil' would lead to the 1979 devolution referendum, reluctantly staged by the rattled Labour Government.

Head office: St Andrew's House Calton Hill Edinburgh, completed in 1939 to house the Scottish Office.

The neoclassical old Royal High School in Regent Road was refurbished as the proposed new home for Scotland's devolved parliament, and supporters mobilised a campaign for a 'yes' vote. Among the campaigners was former Sheriff Peter Thomson, who took his sandwich board to Princes Street bearing the stark message: 'Last Chance for Scotland.'

But it was not to be. The vote was lost, and the 'yes' campaign went down in history as nothing less than a disaster. Only 33 per cent of the electorate had voted in favour of home rule, against a minimum requirement of 40 per cent.

The Royal High was later bought by the city council to prevent it falling into private hands. Ironically, it was officially renamed 'New Parliament House', and it remained a symbol of the fight for home rule for almost two decades, while campaigners maintained a constant vigil in a hut on Regent Road.

With the election of Margaret Thatcher's Conservative Government in 1979, devolution was destined to remain on the political backburner for almost two decades. Yet even without the prospect of a Scottish Parliament on the agenda, Edinburgh remained at the heart of Scottish politics, playing host to demonstrations and rallies in support of striking miners in the 1980s, and protesting against the much-loathed community charge, or poll tax, which helped to rekindle the campaign for devolution and finally to unseat Margaret Thatcher from the Tory leadership.

Vote for me: Tory Nicholas Fairbairn pulled out all the stops in his attempt to win the Craigmillar by-election in November 1959

All smiles: Another future Foreign Secretary, but for the Tories, not Labour, Malcolm Rifkind was pictured with his wife after winning the Newington council seat in a by-election in December 1970

Vote winner: Robin Cook, pictured here as a Labour candidate in June 1970, would eventually rise to the Cabinet post of Foreign Secretary after Labour's 1997 election victory. He died suddenly in August 2005, while hill-walking in north-west Scotland

Capital man: Eric Milligan, one of Edinburgh's longest-serving councillors, in September 1981. He would go on to be the city's Lord Provost twice

Beer shampoo: The future Chancellor of the Exchequer, Gordon Brown, celebrates with friends in a city pub after his appointment as rector of Edinburgh University.

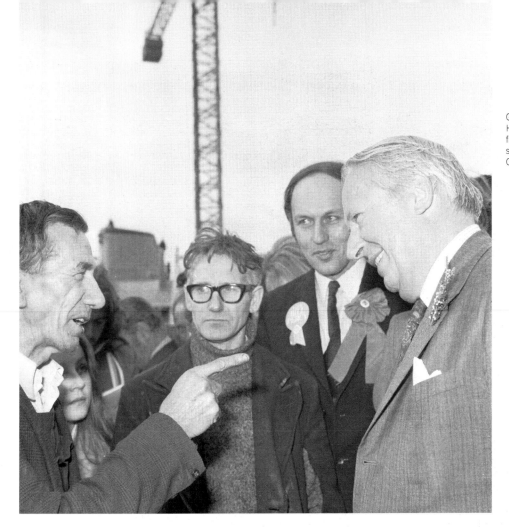

Get the point: Tory leader Ted Heath listens to some home truths from workers at the Robb Caledon shipyard in Leith during a visit in October 1974

Nats all: George Reid and Winnie Ewing at an SNP press conference in Edinburgh in July 1977

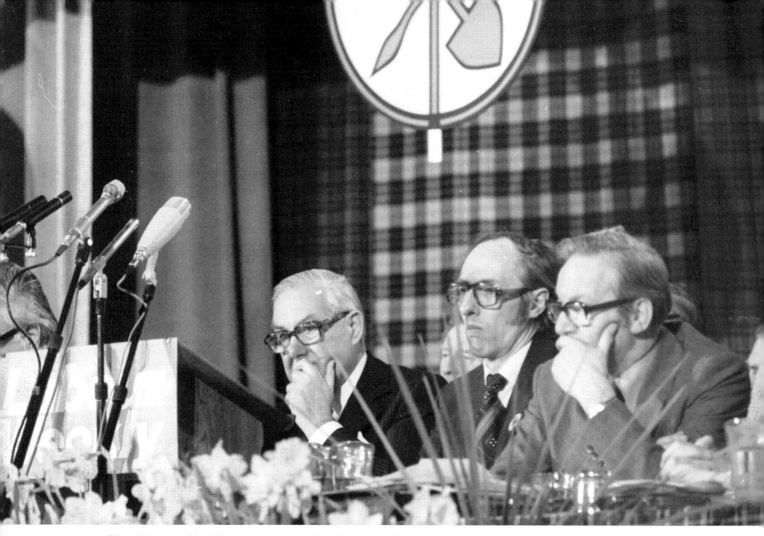

Father of the nation: Donald Dewar was pictured with then Prime Minister Jim
Callaghan at the Labour Party Conference in Doune in March 1978

In local politics, a sea-change occurred at the City Chambers in 1984 when Labour swept to power for the first time, ending years of Conservative rule in the city. Lord Provost Lesley Hinds, who was elected to the then Edinburgh District Council for the first time that night, has recalled that it was an unexpected victory. 'Most of us were quite shocked on the night,' she told the *Evening News*. 'It was a big change. Labour had never been in overall control. People were looking for a change and they were fed up with Edinburgh sitting back and doing nothing.'

One of the first things the new Labour administration did was to scrap Tory plans to build an opera house at the 'hole in the ground' at Castle Terrace, where Saltire Court and the new Traverse

Theatre have since been built. The council soon challenged George Younger, the then Tory Scottish Secretary, over calls for spending cuts, froze council rents, donated £5,000 to the miners' hardship fund, scrapped lavish free lunches for councillors and officials and ruffled Tory group feathers by re-naming a committee room after Nelson Mandela.

In 1988, the Labour MP for Leith, 'Red' Ron Brown hit the national headlines after picking up, and then dropping, the ceremonial mace in the House of Commons. He caused uproar by refusing to apologise. He was suspended from the Commons for twenty days and had the Labour whip withdrawn for three months: the first time in twenty years that the party had taken such an action against an MP.

Yes men: Labour's Donald Dewar, George Robertson and
John Home Robertson were pictured outside the old Royal
High School during 1979's devolution campaign

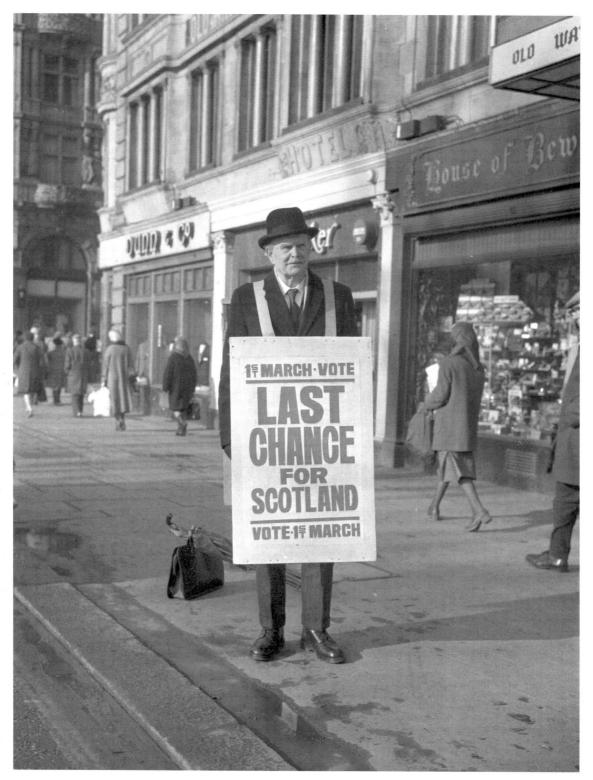

Last chance: Former Sheriff Peter Thomson takes his 'Last Chance For Scotland' sandwich board to Princes Street to promote the 'Yes For Scotland' devolution referendum campaign in February 1979.

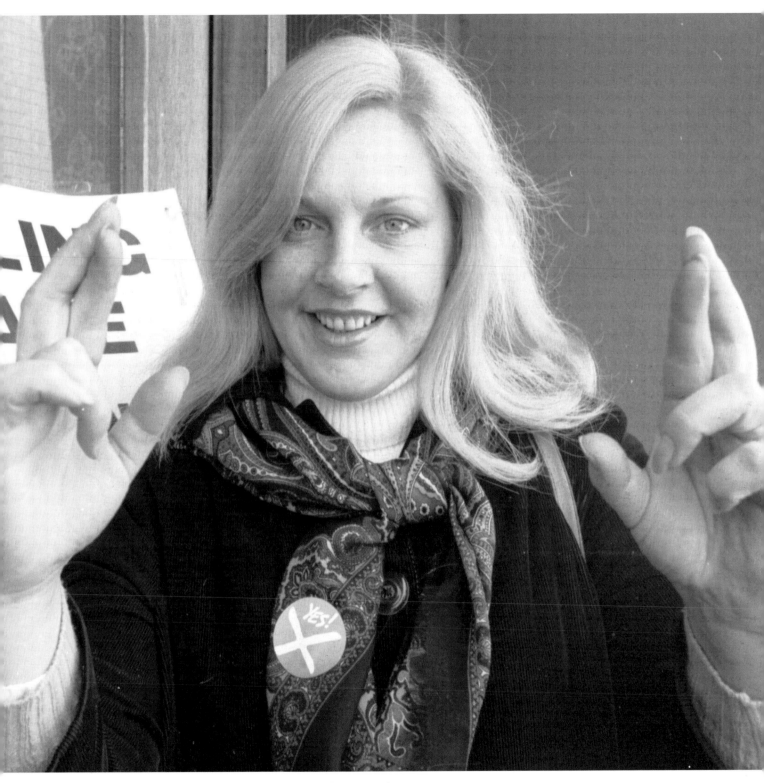

Fingers crossed: SNP politician Margo MacDonald keeps her fingers crossed
during the referendum vote on Scottish devolution in March 1979

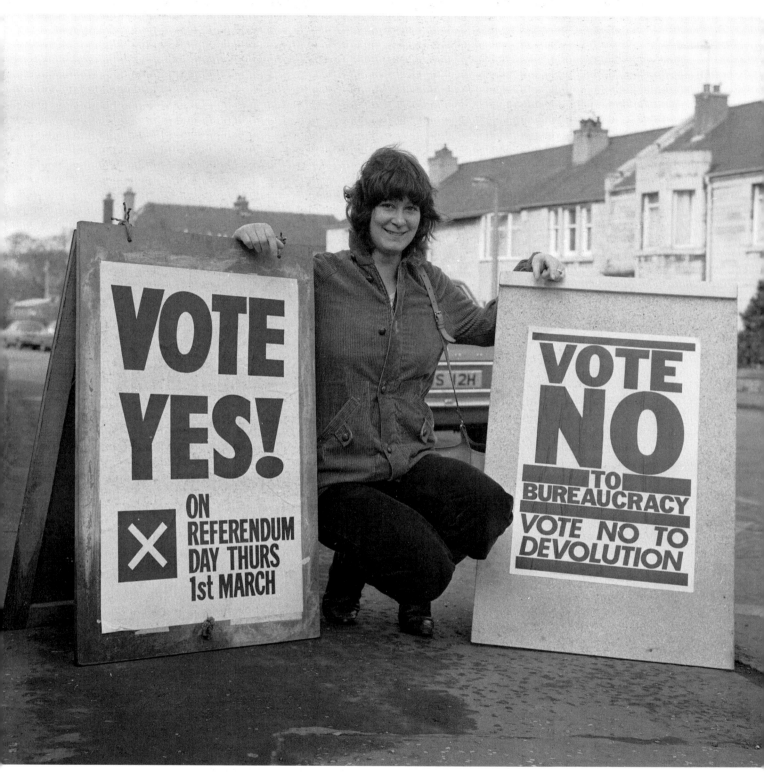

Yes or no?: Nurse Margaret McEwan was pictured outside the
Roseburn polling station in Edinburgh before voting in the Scottish
devolution referendum in March 1979

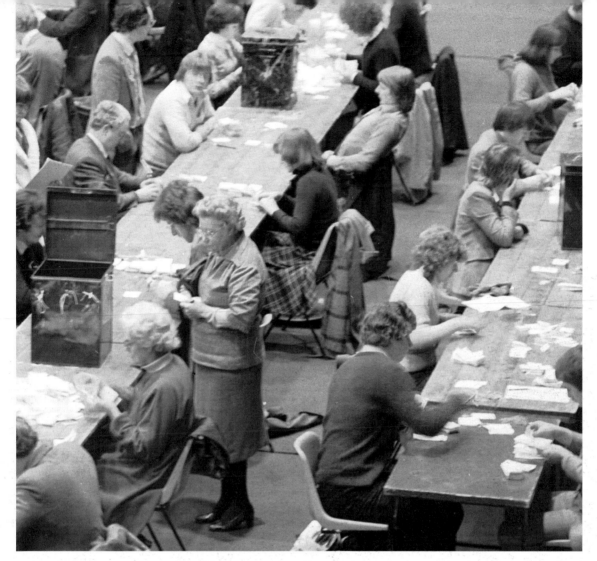

Counting up: The referendum votes are counted at Meadowbank Stadium – but the vote does not go the yes campaigners' way

Edinburgh has helped to nurture the current generation of leading politicians. The city is the birthplace of Prime Minister Tony Blair, who came into the world at 6.10 a.m. on 6 May 1953, at the Queen Mary Maternity Home. Anthony Charles Lynton Blair's first home was a pebble-dashed semi-detached bungalow at 5 Paisley Terrace in the Willowbrae area of the city. His father Leo was a junior tax inspector with the Inland Revenue, but was studying law with aspirations of an academic career. When he was offered a job as a lecturer in Adelaide the following year, the Blairs emigrated to Australia, and then spent some time in Glasgow before moving to Durham.

But the young Tony later returned to Edinburgh, where he was educated at Fettes College, which ironically for a future Labour leader, was one of the city's most exclusive private schools. He enrolled at the school in 1966, and was quickly regarded as clever and talented, although according to his favourite teacher and housemaster of three years, Dr Eric Anderson, one teacher described him as 'the most difficult boy I ever had to deal with', while another had thought him 'argumentative, full of himself and forever hiding his real self behind an impenetrable façade'.

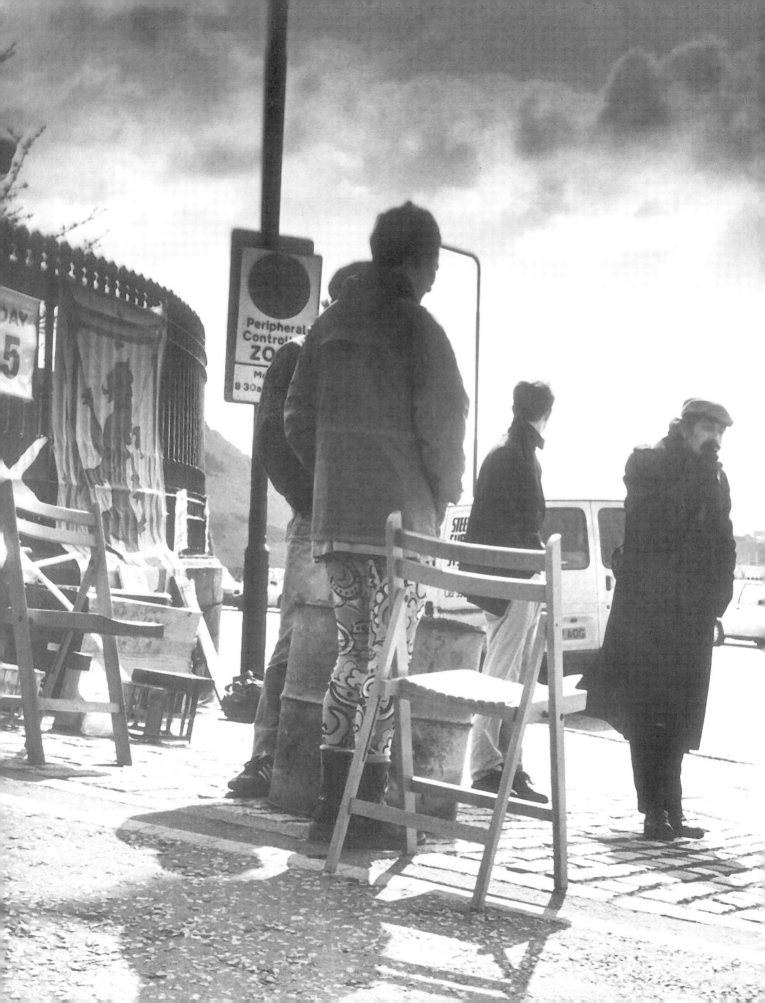

Vigil: After the referendum defeat, the Democracy for Scotland vigil was maintained outside the old Royal High School, which was earmarked for the new Scottish Parliament. This photograph was taken in 1992

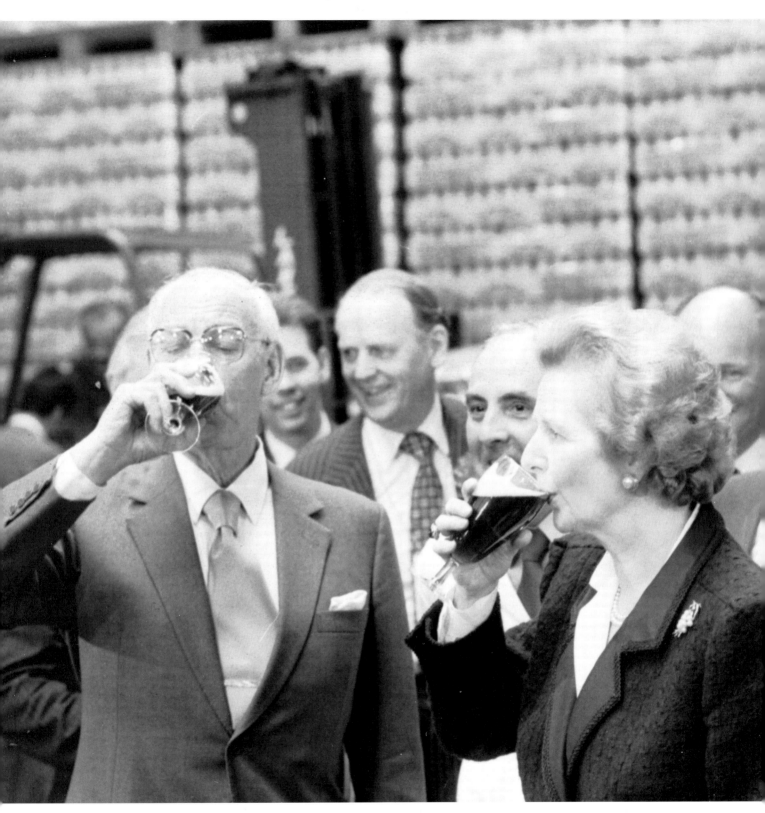

Chin, chin: Margaret Thatcher and husband Denis sample beer
during a visit to the Scottish and Newcastle brewery in June 1987

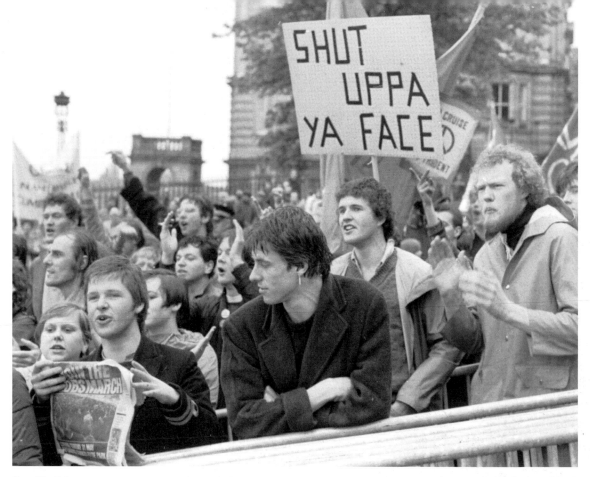

No to Mrs T: Protestors shout at Prime Minister Margaret Thatcher as she arrives in Edinburgh to open the General Assembly of the Church of Scotland in May 1981

Certainly Blair has tended to under-play his Scottish roots. His biographer, John Rentoul, has noted Blair's inclination is to describe himself as English, 'although when he first described himself thus in the Commons he corrected himself, first to say "well born in Scotland but brought up in England", then to declare "I'm British and proud to be British".'

There could be no doubting the Presbyterian origins of Fife-born son of the manse Gordon Brown, who would grow up to be Tony Blair's neighbour at 11 Downing Street as Chancellor of the Exchequer. It is often forgotten that in his student days at Edinburgh University he was regarded by contemporaries as being not only a radical student activist, but something of a hit with the ladies, including Princess Margarita of Romania.

Labour MP Robin Cook later recalled that her good looks were a welcome asset in his efforts to win the Edinburgh Central seat in the 1974 election campaign. 'Her canvass returns were always spectacularly good because the good citizens of Edinburgh Central would open their tenement doors and find this strikingly beautiful woman with long dark hair.'

Almost a quarter of a century later, Gordon Brown and Tony Blair found themselves frequent visitors to Edinburgh once again, canvassing support for the devolution referendum. Once again, devolution was on the political agenda, and it was only made possible after the landslide Labour victory of 1997, when the Tories not only lost power, but were completely wiped off the electoral map in Scotland. The referendum was held on 11 September 1997, and this time the Scottish electorate gave their overwhelming support for a Scottish Parliament with tax-raising powers.

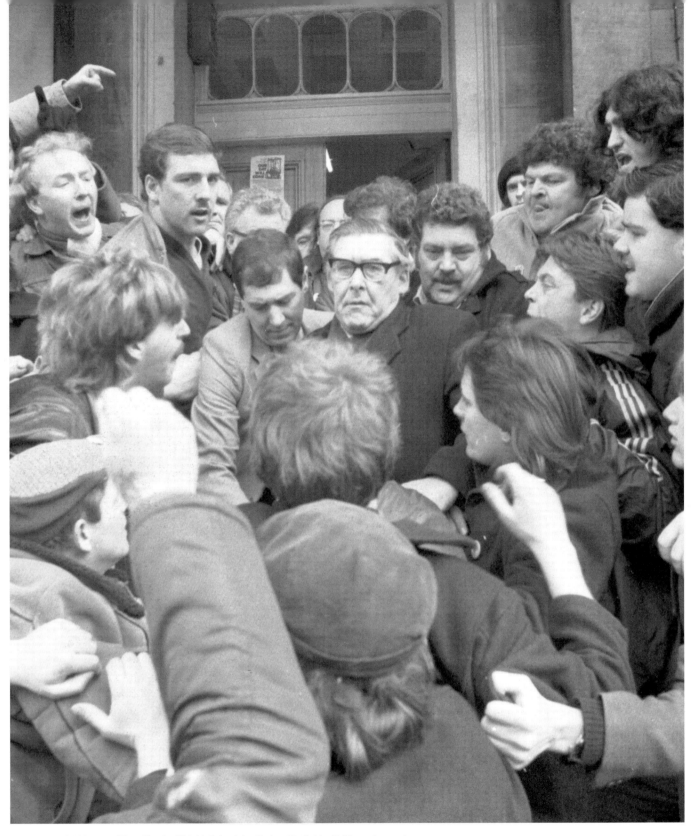

NUM scrum: Miners' leader Mick McGahey is heckled and jostled by NUM members as he leaves a meeting to discuss prolonging the miners' strike in Scotland in March 1985

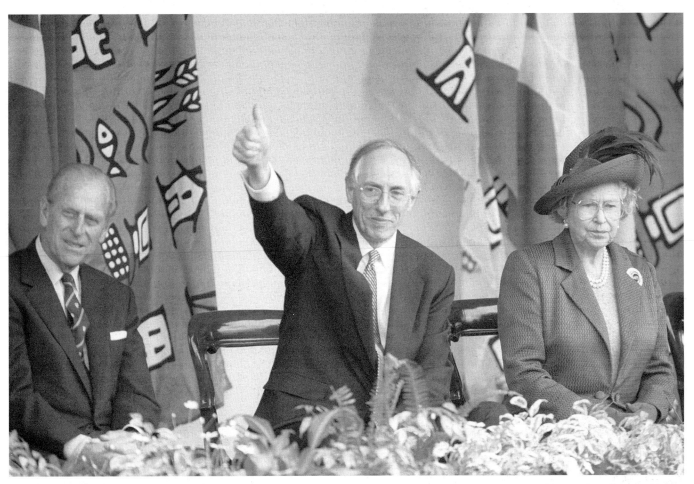

Thumbs up: Flanked by the Queen and the Duke of Edinburgh, Donald Dewar makes it clear he approves of proceedings at the opening of the Scottish Parliament on 1 July 1999

But the man who is remembered as 'The Father of the Nation' is Donald Dewar, the Scottish Secretary and the first man to be First Minister of a devolved Scotland. After the historic 'yes yes' result, Dewar went on to outline the legislation required to transfer powers to Edinburgh. Clause One of the bill could not be more definitive: 'There shall be a Scottish Parliament,' he said, before adding with a rarely seen smile: 'I like that.'

In May 1999, Dewar's dream became a reality as the Scottish Parliament was reconvened at its temporary home, the Church of Scotland's General Assembly on building on the Mound, for the first time in 292 years.

Dewar had rejected the old Royal High School at Regent Road as a permanent home for the parliament. Instead he had decided to build a new one, on the former site of a Scottish and Newcastle brewery at Holyrood. The decision was to have controversial ramifications long after his sudden death from a brain haemorrhage in October 2000.

But whatever the arguments about the spiralling cost of constructing Catalan architect Enric Miralles's design, devolution and the reopening of the parliament had already energised the city with a renewed vigour, as the former Lord Provost Eric Milligan has recalled: 'Edinburgh has been a pretty prissy, Presbyterian kind of place and very provincial in its outlook. Now it sees itself as not just pretending to be a capital city, but a true capital city.'

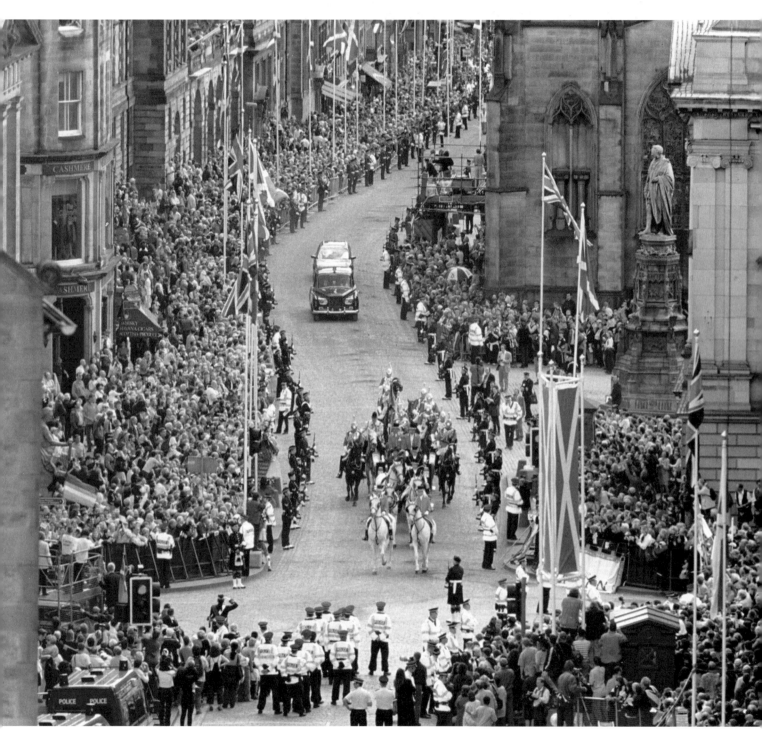

Royal ascent: The Queen and her entourage proceed up the Royal Mile
on the day of the official opening of the Scottish Parliament

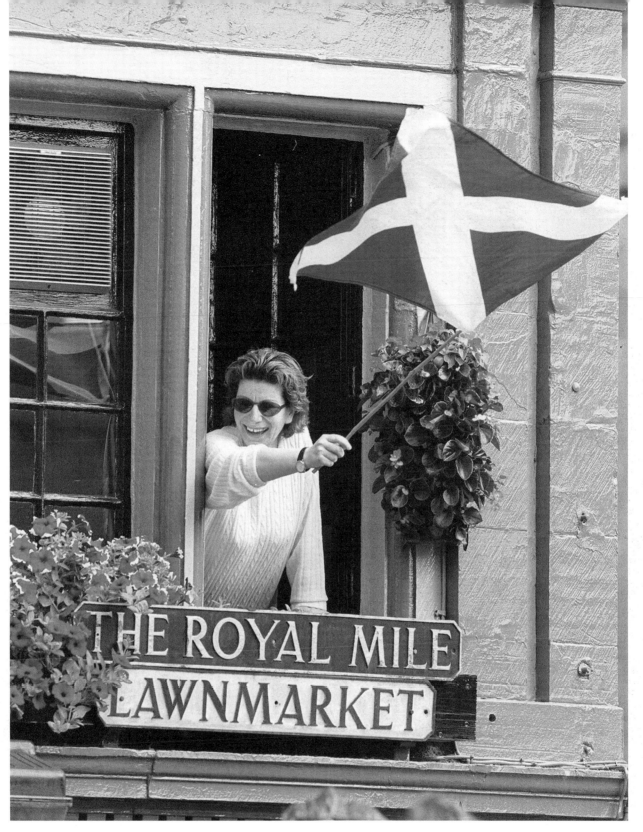

Flying the flag: A woman waves the Saltire from a window at the Lawnmarket as
the Royal procession passes on its way to open the Scottish Parliament

Index